THE FREELANCE PHOTOGRAPHY HANDBOOK

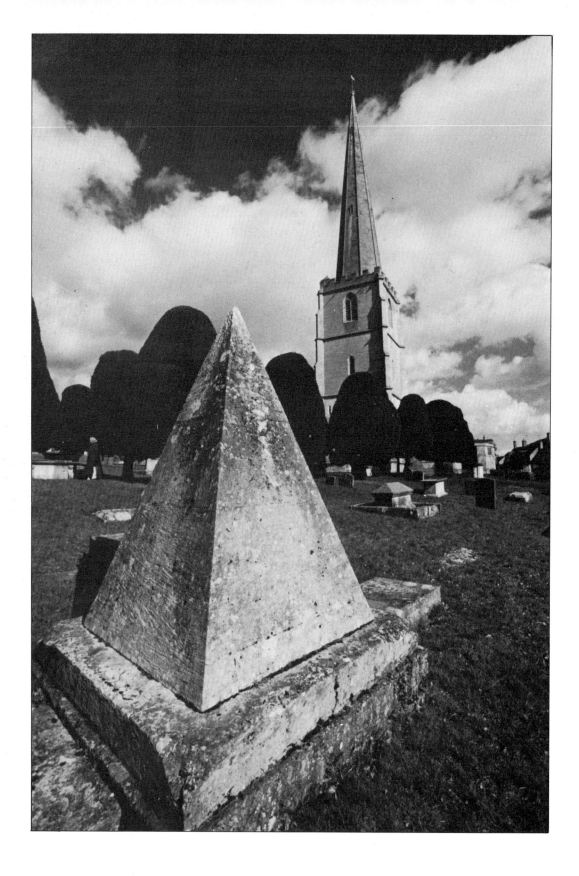

THE FREELANCE PHOTOGRAPHY HANDBOOK

BARRY MONK

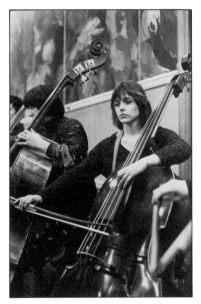

EBURY PRESS

Published by
Ebury Press
National Magazine House
72 Broadwick Street
London W1V 2BP

First impression 1983

ISBN 0 85223 2330

Cover photograph by Paul Kemp

Designed by Harry Green

Illustrations on pages 2–3
You can find interesting picture situations,
such as a village churchyard, within your own
locality.
Music is an area served by a large variety of
publications, many of which could use a
picture of a cellist.
Humour and pets—combine both and you
have a picture with selling potential.

Typeset by Advanced Filmsetters (Glasgow) Limited
Printed and bound by New Interlitho s.p.a., Milan

Contents

CONTENTS

Preface

Over the past ten years I have been able to view freelance photography from two sides. As a press photographer and freelance, I have experienced the rewards and problems of submitting pictures to newspapers, magazines, and other publications. As assistant editor of *Amateur Photographer* magazine, I have looked at thousands of photographs, and spoken to many freelances, both in the amateur and professional fields.

With this book I have brought together the experience I have gained as picture *seller* and picture *buyer* to help other freelances sell their pictures successfully.

If you think freelance photography is just for the professionals, let me assure you—it isn't. Most of the freelances I have come across regularly sell pictures on a part-time basis.

To help you make your photography pay, I have tried to deal with the *practicalities* of freelancing—how to charge for weddings, what the magazines and other publications pay, how an agency can help and what markets are available for certain types of pictures. I have pointed out the advantages, and disadvantages, of freelancing to help you achieve some success, and avoid the pitfalls.

I am grateful to the many freelances up and down the country who have supplied me with useful information and, of course, their photographs. I am happy to give some of them their first publication in a book.

Finally, I hope you, the reader, will find enough incentive in this book to start your freelance activity, or improve your success rate. Selling one picture might cover the cost of the book, but I hope you go on to make a great deal more than that, as well as derive a lot of enjoyment from freelancing.

BARRY MONK

A question of freelancing

There are a number of questions that need to be answered before going into freelance work. Perhaps the first is—*what exactly is a freelance photographer?*

The actual term 'freelance' is applied very widely in photography. While a freelance is more likely to be thought of as a professional, earning a full-time living from photography, many amateurs also call themselves freelance. Some photographers become involved in freelancing without thinking twice about it. Sometimes it is simply a natural extension of their normal photographic activity, or something they just drift into by chance.

Others have to think about the various aspects of freelancing more carefully—and ask themselves a few questions before plunging in.

Whatever your approach is, here are some relevant questions well worth asking before you start out on the freelance road.

What is a freelance?

In the end, the term really describes people who earn money, at various levels, from taking and selling pictures.

The photographic marketplace is, generally speaking, open to professionals and non-professionals alike. This is either a good or bad thing, depending on your point of view. Attitudes among professional photographers towards amateurs vary widely from complete intolerance to positive encouragement. The same anomalies exist among those who buy pictures or hire photographers.

Many professionals, quite rightly, do not wish to see their livelihoods threatened by amateurs, no matter how good they are. Indeed this is one reason why some amateurs are reticent about competing with professionals. Alternatively, it has to be said that there are professional studios who openly hire amateurs, for example, to take wedding pictures on a Saturday.

What the part-time freelance must realise straightaway is that such anomalies exist wherever photography is used, and no more so than in the publishing industry. An amateur might find one local newspaper will accept his pictures, while another will not because the pictures were not taken by a professional. Similarly, union agreements on national newspapers forbid the use of pictures taken by non-union photographers—yet those same newspapers would never turn down an exclusive news picture (say, of a plane crash) taken by an amateur. News is news, regardless of source.

At first, this might seem very confusing and, indeed, it puts a lot of people off freelancing before they even start. But don't be discouraged. Instead, try and take advantage of these anomalies. Bear in mind that in many cases the fact that you are full-time or part-time is irrelevant to those buying pictures, or hiring photographers. What is important is whether you, as a photographer, can do the job properly and produce pictures of the type and standard required. That is exactly what being a freelance is all about.

What are the main reasons for freelancing?

Everyone goes into freelance photography for different reasons. Whether or not you have decided why you want to freelance, it does no harm to analyse the basic reasons for starting so that you know how to pitch your photographic approach and plan your future freelancing strategy.

Making money

Undoubtedly the attraction of making some spare-time cash is one of the biggest incentives to freelance—and why not? You might, at this very moment, have photographs sitting in a drawer that someone, somewhere may be interested in buying. Or you might have enough spare time to tackle photographic assignments that people will be prepared to pay for.

As a photographer, you may merely want to subsidise the cost of your hobby, or graduate towards earning a full-time living out of photography. Either way, a great deal depends on how much time and effort you put into freelancing—but the possibilities to make money are certainly there. Part of the skill of freelancing is to follow up these possibilities and profit from, or at least cover the cost of, your picture-taking activities (see *Is freelancing profitable?* p. 13).

Seeing work in print

Aside from the financial aspects, one of the greatest rewards of selling pictures is seeing them reproduced in print. The publishing market is vast, and literally millions of photographs are reproduced every year in newspapers, magazines, books, greeting cards and posters. And new photographs (and photographers) are always in great demand.

Even photographers whose work is published regularly agree that seeing new work in print is a continuous incentive. Also, because their work is always seen, more commissions or assignments are likely to arise. So, with a little luck, the effect of having work published can be cumulative.

Photography with purpose

One problem that many photographers face is that they often drift along not really knowing what to take pictures of, or what to do with photographs they have taken.

Freelancing can be a tremendous discipline. By planning assignments, taking pictures for specific reasons and possibly selling them later on, photography can take on some purpose and direction.

There can be a real sense of achievement in searching out the markets for your work and selling successfully to the markets in a competitive situation. It is really an extension of the kind of competitions many club photographers will be aware of, where individual

For the active photographer, freelancing can offer great scope. You may not always be able to take great portraits of well-known people, as with the shot of Mohammed Ali here, but it certainly is not impossible if you can arrange to be in the right place at the right time. So careful planning can be just as important as the taking of the pictures.

photographers compete among each other to win competitions. Competing in the freelance market means taking on the opposition — and winning. This kind of incentive more often than not, gives an 'edge' to a photographer's creative output that might otherwise have been lacking.

Improving technique

Undoubtedly, regular freelancing can improve a photographer's technique. In taking pictures, as in many other activities, practice can make perfect, or at least make for improvement.

The more goals you set yourself as a photographer, the more areas of photographic skill and enterprise can be investigated. Through trial and error problems can gradually be overcome. Quite often, a freelance simply cannot afford to be inhibited by particular obstacles of technique, and is more likely to take risks as a result — all to the improvement of his or her craft.

'Perks' of freelancing

Some freelances are able to take advantage of certain 'perks' or advantages that are not always available to other photographers. Regular freelances may be able to secure discounts on equipment, films and other materials, if they are in a business situation. Others, who frequent sporting or other events, may be able to obtain special passes once they have proved their worth as photographers, and can show they will not misuse such privileges.

Earning a living

A few lucky photographers graduate to becoming full-time freelances. It is a heartening thought that most professionals started their careers as amateurs and, with the help of various factors — including hard work, determination, help from fellow photographers and, sometimes, luck — are now able to take pictures for a living.

It has to be said that only a minority of part-time freelances actually turn professional. The life itself can be precarious and some of the most well-known photographers who freelance full-time have to work hard continually to stay successful. Those who are determined enough to become full-time freelances can usually succeed, providing they know exactly what is involved. By starting as a part-timer, and slowly building towards the goal of turning professional, you will gradually be drilled into what to expect, before taking the final plunge.

There are likely to be other reasons for freelancing — each photographer will have particular expectations and requirements. The important thing is to be clear about *why* you want to freelance, then you can style your photographic approach towards achieving some of the goals you set yourself based on those reasons. Having done this, it is surprising how much easier the path towards freelance success becomes.

Are there different types of freelances?

Photographers come in all shapes and sizes, and have different styles and approaches—likewise freelances. Despite that, there seems to be only three main categories into which freelances fit—those who either sell their services or sell their pictures or sell their services *and* pictures as a complete package.

While there are some freelances in the first category, most fit into either of the latter two. The reason for this is that few photographers sell *only* their services—normally the pictures they take can be marketed later on.

An example of a photographer who sells services only might be a wedding photographer who is hired to take pictures on a Saturday by a studio. He or she is paid a set rate for doing the job and gives the films to the studio, who sell the results later. Even here, in some cases, the photographer may take some commission from prints sold. Those who photograph weddings for themselves obviously have the opportunity to charge for their services *and* for the pictures sold subsequently. So the last category can be the most profitable, although more work is involved before and after the actual event.

Freelances may be restricted by how far they can travel to assignments. Some may be lucky enough to have a local race track or similar venue where good pictures may be taken regularly. Here the freelance has ventured to the Le Mans race.
Leica M4-2, 50 mm f/2 lens, XP1 film.

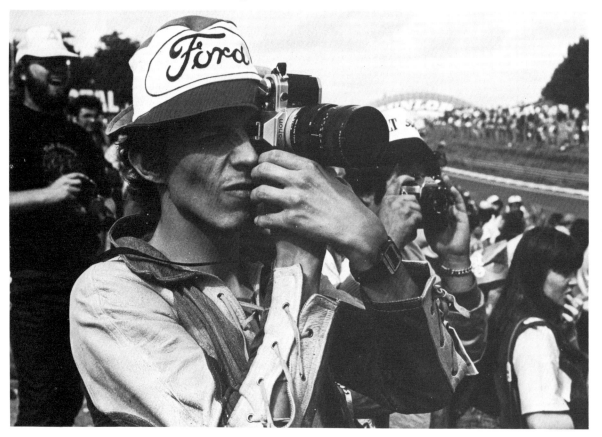

One of the drawbacks in selling your services as a photographer is that you are restricted by the number of assignments or commissions you can undertake, and how far afield you can travel. This is one reason why most freelances in this category only work locally. In the second category, the incredibly wide number of picture-selling opportunities is only as far away as the nearest post box. Since a huge chunk of the market lies in publishing, this market can easily be reached by sending pictures through the mail. Little wonder that most freelances adopt working in this category.

You may already know what particular area you are likely to fall into. If you don't, hopefully these broad category descriptions will help you decide. Having done this, turn to the *Markets* chapter, (p. 17), and find out how best your skills can be applied for maximum financial reward.

Is freelancing profitable?

The answer to this much-asked question is—yes. Freelancing can be a profitable career.

However, the profit that can be made is directly proportional to the time and effort put in by the photographer. While many photographers have benefited financially over a period of time from freelancing, there seem to be few, if any, overnight success stories. Profit certainly is possible, but if it is a 'get-rich-quick' scheme you are looking for, then forget freelancing.

How much profit you make depends a great deal on the area of freelancing you are in. If you just want to take wedding pictures on a Saturday, it should not be too difficult to work out how much profit can be made, providing all overheads are taken into account. Some operators might make £25–£50 from a wedding, while others might attend two or three functions in a day and make a great deal more. This is where the time and effort factors come in.

By selling to magazines, a photographer can expect fees from £10–£50 or more per picture, depending on the picture's value, the type of magazine, whether it is black and white or colour, and so on. Even at the lower end of the fees' scale, a picture sold roughly every week at £10 a time is £520 per year in the photographer's pocket—enough to buy film, equip a darkroom, or whatever.

It must be remembered, however, that freelances rarely make any real profit straightaway. Most will already have invested in cameras, lenses, accessories, film and processing, and clearly these costs will have to be covered before any actual profit level is reached. To some, freelancing represents a way of raising money to buy extra equipment to subsidise their hobby. Here, any money made is ploughed back into the photography, which is a perfectly sound reason for freelancing.

To make a profit on a regular basis, be prepared to plan the financial and marketing aspects. On the financial side this means

watching the money that goes in and out, and looking after the financing of your freelancing activity. It is a good idea to seek professional help on these matters from your bank manager, accountant, or other financial adviser.

Finding the right markets for pictures is one of the key factors to successful freelancing. The best photographers in the world won't make any money unless they find the right sources to sell their photographs to. How the marketplace operates, and how you can break into it successfully, will be explained in more detail later. In the meantime, be prepared to spend some time away from the camera on these areas, or at least organise someone who can help look after the business side while you concentrate on taking the pictures.

Can you compete with the professionals?

A lot of people think professional photographic services are expensive. They certainly can be but, in most cases, you get what you pay for—a high standard of expertise, good-quality photographs, after sales service (extra prints, frames, etc.) and recourse to a governing body such as the Institute of Incorporated Photographers (to which many professionals belong) should there be any problems.

In comparative terms the cost of photography can be fairly low. For a wedding, for example, the taking and supplying of a set of photographs in an album might cost around £100 or less, while the catering for the reception might cost five times that amount. Needless to say, the photographs will have a longer lasting value, and may be considered cheap at the price.

Even so, for some photography, such as family portraits, people regard professional photographic services as a luxury. In which case they either take 'snapshots' at home, or ask a photographer friend with a 'decent' camera to take the pictures—and this is an important area for the part-time freelance.

But should you do such work 'on the cheap'—that is, undercut the local professional(s) and charge less than the going rate for doing a particular job. The quick answer is NO. But a great deal depends on how serious you are about freelancing, and how much work you intend to do.

Certainly, if you just take pictures for friends and relatives there is no reason at all why you should charge professional rates. Unlike a professional, you probably won't have an expensive studio to maintain, so the job can be charged at cost plus an acceptable profit, and still be cheaper than most professionals.

If it becomes more serious that this—you start to undertake work for outsiders on a regular basis, for example—customers will come to you expecting a service. And whether you are an amateur or professional, clients will expect good results for their money. At some stage your interest becomes a business, and undercutting other local photographers should not be entertained.

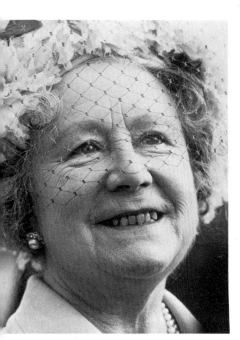

Photographs of royalty or other famous faces need not be restricted solely to the professionals. Here the photographer captured the Queen Mother at an event in Colchester, shooting from within the crowd using a long lens to take this tightly-framed, charming portrait.

Attitudes vary within the photographic profession. Some High Street photographers accuse amateurs of taking away some of their bread-and-butter work, while some studios are quite happy to hire amateurs to shoot weddings for them on a Saturday.

Some amateurs feel that if their work is lower than the professional standard, or if they cannot provide the wide range of facilities a studio may provide, they should charge less than normal.

In some cases this may be acceptable, but any regular freelance should work very hard at improving the standard of his or her photography, rather than simply charge less. Otherwise, that photographer may get a reputation for charging cut-price rates for sub-standard work—hardly a recipe for success.

Find out what the local professionals are charging by ringing them up and asking—then set your own fees competitively on that basis.

Are qualifications needed?

In terms of formal training there is no recognised 'freelance diploma'. Even if there were, 'the chances are it would be of limited use to anyone wishing to make money out of photography.

Organisations that run freelance correspondence courses sometimes give certificates to members who complete their training. While the courses themselves may be of some use, the piece of paper at the end is really of token value. What is important is whether the student has grasped the principles of freelancing and, more importantly, knows how to apply them.

Obviously, in some areas of photography, some technical training or instruction can help. People can easily take a full- or part-time course on various aspects, from basics to advanced techniques. You will have to decide how much you actually need to learn before freelancing.

There are several ways of learning about freelancing. Obviously, read as much about the subject as you can. Look at as many photographs as you can and talk to as many photographers as possible. Find out how they tackle the same subjects you are interested in. In other words, keep your ears and eyes open and ask lots of questions—it's the only way to learn. Obviously, the more you have going for you as a photographer, the better. But if you start with a few good pictures, and have the will to do something with them, that should be enough to start you on the road. Everything else can be developed from there over a period of time.

How do you get started?

Some photographers get into freelancing by sheer chance, while others plan the venture carefully. For example, if you decide to send in some pictures to a photographic magazine 'on spec', and they are later published, this chance could give you enough incentive to carry on and develop your freelancing.

While no qualifications may be needed for freelancing there is no doubt that a few basic personal qualities can help. These might include:

- Knowledge of photography
- Knowledge of the subject area you wish to freelance in
- Interest and enthusiasm for what you are doing
- Consistency
- Drive and initiative
- Competitive spirit
- Nerve
- Ambition
- Sense of humour
- Stamina

Alternatively, you may want to become a regular freelance sports photographer. This can call for a more definite plan of action—attendance at small local events to build up a portfolio, using that portfolio when approaching organisers of larger events, accumulating 'stock' pictures of competitors for the various markets, attracting commissions to cover events, for example.

Some photographers find they need the latter kind of disciplined approach in order to stimulate their interest—having a definite goal can be a real incentive. It can help if you write down your own plan of action, listing your photographic interests, how and where coverage is possible, what the likely markets are for your pictures, and whether you need to diversify into other areas.

In many ways, starting your freelancing activity is half the battle, which is why it pays to do your homework first. It is then up to you to keep the momentum going by making the best of opportunities that you can create, or that are offered to you.

The wide world of freelancing

Freelancing cuts across practically every area of photography—and there is plenty of opportunity for the photographer to become involved in some aspect.

Which area of freelancing you become involved with is entirely up to you. All you have to do is weigh up what type of photography you enjoy against the possibilities of selling that kind of photography. Some photographers start by trying to sell the sort of pictures they are already taking—landscapes or sport, for example. Others move into areas they have not tried before in order to make some extra freelancing cash.

Either way, the freelance has the choice, bearing in mind market possibilities for certain types of pictures and restrictions of locality. Clearly, if there isn't much opportunity for freelance work in your immediate area, it might be necessary to move around a bit to take the pictures you need.

Actually getting started in freelancing can be the hardest part of all. But once you gain some experience in whatever field you are operating in, and start to build up a reputation of being a photographer who can produce the right pictures for the market, success can snowball from there.

On a local basis, the photographer should expect to work out how much expense may be involved in covering a particular job. Against these overheads—including film, travel, processing and other applicable expenses—the freelance can then decide on an acceptable profit margin. This is discussed in more detail later on.

All that is required from the photographer is a certain amount of photographic skill, an eye for a good picture, the ability to present good material properly, and a finger on the pulse of current market preferences and trends.

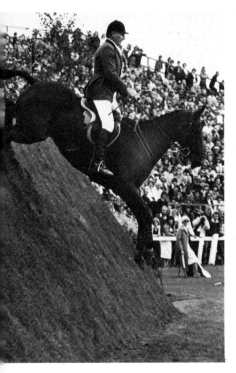

It helps if the freelance has some definite goals when shooting an assignment. In the picture here, taken at Hickstead, the photographer tried to capture some of the risk and excitement of the sport.

PART 1:
Markets

Local freelancing

How many scenes like this might you find in your local area? Sometimes you might come across a 'one-off' picture of news interest, or be able to shoot a feature series on local activity.

As a photographer, you may not have to look much further than your own locality for freelance work. In fact you might be surprised at just how much potential there can be 'on your own doorstep'.

Sometimes opportunities can come quite by chance. Relatives or friends may ask you to take pictures at a party, or you may be able to cover a colleague's retirement presentation. Once the word gets around that you are a keen photographer, profitable opportunities can crop up.

The 'key' to local freelancing is to *spread the word*. Tell as many people as possible about your interest, and show a few pictures around if necessary. Sooner or later someone is bound to ask you to cover this or that event, and from there things can snowball.

To set up on a commercial basis, it will be necessary to advertise your services, perhaps in the local newspaper, or by sending out letters or printed leaflets to prospective customers in your area.

There are many advantages in working locally. First of all, it is easy to become familiar with the area and the people in it—and, more importantly, the type of photography in demand. For someone who is genuinely interested in working hard as a freelance photographer there can be excellent scope to attract work by offering a reliable service and good quality photography. In some cases, it can lead to a full-time career.

Finding the right market

It has to be said that taking pictures is often the easiest part of freelancing—actually finding the right market for those pictures is harder. But it isn't an insurmountable task providing you are prepared to do some research first.

The first thing you should do is decide whether it is your services as a photographer, or just your pictures alone, that you wish to market. When you market your services, it is most likely you will be handling photographic work within your own locality, and there are many opportunities in this line for taking and selling pictures. However, if you intend marketing your pictures only, a much bigger market of publishing is open to you. Since most published pictures are submitted by mail, this potential worldwide marketplace need only be as far away as your nearest postbox.

But whether you intend to sell your photographic services, or just photographs, it is necessary to find the right niche for your work.

On a local basis that might involve looking at the work of photographers in your area. What sort of service are they providing? What fees are they charging? Is their photography wide-ranging? Is there an area a competitive freelance could work in? What work, if any, is not being handled sufficiently by any other local photographers? Answers to these questions may well reveal an opening for freelancing that you didn't suspect was there. If you don't ask, you won't find out, and you won't succeed.

In the publishing market, look at as many examples as possible—magazines, books, posters, calendars, for example. Half a day in a large newsagents can be well worthwhile if it gives you a good idea of the sort of pictures that are selling.

Wedding photography

Most wedding photographers, much to their credit, make the job look easy. Onlookers often have the impression that it is simply a matter of forming groups of people in front of the camera and clicking the shutter.

Of course, it isn't as easy as that. Many professionals will probably admit that wedding photography can be one of the most traumatic ways of earning a living in the photographic field. It can take a lot of work before, during and after the ceremony. But for someone who is prepared to plan carefully, and approach each assignment with determination and a degree of skill, the rewards are certainly there.

To understand the approach to wedding photography, it is necessary to look at the entire set-up of a traditional wedding. In most

Here the bride is the centre of attention on this informal wedding shot. Pictures like this may not sell very well, but they are impressive in a portfolio, and thus useful for attracting more work.

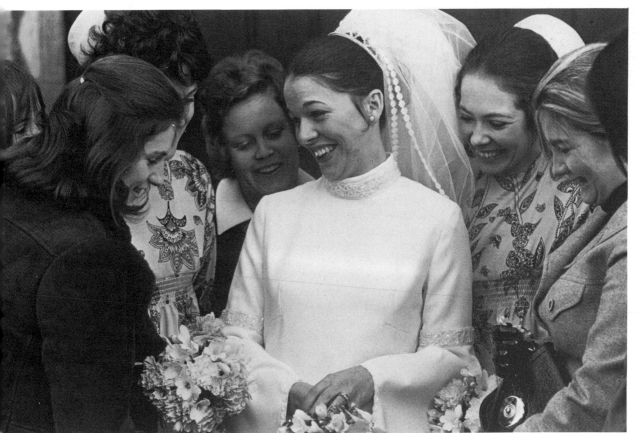

cases, the photographer is just one of many who contribute to the 'big day'. There is the church minister (or registrar), caterers, florists, car hire firm—along with the photographer, they all fit into the overall jigsaw.

But the actual business of photographing a wedding isn't just confined to one single day. Having found the clients (by advertising or word of mouth) the photographer may have to visit the couple, show them a portfolio of work and discuss their requirements before persuading them to make a positive booking. This is time and money invested, sometimes months before the event, although a booking fee (with the balance of the full cost before the wedding day) may be taken in advance to cover any outlay.

There may be time spent liaising further with the couple on all the arrangements and an approach must be made to the church or registrar's office for special permission for taking pictures. Other important factors, like film and transport, also have to be considered.

On the day, the photographer will have to arrive in plenty of time to photograph guests, if this is required. When pictures have been taken after the service, it will then be necessary to attend the reception for more pictures.

After the wedding, the original order is delivered to the couple and arrangements made for any reprint orders. All in all, the process—from beginning to end—can take a year, sometimes longer.

Alternatives
There are two ways of approaching wedding photography: work as a part-time operator for a local studio, or work for yourself. There is a case to be made for both alternatives and which one you choose depends on how deeply you wish to be involved with the organisational side of wedding photography.

Working for a studio
A lot of High Street studios use part-time freelance help, usually on a Saturday, for their wedding coverage. Faced with a choice between turning wedding assignments away, or taking on reliable part-time operators, many go for the latter. Turning down work, and giving it to a rival photographer, makes little business sense.

There are advantages for both studio and part-time freelance working together. The studio can take on a lot more work than it could with current staff, without the overheads involved with full-time employees. The freelance can work regularly and need not be involved with the before- and after-wedding organisation or selling, which would be handled from the studio premises.

In most cases, the freelance receives a set fee per wedding and may be paid commission for extra print orders from each wedding as an incentive to do the best job possible. Most part-time wedding operators use their own equipment and transport, although the studio supplies film and may be able to help with any additional equipment.

Of course, there are also disadvantages with this system. First, the studio has to be careful in selecting freelances, since they cannot afford to have their reputation damaged by bad wedding coverage. A freelance may have to prove his worth before being taken on— even then, the studio will have to invest time and money showing how a wedding is to be covered. The freelance works on a 'take-the-money-and-run' basis, with no extra organisational work involved. There is little or no direct contact with the clients before or after the actual wedding day.

Where no extra commission is paid, the likelihood of making more profit is negligible. There is also little chance of building up a reputation as a wedding photographer while working anonymously under a studio name.

Working for yourself

When you undertake wedding photography on your own, there is a great deal of work to be done in addition to taking pictures. To be anywhere near successful, a wedding freelance really has to set up a small part-time business in order to attract customers and look after the 'before and after' dealings with them.

Before

To attract prospective clients, a wedding freelance should have some idea of the wedding services already available in the area. A few telephone calls, or informal visits, to local studios should be made to ascertain the levels of service, prices, and so on. *Don't look to undercut the local professionals.* Use their prices as a basis and formulate your own level of service, adding any extra refinements to help attract customers and adjusting your price, if necessary.

Working alone, you will need to build up a portfolio of wedding pictures to show clients. This can be done by covering friends' or relatives' weddings (perhaps alongside, but not obstructing, the official photographer) or arranging a 'mock' wedding, with friends posing in full dress. A satisfactory presentation package, with prints in an album or folder, will show some evidence of your worth.

The best way to advertise your services is by word of mouth, through friends, relatives and colleagues. Beyond that, advertisements in the local paper are essential—usually under the 'Photography services' or 'Personal' columns. The cheapest, and often most effective, way of advertising is to submit pictures to the local paper for inclusion on their weddings' page (they should be recent, and in black and white). There may be little or no payment, but most papers give the photographer a credit line which can help attract further work.

Other requirements, apart from the portfolio already mentioned, include stationery (for correspondence, price lists, publicity), brochures showing folders, albums, frames (these can be obtained from manufacturers), and any other business materials (see *The business side*, p. 152). Transport and a telephone are essential.

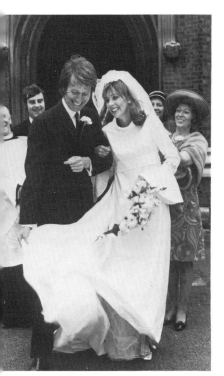

Style is particularly important in wedding photography, whether you work for a studio or for yourself. Here the photographer has successfully avoided the formal 'line-up', and captured bride and groom in happy mood leaving the church, seemingly unaware of the camera. This shot was probably set-up but doesn't look it—a skill that every freelance wedding photographer should try hard to develop.

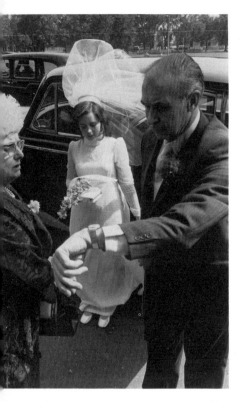

As well as following the traditional coverage, the freelance should keep an eye out for off-beat moments, like the anxious father of the bride checking his watch. Again, not the sort of picture that the couple might buy, but useful for a portfolio, or possible sale to other markets, such as publishing.

To run a successful freelance wedding business, even a part-timer must be able to offer as many services as possible to compete with local established photographers. The whole operation has to be planned carefully, and cannot be rushed.

When visiting prospective clients, look as smart and professional as possible. Show your portfolio and outline the package of services offered (see separate item) giving relevant details of pictures taken and prices. Have your diary available to check any previous bookings made and take along a booking form (printed or typewritten) to take down all the essential details of the wedding day. This should include: names and addresses of bride/groom, contact telephone number, time, date and venue of wedding (and reception), type of wedding package required, and any other relevant details. This should be signed by the couple, with copies for them and the photographer, and a booking fee of 10 per cent taken. This is later deducted from the overall cost of the initial package, which should be paid in full two weeks before the ceremony.

After the visit, contact the couple regarding any last minute arrangements and, where necessary, contact the vicar at the church for special permission to take pictures inside.

On the day

Arrive at least an hour earlier than the planned time of the wedding. This time can be used to set up equipment, see the vicar or officials, and photograph the groom and best man or other guests arriving early. Then proceed according to the coverage you are offering (see separate item).

After

Have all films processed and printed as soon as possible and delivered to the couple—a prompt service can mean a better reprint order. Special reorder forms may be provided if necessary, unless the photographer takes the orders personally. Discounts may be offered to encourage fast ordering. File negatives carefully using the reference system already set up (see *Keeping a picture file*, p. 148). Use any good pictures for your portfolio.

Wedding coverage

There can be as many ways of covering a wedding as there are different wedding ceremonies. The weddings you might be asked to cover can range from registry office affairs, to small church ceremonies, to large morning dress occasions.

It is a good idea to plan different levels of coverage which take into account a variety of prices according to the number of pictures provided, the size of initial prints, supply of albums or folders, and any special services.

Start by planning a 'basic package' that includes general coverage of the occasion at a fairly modest price. This might include a set

Basic 18-shot coverage of a church wedding

- Bridegroom
- Bridegroom and best man outside church
- Bridesmaids
- Bride and father arriving by car
- Bride and father entering church
- Interior of church from rear gallery during ceremony

- Close-up of couple at altar (if permission granted)
- Signing register in vestry
- Couple walking down aisle after service
- Shot of couple in church doorway (taken from inside)
- Couple in front of church
- Bride alone

- Bride and bridesmaids
- Bride/bridegroom/best man/ bridesmaids
- Bride/bridegroom/both sets of parents
- Informal throwing of confetti
- Bride and bridegroom in car
- Cutting cake at reception

This package can be added to in 18-shot stages to include extra coverage as required

- Selected guests arriving (specified by couple)
- Bridesmaids individually
- Bride kissing father
- More of bride and bridegroom
- More of bride (possible special soft focus effects)
- Bride receiving horseshoe, or throwing bouquet
- Bride with parents
- Bridegroom with parents
- Speeches being made
- Couple leaving reception

number of prints in folders or an album—over and above that, the couple can order extra reprints for friends or relatives at extra cost. This basic package can then be changed as necessary, taking more pictures per wedding, or supplying larger prints.

If the photographer keeps to, say, *three* wedding packages, this will be fairly easy for the customer to understand and the photographer to market, and a set of costings can be compiled for all three. Some examples are shown here.

Assuming the photographer is using the 35 mm format, basic coverage of a wedding could include up to 18 different pictures. These could be shot on a 20-exposure film, but it is far better to use a 36-exposure film, taking two shots of each subject. This is a useful safeguard against the bride or groom blinking when you take the picture, and you can also experiment with exposure, or use flash when necessary. Also, if a particular negative is scratched or damaged, there is always a second image as a safeguard.

Up-grading each package by 18 shots means the 35 mm photographer can make optimum use of each film. Any spare prints can either be used for the portfolio or presented to the couple later at a slight discount.

The key to successful wedding photography is careful planning. Liaise carefully with the couple beforehand, find out what their requirements are, and let them know exactly what *you* will want from them—beforehand, and on the day. The important thing is to make them aware that reasonable time must be put aside after the ceremony to take the pictures, and it is in their interests to let the photographer do his or her best to provide a set of pictures they will be pleased to keep.

How to work out costs

To give some idea of the costs involved in a wedding package, and how to charge the client, I have put together three possible alternative 18-shot packages. All costs are, of course, approximate, but they give a rough indication of how prices can be worked out. Overheads are based on a rough assessment of the costs of advertising, transport,

Package 'A' includes:
1 roll Vericolor 35 mm film,
36-exposure (VPS 135–36)
18 5 ×7 in prints
(18 spare prints) *
18 folders @ 20p each

Package 'B' includes:
1 roll VPS 135–36
18 6 ×8 in prints
(18 spare prints) *
One album

Package 'C' includes:
1 roll VPS 135–36
18 8 ×10 in prints
(18 spare prints) *
One album

*These spare prints may be offered free, or at a discount, to the couple as an incentive for them to gather in extra reprint orders from relatives and friends within a specified time—say, 3 or 4 weeks. This minimises the amount of selling the photographer has to do and ensures a healthy reprint order within a short time of the wedding.

Package	'A' £	'B' £	'C' £
Film	2.30	2.30	2.30
*Prints	12.00	18.00	26.00
Folders	7.20	—	—
Album	—	15.00	15.00
	21.50	35.30	43.30
Overheads	21.50	21.50	21.50
Cost	43.00	56.80	64.80
Profit	43.00	56.80	64.80
Total cost	86.00	113.60	129.60 ◀ This price charged to client

* Print prices are for laboratory machine-processed prints. Add between 50 and 100 per cent for price of hand-produced prints. Costs may be different for home processing. Folders and albums are available from specialist stationers, some photographic retailers, or by mail order via advertisements in the photographic press.

stationery, postage, and other miscellaneous items. These overheads will vary according to individual outlay. In each case, profit is equivalent to the cost, and the two figures are added together for the total cost to the customer. Profit can obviously be increased or decreased according to individual requirements.

When calculating how much extra to charge for a further 18 shots, use the same calculations as above, reducing the overheads, since much of these will have already been covered in the original costings.

The cost of extra reprints will vary depending on the laboratory used. As a general rule, you should charge at least double the cost of each print. Some laboratories offer special bulk discounts, so take advantage of these. Look out for a laboratory that can offer special services, too, like printing on canvas, or making montages.

A normal fee of 10 per cent (approximately) should be taken as a deposit when the wedding is booked. The remainder should be paid two weeks before the event. Provide invoices and receipts to the customer as a matter of policy.

Events

Freelances who live in a large town and city can probably pick and choose between the many events available, particularly during the busy summer months. Even small town and village dwellers may be able to find enough local activity to keep the camera active.

What sort of events can be covered? Well, possibilities include parties, fairs, fêtes, carnivals, outings, sport, and so on. More often than not, the photography at such events can be fairly straightforward—all you need is the 'pluck' to go out and do it.

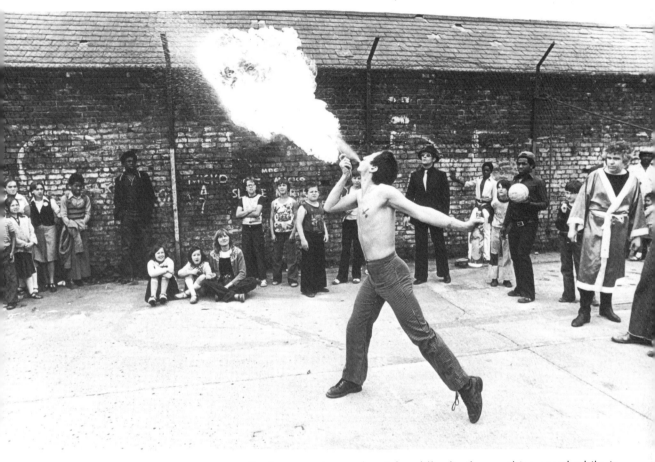

Outdoor events yield all sorts of colourful characters, like this fire-eater. Be prepared to take pictures like this from different angles and select the ones with most eye-catching impact.

Finding events need not be difficult. If something worthwhile is going on it is usually well advertised in the local paper, on posters, on club notice boards, or similar places. You might even be participating in an event yourself, or hear of one through a friend. If you are invited to a large party, for instance, consider if it might be worthwhile taking along a camera and shooting some pictures. Weigh up the sort of pictures you are likely to get, and how many you might be able to sell. And, where necessary, don't forget to ask the organiser(s) for permission to take pictures.

Planning

Every event, from a small house party to a large outdoor affair, needs a different level of advance planning and preparation. For larger events you may have to approach an organising committee for permission, or even obtain a special pass, to take pictures. They may ask to see some evidence of your work, so be prepared to cut through some 'red tape' in some cases—it is usually worth it, particularly if you want to cover similar events later on.

Most functions can be covered with basic equipment. At a party, for instance, all that may be needed is a camera with a standard lens and perhaps a flashgun. In some cases, a wide-angle lens might be included for group shots within a confined space, a small room, for example.

At a larger event, like a regatta, a longer telephoto lens (or zoom lens) will be useful to capture action that is too far away for a standard lens. A light tripod may also be handy.

Always take plenty of film— any left over can always be stored and used later on. Think carefully about the *type* of film taken, bearing in mind the market(s) you have in mind. If the intent is to sell pictures to the people you photograph, most have a preference for colour prints, so take colour negative film. Shoot on black and white if you are covering an event for a local paper, or colour transparency if the pictures are destined for publication in a brochure, magazine or book.

As well as any gadget bag accessories, a notebook and pen are useful to jot down any relevant information. In some cases, when taking orders for pictures from the people you photograph, an order book may be needed. Duplicate or triplicate books are available from most stationers.

Try and get as much advance information as possible. Are there any special people involved (carnival queens, celebrities, or similar)? Are there likely to be any presentations, or 'happenings' worthy of a picture? Can a schedule be obtained so that you can time your arrival, and not have to intrude or waste time waiting around? A few questions answered initially can smooth coverage of an event enormously and make you more efficient.

With this basic information, you can then decide on the best approach—*where* you need to be, and *when* you need to be there.

The next step is to decide on the possible outlets for your pictures once they have been taken. This can vary depending on the type and size of the occasion. At a small celebration party, for instance, you might only sell pictures to the guests you photograph. However, if the party has some possible news interest—if it has been thrown for two sisters getting engaged on the same day, for example—the local paper may be interested in a picture. Don't forget to obtain any information that might be necessary for a picture caption—this could also help you sell your work.

For a large event, like a carnival, it is easy to take dozens of pictures of people in fancy dress on the floats. In some cases, the organisers may be interested in publicity pictures for next year's events. Take up every possible option and make the best of every shot taken. Bear in mind that this is speculative work and if the pictures are not bought you will be out-of-pocket for the cost of film and any processing and printing!

Day events

Always arrive early at an event or function. That way you can check on information you may already have, find out any extra facts about what is happening, when and where to take pictures, and how long you can expect to be there. The latter is important if you have another event to go to afterwards.

Sometimes being there early allows you to take some pictures before the main crowds arrive—perhaps some shots can be set up beforehand. This might be important at, say, a carnival, where the best pictures are to be had at the assembly point before the floats move off. With all the important group shots of people in fancy dress taken care of, you need only concentrate on a few procession pictures later on.

If a programme of the day's happenings is available, this will be of great help. Included might be a list of participants or, in the case of a sporting event, competitors. At an athletics meeting, runners will probably be identified by numbers initially, and names can be checked against the programme later when captioning the photographs.

If you take the time and trouble to attend an event, always make the most of being there. Take as many pictures of as many different activities as possible, and keep your eyes open for any interesting (even newsworthy) pictures that might be saleable.

Evening functions

One important aspect of 'social' photography is evening work and there may be opportunities for covering private parties, formal dinners and so on. If there is a popular nightclub or restaurant in your area approach the management with a view to becoming the 'resident' photographer. This might involve photographing table groups and selling pictures to customers. The venue can benefit from this by offering this extra service to its customers—in return you might be able to provide pictures of acts appearing at the venue, or of other activities associated with the venue.

For this type of photography it is best to photograph groups of people, rather than individuals. That way it is possible to secure the maximum number of print orders from each shot. Since most people have a preference for colour prints, offer this kind of service—have a sample print, perhaps attractively mounted in a folder, ready to show prospective customers.

Equipment need be no more than a 35 mm (or rollfilm) reflex camera and a well-charged flashgun, or a couple of sets of fresh batteries—it is surprising how soon flash power can diminish during

Covering evening social functions can be more difficult than a freelance might imagine. In a group photograph like this, for instance, the photographer would first of all locate the organiser of the event, and then gather all the relevant people together for the picture. In such a large group it is better to arrange people in a slight semi-circle, rather than a straight 'firing' line. Also avoid intrusions, like the table in the foreground of this picture.

an evening's continuous shooting. Also, take a duplicate (or triplicate) book for customer orders and/or receipts when the client pays for or orders prints.

Dress is obviously very important at many evening functions, so always look as smart as possible, and check beforehand in case formal dress is required.

Bear in mind that the local press may be interested in pictures of local people at functions. This is particularly true of formal occasions, where local dignitaries may be attending. Visiting celebrities are also of some news interest.

Events package

How much money can be made from covering events? Well, a great deal depends on the size of the event, the sort of pictures you are taking, the number of people present, and so on. Also very relevant is whether you intend to sell the pictures taken for publication (see *Publishing markets*, p. 44) and/or sell them to the people photographed at the event.

Costings

Here is an example of a typical events package, based on supplying one colour print in a folder to each person photographed. The costings are based on two people photographed together in the same shot, buying one print each. The package you decide to offer may be a variation on this, depending on your requirements.

	£
One roll VPS 135–36 colour negative film	2.30
*72-print package (5 ×7 in, two prints per shot)	22.00
	24.30
Folders @ 20p each	14.40
	38.70
Postage of prints to customers	10.00
	48.70

The profit level is up to the photographer. Overheads including transport, stationery and advertising can be calculated separately.

Assuming a charge of around £1.50 per print in a folder, posted to the customer, the total income will be:

$$72 \times £1.50 = £108.00$$

less cost	48.70
Profit	£59.30 (less overheads)

This profit can easily rise with extra reprint orders. Also, the more people in each picture, the better the profit margin because of higher print sales.

* Prices relate to outside laboratory processing

Payment

For events packages where the customer is ordering prints 'on the spot' full payment should be taken, along with details of name and address for posting the photograph(s) on later. A receipt, of course, should also be provided.

Home portraiture

Photographing people in their own homes can be a useful way of earning some freelance income. This type of photography need not be complicated—most home portraiture requires the minimum of equipment. What is important is a sound business approach and ability to work well with people.

To get some idea of what portraiture involves, look at as many portrait photographs as you can. Look in books and magazines and see how people have been depicted by various photographers. Visit local photographic studios and look carefully at the portraits on display, and at the type of lighting and camera techniques used.

The most obvious thing you might see in most portraiture is *simplicity*. Photographers who take pictures of people concentrate on capturing physical expression in the most straightforward way possible, leaving out any photographic 'frills' that can detract from the main subject. Some of the very best portraits can be taken using natural light from a nearby window or skylight, or by using a single lamp or flash. Either way, the simplest approach is usually the most rewarding—one camera, one lens and one light source may be all that is needed.

When looking at other photographers' portraits, don't try to copy their styles, but rather *adapt* the approach you favour most and see how it works. The key to successful portraiture is experimentation—try different subjects, indoor and outdoor locations, natural light and artificial light, formal and informal shots, and so on. Assess the pictures objectively, canvas the views of those you have photographed, and decide which style of approach is both workable and popular.

Daylight is by far the most natural and pleasing way of lighting portraits at home. Pictures may be taken outdoors, perhaps in a garden, or indoors using light from a window. But bear in mind that shooting with natural daylight is largely dependent on unpredictable factors like weather, time of day, and the number of windows when working indoors. Since many customers require pictures to be taken on a specific day or at a certain time (which might be an evening when they are at home) some form of artificial lighting, either lamps or flash, may have to be used.

With artificial lighting, a portrait session can be undertaken practically anywhere, at any time. Flash is by far the most popular way of lighting portraits, mainly because it is fast and easy to operate, consistent (for light coverage, output, recycling time, camera exposure

Not all portraiture at home needs to be handled indoors. Subjects can be posed outdoors, in a garden for instance. Here the photographer could have altered the pose so that the baby was more clearly visible. The distraction of the mother and child at the window might also have been avoided.

In this portrait of photographer Bill Brandt I used natural window light and included more of the surroundings to create an informal atmosphere.
Konica C35, 1/60 sec f/8, HP5 film.

and light colour and quality) and portable. One or more flash units can be used simultaneously, depending on the particular type of lighting set-up required.

Making a start

It is essential to build up your own portfolio of portraits to show to prospective customers. Family pictures and, in particular, pictures of children, are always popular, so include as many of these type of pictures as possible. Relatives, friends or work colleagues may be able to help you by posing for pictures—indeed, they may be your first paying customers.

You can find work by 'word of mouth', by putting a card in a newsagent's window, by distributing typed or printed leaflets in your immediate vicinity, or even by advertising in the local paper. A great deal depends on how much money you wish to invest initially before you attract any customers, although this can normally be recouped within a short time.

It will then be necessary to visit interested customers to show them some samples of your work, explain the type of service being offered, and fix up an appointment for the photographs to be taken. The samples you produce might include a family group, children together, individual portraits, and perhaps even a picture of the family pet. Show examples of the sizes of prints available—perhaps 5 ×7 in, 6 ×8 in or 8 ×10 in— preferably mounted in folders or frames. Most people prefer to buy the complete finished article. The addition of this extra service can mean extra profit for the photographer. Some frame manufacturers produce brochures that may be shown to the customer, who will probably appreciate a choice of different frame styles (wood, metal or inlaid).

This initial visit will also help the portrait photographer to assess the photographic potential of the house, and decide whether an indoor or outdoor setting is best. If the house has a particularly attractive garden this might be used for a daytime session, perhaps at the weekend. If a room indoors is to be used, make any necessary suggestions about moving furniture or background objects so that this can be sorted out before you arrive to take the pictures. If backgrounds are likely to prove a problem, be prepared to bring a roll of special background paper to pose the subject(s) in front of.

Taking the pictures

Every portrait session is different, and relies almost totally on the relationship between photographer and sitter. Generally, people are uncomfortable in front of the camera, and some even dread the thought of having their picture taken, particularly if it is at someone else's insistence.

Even in a formal situation the photographer should try and create an *informal* atmosphere. Chat to the subject while setting up the equipment, and perhaps ask to put on some light music to create a more relaxed mood. With children it is a good idea to let them look through the camera viewfinder, and perhaps even take a picture of the photographer. Every photographer has an individual approach to dealing with a sitter—some even 'pretend' to shoot a roll of film, when the camera is empty, so that the subjects become more used to the camera. A film is then loaded and the actual photographs taken.

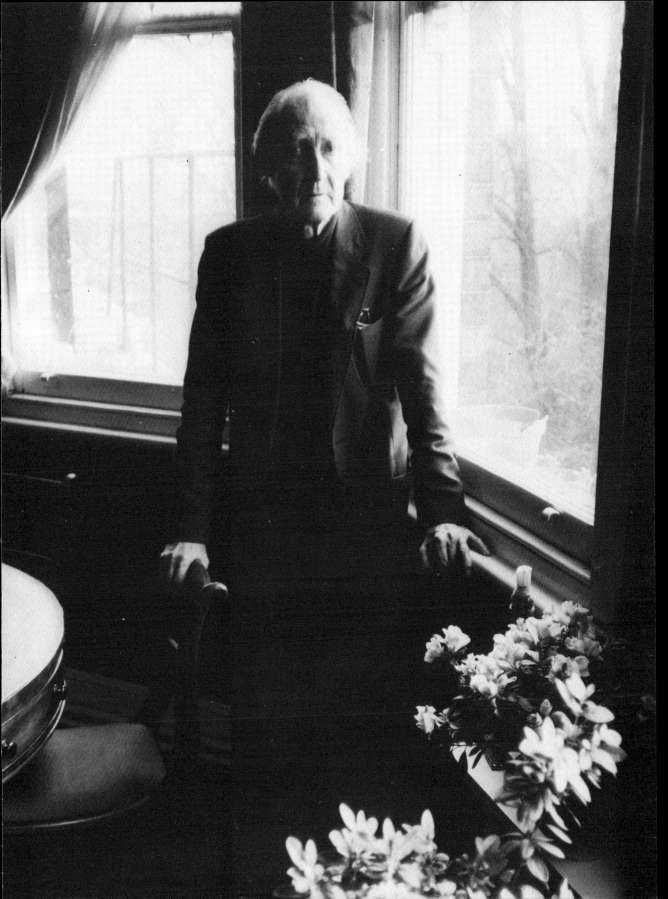

A lively natural portrait which might sell to a number of different markets, from photographic magazines to travel brochures.

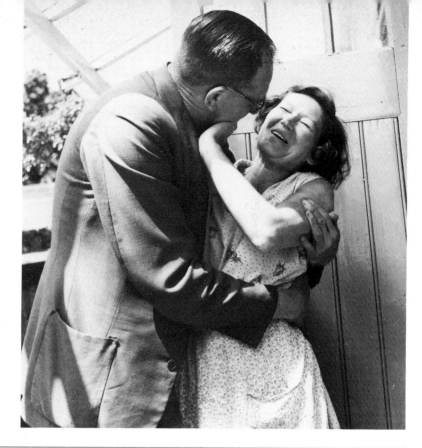

A portrait does not have to be staid, as this lively example of a couple embracing shows.

Portrait package

Every portrait package should be designed to suit a photographer's requirements and/or customer preferences. Some freelances prefer to provide a set of proofs first, and let the customer order enlargements from these. Others provide enlargements from all the shots, cutting out the proofs-to-customer stage.

Outlined here is a typical proof package costing around £60. A relatively small profit is made on this initial package, with further profit to be made on framed enlargements later.

Costings

	£
One roll VPS 135–36 colour negative film	2.30
*Processing (up to 36 5 ×7 in proof prints)	12.00
Small preview album	5.00
	19.30
Approximate overheads	20.00
	39.30
Profit (variable)	20.00
* Outside laboratory processing	59.30 (quote £60 to client)

Enlargements can be the most profitable aspect of the whole portrait package. As an incentive to the customer a typical enlargement deal, complete with frames, might be offered. This could include:

	Cost	Charge client
One framed 8 ×10 in print	£12	£25
Two framed 6 ×8 in prints	£10	£20
Two framed 5 ×7 in prints	£8	£16

Other enlargements can be ordered as required, with or without frames.

Payment

A fee of 10 per cent should be taken when the session is booked. The remainder should be paid on the day of the session.

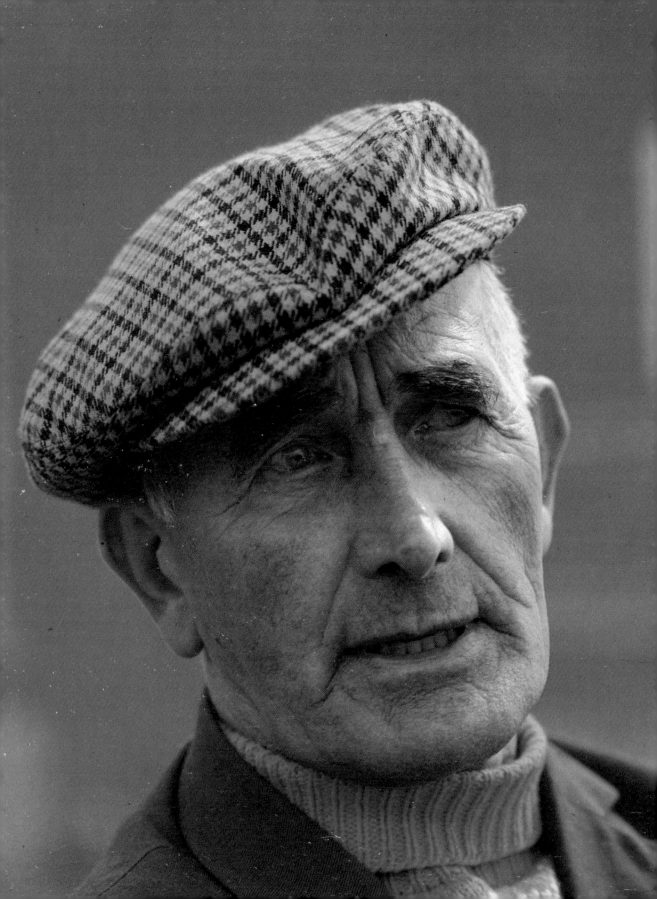

Character is important in portraiture, and this comes through in this shot of a Shetland man.

Most subjects tend to sit rather stiffly in front of the camera, staring blankly into the lens. Try and keep a conversation or rapport going, taking a variety of pictures in between. Try different poses and variations of groups, until the best compromise for both sitter and photographer is reached. Try and keep the camera angles and lighting as consistent as possible—most subjects get very restless if the photographer is continually messing about with equipment.

Studio base

While portrait freelancing relies on the photographer taking pictures in clients' homes, a photographer may wish to set up a home studio. Temporary space may be found in a room in the photographer's home, or a permanent set-up might be established, perhaps in a converted garage or large shed.

There are advantages in doing this. The photographer can have full control over the lighting and backgrounds. All equipment can be left set up, saving valuable time during the session. Time and money is also saved by not having to travel to clients' homes.

There are also disadvantages. Most people who take the trouble to have a set of portraits done usually visit a High Street professional who is likely to have proper studio premises. People who arrive at what they think is a studio, only to be confronted with a converted garage, can be put off.

Remember that most people will accept a part-time freelance to take pictures in their own homes and, despite the advantages of a studio base, the photographer can be better off being mobile.

Finding commercial work

In many areas the business community is often a small one and it need not be too difficult to find freelance work within it. The only problem is getting started. While it may be relatively easy to find work in a company you happen to work for, going further afield takes a lot more effort and determination.

As with any business venture, freelancing in the commercial environment requires a very professional attitude and approach. It would be foolish to strap a camera around your neck and trail around different factories on an industrial estate, canvassing for photographic assignments—you'll be lucky to get past the front desk. The whole thing has to be handled on a business-to-business level. Any company thinking about paying for the services of a photographer will want someone trustworthy and reliable, who can produce some evidence of past work or reputation. To be in this position, the freelance needs to do a lot of preparation beforehand.

First approach

Before approaching any company with a view to doing some photography for them, you are likely to need at least two things: an

introductory letter or printed publicity material, and a portfolio of work. The former can be used to outline briefly the sort of services you can offer as a photographer, and details of when and where you can be contacted should the company concerned wish to follow up your approach (see *Write on*, p. 146).

But that is usually the easiest part—the portfolio can be a lot more difficult. How can you present a commercial portfolio if you have never done work like this before? Well, it isn't easy—but it can, nevertheless, be done.

The type of commercial and industrial photography needed will vary from business to business. If you know a little about the company or companies you are approaching, try and take some shots that might appeal to them. It need not be too difficult to compile a portfolio consisting of portraits of businessmen, factory exteriors and interiors, people at work, studio shots of products, and so on. All of this can be achieved with the help of friends or colleagues in your area and a portfolio of, say, a dozen first-class 8 × 10 in prints can be put together in a presentation folder to show prospective clients.

Of course, this involves an investment in both time and money, and it may or may not pay off. If it doesn't, you have at least been able to broaden your photographic experience, and that will always be helpful for any future freelancing. If it *does* work, and clients are impressed enough by your work to offer you an assignment, the effort may be well worthwhile.

Company activities, like this bike ride, feature regularly in company in-house journals.

In-house magazines

Many large companies have their own in-house magazines. These journals are produced to promote a company's activities and act as a communication outlet for all employees. A typical in-house journal might include a financial report, details of new products, employees' social activities (parties, outings, sport, or clubs) and other relevant information.

In-house publications are either produced by a company's publicity department, or by an outside publishing company on a freelance basis. Since most of these journals need pictures to illustrate the various activities, this is an area the part-time freelance can operate in most successfully. As well as being paid for taking pictures, the published work may be seen quite widely (some firms have overseas subsidiaries) and further work, as well as reprint orders, can follow. It is very valuable to have work published on a regular basis—indeed, many press photographers have started their careers by working on in-house journals.

Usually this type of work is done in black and white, although some in-house publications use colour (from transparencies).

There might also be some social activity at the workplace offering freelance opportunity—an employee getting married, a retirement presentation, an award for long service, or recognition of special achievement, for example. There can also be opportunities at work parties, special outings and involvement with local charity events. Since this type of photography involves people, often in groups,

there may be plenty of reprint orders and a chance to make good profits from the minimum number of shots.

If you are keen to take photographs within your own company, let as many people as possible know and show a few pictures around. Talk to senior colleagues, or those in charge of publicising your firm's activities, and ask about the possibility of doing some work. Once you start taking pictures, other work can crop up, sometimes from outside the company you work for.

Two words of warning. First, beware of tackling anything too ambitious. Some firms are likely to use an enthusiastic photographer on the staff for a difficult job that should really be handled by a professional—just to save money. For example, trying to photograph a giant piece of plant machinery with a 35 mm camera and small flashgun might be a waste of time, and embarrassing for all concerned.

Second, don't let the fact that you work for a particular company mar your business attitude to taking photographs. While it might be impracticable (but not impossible) to ask for a 'day rate' payment for taking pictures during your normal working time, make sure your company pays a fee for your photographs. This should cover the cost of all materials and expenses as well as leave a worthwhile profit for your time and effort.

In some cases it might be necessary to seek advice from your employer, a union representative, or personnel department, before undertaking photography at work.

Local commercial and industrial photography

Commercial and industrial photography is an area that not many freelances venture into. But when you think of how many different businesses there are likely to be in your area—from shops to offices to factories—it is an area well worth investigating.

Companies often require photographs of their products or business activities. Some larger firms usually have their own in-house photographers, while many hire outside professionals for specialised work, such as detailed shots of tiny components, pictures of giant pieces of machinery, or any special jobs that require the equipment and expertise that only a professional can provide.

Of course, professionals are not always used for every commercial and industrial assignment and, indeed, there are some jobs that, frankly, professionals do not always bother with.

Over the years most commercial and industrial outlets have become aware of the importance of good visual imagery to present their products and services. For a freelance who is prepared to work hard and present a high standard of commercial photography, there is no reason why a good supply of local regular work should not be found. In some cases such work can be very well paid—however, this kind of photography can be very demanding and, because the

Watch for small details when photographing people in a work environment. For example, make sure that proper safety procedures are shown, as with the man wearing ear protectors here—but shouldn't his colleague be wearing them also? If necessary, have a supervisor with you to advise on such matters, otherwise a re-shoot might be necessary.

photographer is working within a business environment, it must be handled as seriously and professionally as possible.

Photography at work

Many part-time freelances start by taking pictures at their own place of work. As an employee you may be able to use photography to help with your particular line of work, perhaps to sell a particular product, or give outside clients an idea of how your company operates. As an example, it may be possible to produce an audio-visual slide presentation, perhaps showing how a product is made, for sales conferences. You can arrange payment for producing such a show and it might lead to further opportunities.

Many companies also produce sales and publicity literature and you might take photographs for this purpose. This kind of work need not be over-complicated—it might only involve portraits of company representatives, or the chairman at his desk, or something similar. A great deal depends on the type and size of the company and the area of business it operates in.

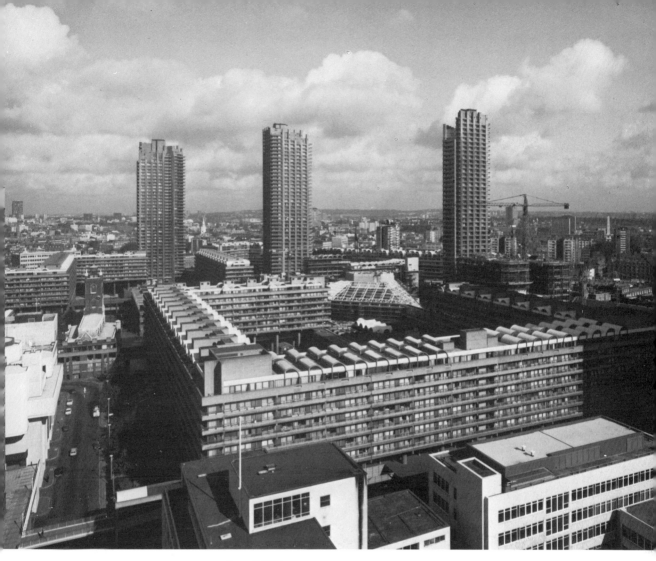

Shots like this of an urban landscape might well be sold to a local council, local newspaper, owners of the buildings depicted, and so on.
Hasselblad SWC, 38 mm lens, FP4 film.

Possibilities

It isn't until you start looking carefully that you realise just how much local commercial work is available. In fact, wherever business is going on, there is likely to be a need for photographs of one sort or another—and a need for freelances to take them.

Here are just some of the possible areas worth trying.

Factories There are a number of photographic opportunities within a factory, from shots of products and people at work (for brochures or publicity) to social photography (factory presentations, parties and outings). Sometimes just one large factory can produce a regular amount of work for a freelance who is prepared to come up with ideas that may be of use to employers and employees alike. Most of the work need not be involved or complex—a freelance can always turn down an assignment that might require specialist equipment and knowledge.

Offices While the office environment may not offer as much photographic scope as a factory, there are still opportunities to photograph people at work, social activity, and so on. There might also be a

social club or sports club run by the company where freelancing might pay off.

Shops With the exception of the various large chain stores, which often look after their own photographic requirements, there are likely to be many local shops and stores needing a freelance for occasional work. Interior and exterior shots, window displays, staff at work and advertising material, might all be possibilities.

Pubs Walk into any pub and you are likely to see a picture of the exterior mounted somewhere in the bar. If you don't, there is the opportunity of selling the idea to the landlord. In some cases it can be a good idea to photograph a few pubs in the same area, show copies of the colour enprints to the landlords, and see if they are interested in purchasing framed enlargements.

The photography itself is usually straightforward and, even if only one landlord takes up your offer, the costs can be minimal enough to ensure a reasonable profit.

Restaurants Many restaurants use photographs for menu covers, displays and local advertising. Examples of the work involved might include exteriors, interiors, chef at work and waiters serving customers.

Estate agents Many estate agents use photographs of the particular properties they have for sale. These are usually displayed in an estate agent's window and may be used for local press advertising, leaflet hand-outs, and so on. Exterior and interior shots showing the best aspects of the property are usually all that are required. In the case of exteriors only, the properties can usually be photographed at the freelance's convenience, which is particularly useful if time is likely to be a problem. It should not be difficult to shoot half a dozen properties or even more in an afternoon providing they are in the same general area.

These are just a few ideas for finding local commercial work. There might be other possibilities that you can follow up—check the local newspaper or telephone directory for possible outlets, and make up a shortlist of companies you think may be worth approaching. If you have any relatives or friends who work for companies that may be interested in your services, talk to them—they may be able to recommend you.

Sometimes the best work comes from your own initiative. It is really up to *you* to come up with ideas, find the contacts, and approach prospective customers. In the commercial world, a freelance must adopt a commercial attitude, from the initial approach to the supplying of the photographs. And remember to keep some material for your own portfolio to show any new clients—and be prepared to follow up on any assignments already carried out.

Equipment and film

In many cases commercial and industrial work can be extremely demanding technically—sometimes very high-quality results are

Sometimes specialised equipment can be used to produce a more unusual picture. Here the photographer chose a low viewing angle, and used a very wide-angle lens to make the lines of the building converge.
Nikon F3, 15 mm f/3.5 lens, XP1 film.

required, and the freelance will have to look very closely at the cameras, lenses and film chosen for the job.

For the routine commercial work mentioned earlier (pub shots, social photography, etc.) a standard 35 mm set-up may be quite adequate. But if you are commissioned to take special photographs of, say, a factory interior, or close-ups of products for advertising purposes, special equipment may need to be borrowed or hired. In the latter case, this may apply to a large-format camera like a Hasselblad, which can be hired from a camera shop or special hiring service like Pelling & Cross in London for around £10 per day (the cost can be offset by the fee you decide to charge and still leave a profit). The same applies to hiring special lenses, such as an ultra-wide-angle for interiors. Such lenses can be very expensive and, for the limited use you may get out of them, it is really only worth hiring.

Film choice is obviously important. Always check beforehand how your pictures are likely to be used—it is pointless shooting colour negative film if the company concerned wants shots for a brochure, and colour transparencies will be needed by the printer. On a commissioned job try and ascertain exactly how many shots will be required and take more than enough film in case of problems. A spare camera body isn't a bad idea also in case of mechanical failure such as a jammed shutter.

For interior work, check the location beforehand and decide whether any special additional lighting may be necessary—again, this can be hired.

A few striking images like this, linked carefully together and supplemented by sound, can produce a good audio-visual show.
Leica M4-2, 21 mm f/3.5 lens, XP1 film.

Copyright in commercial work

It is very important for any freelance involved in commercial or industrial photography to understand the law of copyright and how it affects any photographs taken.

Put simply, if a company commissions you to take photographs for them, *they* hold the copyright and you may not reproduce the photographs, or use them in any other way, without first seeking permission. However, you are entitled to keep any negatives (for further reprint orders from the company) unless you agree to sell them outright, usually for a higher fee. However, you are under no legal obligation to do so.

If you take photographs on your own initiative, and you are not commissioned by anyone, the copyright on the photographs remains entirely with you.

If you have any doubts at all concerning copyright, always seek legal advice first.

Audio-visual presentations

A great many companies and businesses these days are using audio-visual (AV) presentations to promote their products or services. A good AV show usually consists of a slide presentation, often using two or more projectors, backed up with a sound commentary and/or music or sound effects. A well-planned AV show can be an effective, fast-moving and almost movie-like presentation, requiring a lot of careful preparation.

Freelances with some experience of AV may well be able to provide this kind of service commercially. When putting together a good AV show, a script has to be prepared detailing how many photographs need to be taken, and in what sequence. If a company has prepared a basic script for commentary, the photographer is left with the task of supplying the supporting visuals. In a typical two-projector show, around 200 colour transparencies might be needed.

Commercial charges

If you decide to go into commercial freelancing, what is the 'going rate' for the job? Well, a lot depends on the type of job. For a commissioned assignment on location, you might charge a fee involving an attendance allowance (charged by the hour or day), plus a set fee per shot required. Otherwise an overall fee might be charged for specific types of job, taking into account your time, the overheads involved and the profit margin.

For work undertaken on your own initiative, you might have to adopt a different pricing structure, taking into account film and processing costs, overheads and profit. An attendance allowance will probably not be relevant here since there is no commission as such.

Outlined here are examples of how two different approaches to commercial freelancing might be tackled—one is a commissioned assignment, the other carried out 'on spec'.

Commercial package 'A'

A freelance is commissioned by a factory manager to supply 10 colour shots for a company brochure. The photographer is able to use his own 35 mm equipment and, in order to cover variations of shooting angle and exposure for each shot, he elects to shoot one roll of 20-exposure film for each shot (total 10 rolls of film). This is not unusual in commercial work since the best quality photographs will be required and photographers often need to cover themselves adequately with a variety of pictures to get the best alternatives. Having more shots than needed also acts as a 'safety valve' against any mistakes made.

The Brief: Provide 10 colour shots for a company brochure. Colour transparencies required. Film choice: Kodak Ektachrome 20-exposure (10 rolls)

Costings

	£
10 rolls of film @ £1.70 per roll	17
*Processing (slides unmounted) @ £1.70 per roll	17
	34
Transport and other overheads	30
Cost	64
Profit (as cost)	64
	128 (or approximately £12 per shot)
Attendance fee 4 hours @ £25 per hour	100
	228 ◀ charged to customer

Add extra costs such as slide mounting or VAT, as applicable.

* Outside laboratory processing

Commercial package 'B'

A freelance decides to photograph some pubs in an area. He selects 10 likely venues and takes two exterior shots of each, using one roll of 20-exposure colour negative film. Enprints are made from the processed film and shown to the respective landlords with a view to receiving an order for one framed 8 ×10 in colour print of each pub.

Costings

	£
Film—1 roll VPS 135–20	2.00
*Processing and printing ($3\frac{1}{2} \times 5\frac{1}{2}$ in)	5.00
	7.00
Overheads (travel, postage)	10.00
	17.00
Cost per pub shot	1.70
Cost of supplying one framed 8 ×10 in enlargement	10.00
Total cost (enprint plus enlargement)	11.70
Profit (as cost) per pub	11.70
	23.40
Round-off figure charged to pub landlord (add £1.60)	25.00
Profit per pub (£11.70 +£1.60)	£13.30
Profit per 10 pubs	£133.00

* Outside laboratory processing

Payment
In most cases it is unlikely that any deposit or advance payment will be made for commercial work, unless a definite print order is made from pictures already taken (as in the pub shots). Most commercial organisations will expect an invoice upon supply of the photographs.

Publishing markets

The magazine market has vast potential for the freelance. These are just a few of the journals in the women's field.

The publishing market is potentially the biggest market for the freelance photographer. Unlike local freelancing, which relies heavily on the photographer making the best of the opportunities within an immediate locality, the scope of publishing is almost limitless. And it can be reached via the nearest mailbox.

Apart from the financial aspects, actually seeing work in print is very rewarding for any photographer. This in itself spurs many freelances on towards even greater goals—some even become successful professionals.

This chapter takes a broad look at publishing, from local newspapers to specialised magazines, and from posters to books. Of course, each area of the publishing market is different, and the requirements regarding the type and number of pictures used vary.

It is very important for you to look at the particular aspects of the market you are most interested in servicing. Then look at specific newspapers, magazines, or any regularly published material within that area and assess carefully the photographic requirements. Ask yourself if you can fulfil those requirements, either with photographs from your own stock file, or by taking pictures specifically with that market in mind.

Sometimes it pays to try a few different areas of the market to find out what the response is to your pictures. Be prepared to capitalise

on successes, and learn from rejections, of which, unfortunately, there are likely to be many.

Continuous success (and publication) is only possible by providing material that is *right* for a particular market. How do you know what is right? Well, there is really no shortcut to the answer—only experience, and an ability to learn from any mistakes made, will provide a good guideline. But even that won't be foolproof.

Sometimes luck plays a great part in publishing success. If a set of pictures arrives on an editor's desk at the right time they might be published straightaway—a few days later they might be rejected, or placed on file for possible use sometime in the future. You can't always tell, but, in some cases, it is possible to plan ahead so that circumstances are slightly in your favour.

Making a submission

If you have a rough idea where in the market you are most likely to try selling your work, the next stage is to start submitting. How you approach a national newspaper is obviously very different to how you approach a gardening magazine, as you will see in this chapter. Setting aside hard news and similar material, there is a general form of approach that can be adopted for most publications.

First of all, assemble carefully the pictures you wish to submit. Always have a definite goal in mind: for example, for possible use on a cover, as a portfolio or for single picture use. Be as ruthless as possible in selection and submit the best, or most relevant, material you have—one or two 'below par' pictures may detract from an otherwise good portfolio and may mean it is rejected.

Information on submissions is often available from some journals beforehand, but here is a general guideline on what to send, and how to send it.

Pictures

Most publications use black and white prints and/or colour transparencies, but rarely colour prints (except, perhaps, if the photograph is of a major news event, or has similar importance). Colour transparencies may be supplied in various sizes. In many cases 35 mm slides are acceptable, although some publications are likely to opt for 120 rollfilm size transparencies (6 × 6 cm, 6 × 7 cm or 6 × 4.5 cm) or larger sheet film formats (4 × 5 in upwards).

With black and white prints it is best to supply glossy or matte surface papers, avoiding textured surfaces (stipple, lustre, etc.), which can show when the print is reproduced. Most magazines are not too bothered if a print has a border or not. Print sizes of around 6 × 8 in or 8 × 10 in are usually required because they are easy to handle and file for later reference.

How many pictures you submit will depend on whether the intention is for single or portfolio use. Always send a selection if you

can—up to twenty transparencies or a dozen prints should be enough for initial submission. This would be a manageable amount for most magazines to consider—if they require more, they can always contact you later.

It is worth noting that most publications have more pages available for black and white than for colour—therefore, the chance of having black and white pictures published is much higher. If you only shoot colour, it is sometimes a good idea to tell the editor you don't mind your colour shots being used in black and white if it increases the chance of publication. Of course, this is only feasible if the photographic content is more important than the colour aspect of the photograph. If the editor decides to have black and white prints made from your transparencies there might be some loss of image quality. But, occasionally, the sacrifice is worth the chance of having an image published.

A typical package

Bear in mind that editors are busy people. They may have to look through a great many freelance submissions every week and it helps if the material can be opened and assessed quickly. The photographer can help the editor—and his or her own chances—by presenting work properly, with all the necessary information the editor might need to know in order to use the pictures.

By putting together a good editorial 'package' the freelance can be fairly sure about three things: the material will arrive in good condition, it can be opened and viewed easily by an editor, it can be filed easily or returned safely to you.

There is no 'magic' involved in this package—only some careful preparation and packing. Here is what a typical package might consist of:

Plastic slide wallet These transparent wallets can hold around 20 35mm transparencies (also available for other film sizes) and enable slides to be viewed quickly, without the need to handle (and perhaps damage) individual slides. They can be folded flat into an envelope or bag for postage. It is better *not* to send slides in a box—they are difficult to pack, and each transparency has to be taken out and viewed individually. Not very convenient.

Transparencies and/or prints Don't send too many pictures—around 20 transparencies or 12 prints should be sufficient. Prints of around 6 ×8 in or 8 ×10 in are easy sizes to send and file.

Label all prints and slides with your name and address in case any go astray when they reach the publication. Number each picture also.

Captions Write (or preferably type) the number of each picture and any relevant information on a caption sheet. Technical details (camera, exposure or film type) may only be relevant for a photographic magazine or book.

Story When supplying a story supporting the pictures, it should be typewritten. In some cases, it is a good idea to provide just a synopsis of your ideas first.

Covering letter This should include your name, address and, if possible, a daytime telephone number where you can be reached. Outline the material submitted and any other relevant information.

Stiff envelope or 'Jiffy bag' It is essential for photographs to be sufficiently protected in the post. Special envelopes and bags are available from stationers. The Post Office can advise on any packaging problems.

Stamped addressed envelope A stiff envelope or bag should be included, complete with return postage, for the return of your material.

To ensure the safe arrival of your pictures, it is a good precaution to send them Recorded Delivery, and enclose the return cost of the service (some will do so anyway, although it is better to be on the safe side). A few days after sending the package, telephone the publication to ensure it has arrived safely. Most editors acknowledge receipt of material, or return it almost immediately.

The longest a publication should keep material is six months—this gives plenty of time to schedule it for a particular issue. It is the *photographer's* responsibility to keep track of the pictures, by letter or by telephone. If it seems unlikely that the pictures will be used within the immediate future, ask for them to be returned so that they can be placed with another possible client.

COPYRIGHT

Many photographers are unsure about copyright and how it affects their photographs. While there is insufficient space here to go into all of the ins-and-outs of the law, there are a few simple pointers to remember.

When you take a photograph, the copyright for that photograph belongs to you. If someone commissions you to take a photograph, the copyright belongs to them. For instance, if you photograph someone in the street, or other public place, you own the copyright to the photograph. Alternatively, if a couple commission you to cover their wedding, they will hold the copyright to the photographs—and you will need to ask their permission before allowing the photographs to be reproduced, or used elsewhere. In the latter case, incidentally, the photographer is entitled to keep the negatives, although they can be purchased if the photographer agrees.

In submitting a picture (or pictures) to a magazine or publication you are not selling the actual photograph, but certain 'rights' to the use of it, subject to certain conditions. For example, with most news pictures, the freelance may sell the 'first UK exclusive rights' enabling the newspaper to reproduce the photograph first, in return for a fee. If that newspaper then wishes to use the picture again, or syndicate it to other newspapers, they must agree this with the photographer and pay an extra fee against the monies made.

In some cases, a publication may offer to buy the copyright to a photograph, often for a much higher fee. This might seem lucrative, but the photographer can lose out. One example was the freelance who photographed John Lennon signing autographs in front of the man who was later to be his assassin. It was reported that the photographer sold the photograph, and his rights to it, for around $2000. The picture was then syndicated by the newspaper for many thousands of dollars more and, because of its historical value, the picture will no doubt continue to sell for many years.

Therefore, the general rule is never to sign away your copyright. If you have to enter into a contract regarding the use of one of your photographs, read it carefully and, if possible, have it checked legally before signing.

Further information about British copyright can be found in the Copyright Act 1956, available from HMSO in London.

Union or non-union?

Most professional journalists and photographers working in publishing belong to a union—usually the *National Union of Journalists*. In some cases, agreements between unions and publishers stipulate that material from non-union freelances should not be used, so that the livelihoods of professionals can be protected. This sort of agreement does not apply everywhere and, in specialist magazines particularly, editors would find it very difficult to produce publications without the help of non-union freelances.

To become a member of the NUJ a photographer must prove that 75 per cent of his or her income comes from freelancing. Overall, the attitude towards non-union, or even simply non-professional, photographers varies. The only way to find out how a particular publication stands on this issue is to approach it with your pictures. They can only say no—and it is well worth a try if they say *yes*. You have nothing to lose.

Pictures for reproduction

Many photographers, when submitting photographs for publication, do not fully comprehend some of the problems that arise when trying to reproduce them in printed form.

47

Since reproduction actually involves 'rephotographing' a picture, so that it can be placed on a printing press plate, there can be some changes in either tone or colour. Advanced printing equipment enables fairly accurate reproduction—but there are some difficulties that the photographer can help overcome.

The first is contrast. Many magazines and newspapers use web-offset printing which, in some cases, can increase the contrast of a photograph, making black tones blacker, and white tones whiter. Providing a slightly flatter-than-normal print, with less contrast, can result in much better reproduction.

With colour, the problems of contrast are not so marked, but a printer can have problems with a transparency that is slightly too light or dark. If you can provide a transparency that is as near correctly exposed as possible, with sharp clear colour, the reproduction will inevitably be better than with a dull, lifeless image.

Local newspapers

Most areas have a local newspaper, sometimes more than one. Local papers are published at varying frequencies—every evening or morning, weekly, bi-weekly, for example. Some areas have both daily and weekly papers, often published by the same company.

Approach

So how do you approach a local paper for freelance work? And who should you see? Well, a great deal depends on the particular paper—some have a favourable attitude to freelances, others won't even let you through the front door. Either way, the only way to find out is to *try*.

Some freelances are lucky enough to start by offering a paper a 'one-off' exclusive picture of a news event—a bank raid or plane crash, for example. Whether the picture is used or not doesn't really matter—at least you have been able to make the contact, and they will be aware of you if you approach them for more regular work later. Not every paper is going to shower you with work just because you were lucky enough to snatch an impor-

tant picture, but you may be able to follow up with less newsworthy, but usable, material and receive a sympathetic response.

Walking in 'cold' to a paper, without the benefit of a smouldering exclusive in your camera, takes a lot more willpower and determination. It helps if you have a portfolio of work to show the paper, otherwise they will have no idea of your capabilities. Beforehand, look carefully at the paper's picture content—it is likely to be full of pictures of faces, so make sure your portfolio has examples showing local people. Avoid pretty scenic views or holiday snaps. The portfolio should contain around 12 black and white prints, around 6 × 8 in or 8 × 10 in.

Who you see might be crucial

to whether your pictures are used or not. Many local newspapers have a picture editor—he or she controls the picture content and the use of photographers, and this is the person you should see. Ring the picture editor in the first instance and either make an appointment to visit, or arrange to submit some examples of your work for consideration. If the paper does not have a picture editor, approach the editor and/or the senior photographer—the latter is more likely to know whether a freelance would be useful, and may be helpful in assessing your photographs. Not every freelance is on the right track; encouraging, even critical, words from someone in the business can be of enormous help.

Generally, the number of conventional local papers has fallen over recent years. Some have been replaced by 'freesheets', which contain mainly advertising, with minimal editorial, and are distributed free to households in the area.

Coverage

Local papers usually have their own staff photographers who supply most, if not all, of the pictures. Coverage can be quite wide and variable but, on most papers, it falls into four set categories:

Hard news—fires, crashes, criminal incidents, etc.
General news—local politics, organisations, events, etc.
Features—celebrities, local people, specific activities, etc.
Sport—football, cricket, darts, etc.

The number of pictures to stories in a newspaper is often quite small, and this is reflected in the ratio between photographers and reporters. Quite often the photographer(s) cannot cover every job that comes up and the alternatives, depending on the paper concerned, are *not* to cover the job, or to use a freelance.

Use of freelances

In most cases, a local paper uses freelances to cover work that the staff photographers cannot, or will not, do. Most of these assignments tend to crop-up at busy, 'unsociable' times—evenings and weekends—and, because of the nature of press work, very little notice may be given.

Circuses can be very visually exciting, with high wire acts, animals, and other spectacles. Make sure you have a long lens so that the activity in the ring can be captured in close-up detail, as with the shot of the clowns here. You may need to ask permission of the circus management before taking any pictures in the arena. Remember also not to use flash, otherwise animals may be disturbed—most circus lighting should be sufficient for taking pictures, although you may have to use a fast film.

When covering local events, don't just concentrate on the main action—quite often good photographs can be taken within the crowd.

Most of the jobs to be covered in a day are kept in a diary by the editor, picture editor, chief photographer, or whoever looks after the photographers' schedule. Each photographer may be assigned to a job, depending on the time and location. But if the photographer has to be diverted on to a last-minute hard-news story, the chances are a freelance may be asked to cover the more routine jobs.

Sometimes the use of a freelance can mean that a particular assignment can be given more time and, hopefully, better picture coverage. For example, on a typical Saturday afternoon, a staff photographer might have to attend a few fêtes and other events, as well as spend some time at a local football match. It might be wiser in this case to ask a freelance to cover the entire match instead, and get a better selection of pictures.

Payment

Most local papers have a very low budget for freelance payments. Local wedding photographers who submit pictures of married couples for publication often don't get paid at all. What they *do* get is a credit line, which is like a free advertisement.

If a local paper is unwilling to pay very much, always ask for a credit line so that you can perhaps attract other work, and also prove that specific pictures were taken by you. A set of press cuttings

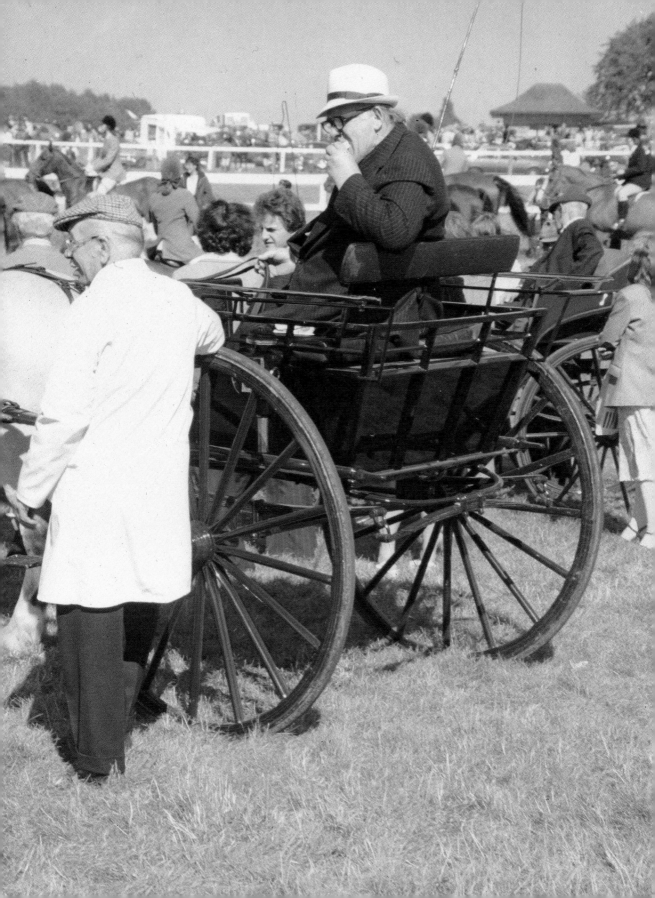

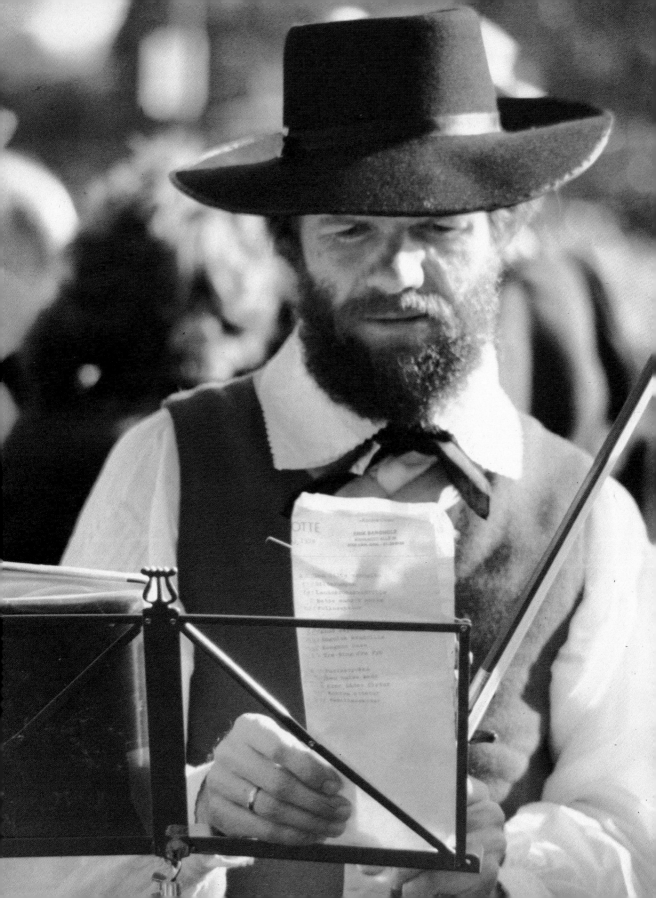

Local newspapers always look for pictures of local people taking part in local events. In most cases the demand may be for black and white, but a colour shot like this may be accepted by some newspapers for it can easily be converted to black and white if necessary.

with your name against them may well help to further your career in freelancing. Many photographers I know have started freelancing on small local papers and, by being able to prove their worth with published material, have gone on to become Fleet Street or news agency professionals.

Most papers, if they hire you, should at least cover all your out-of-pocket expenses—travel and meals—as well as film and processing (unless they are willing to supply these facilities). Always check beforehand—even if you can't make any profit, you should certainly not be out of pocket.

What to photograph

Freelances who are asked by a local paper to go out and take pictures of specific news stories or events are in the minority. Those that do usually have a fairly good briefing on what is required and may be shown similar situations covered by staff photographers as a guideline to what is required.

Sport is an important part of any local paper's coverage, and the freelance can score by going to the more unusual and less covered sports, like water skiing as shown here. *Pentax, 300 mm lens, FP4 film.*

Working 'on spec' the freelance has to be slightly more hard working and imaginative. Try and find out if a paper's staff photographers are covering a good picture event, such as a fête or some-

thing similar. If not, try and go along, take a few pictures, and let the paper have them as soon as possible. They may be grateful for your efforts, and expand a ten-line story into a picture feature, using your work as illustration.

Or if you happen to be attending a function in the evening, offer to take some pictures of people enjoying themselves at the event. Are there any local dignitaries attending? Is there a special presentation being made? Such things can be newsworthy.

If you intend to photograph these events, bear in mind that local papers often like to see groups of people in a picture—that way, more are likely to buy the paper. *Note: don't forget to take names (left to right in the picture) for the caption details* (see *Captions*, p. 146).

A freelance can also be very useful in supplementing a local paper's normal coverage. For example, it might be a good idea to do a picture feature on a local character, such as a farmer or postman. A staff photographer may not be able to spare the time photographing different aspects of this person's activity, but you might. Look out for any unusual 'off-beat' stories that might make a good picture— perhaps a local person has an unusual pet, like a boa constrictor. Follow up as many ideas as you can—sometimes an unusual picture can be the most saleable. Even if the local paper doesn't buy it, there could be a market elsewhere.

Try and provide a picture editor with a good variety of pictures, not just one or two. Sometimes the shape of a picture can dictate whether it is published or not, so try and provide both upright (usually the most popular) and view shaped shots. Alternatively, try and compose your shots in such a way that they can be cropped later to either shape.

Local newspapers will look for really good character shots, like this one of a man with his dog.

Captions

Often the information supporting the picture can be as important as the picture itself. Any picture in a newspaper will have to be supplemented with either a story or a caption, and quite often both. Every caption should contain the 'five Ws': *who, what, where, when and why*. Ask yourself these questions and get them answered on the spot—you might not get the chance later. A fully captioned picture is shown here.

Names are usually the most important aspect of a caption. If you photograph someone, try and get his or her name—with a group of people, take all the names if possible, from left to right in the picture. And always check spellings: if someone says his name is Ian Johnson, that could be just as I have spelt it, or it may be Iain Johnson, or Ian Johnston, or Iain Johnstone . . . always check if there is any doubt.

As well as this information, try and supply the contact for the story if a reporter from the paper is not with you. It will be much easier if the reporter has the full name, address and, preferably, telephone number, of the person(s) in the photograph, or those involved with the event or story concerned.

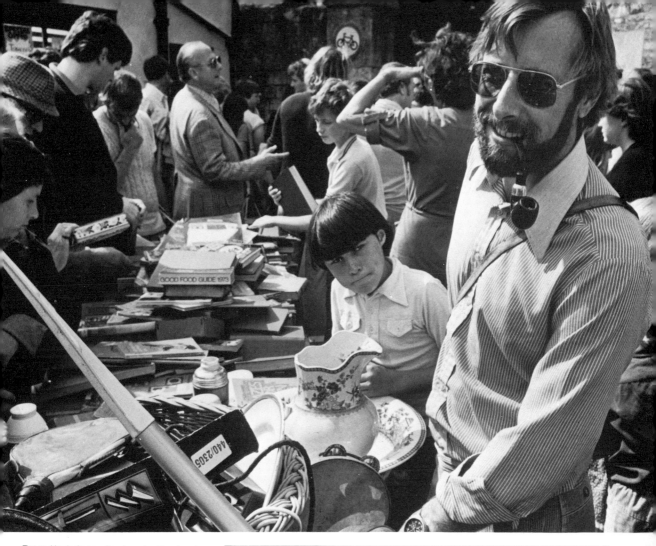

Try and include people when shooting local events. The stall-holder and the inquisitive boy are the main subjects in this shot taken at a flea market. In a similar situation, take the names and other relevant details for a caption. *Leica M4-2, 28 mm f/2.8 lens, XP1 film.*

Local papers/summary

Coverage
Most local news coverage includes hard news, general news, features on local people and events, sport and recreation, local places of interest, and many more.

Requirements
These can vary according to individual newspapers. Most require black and white only, print sizes of 6 ×8 in or 8 ×10 in, and a glossy finish (avoid textured surfaces, such as stipple, as they are likely to be seen in the reproduction). Sometimes newspapers ask for prints to be flatter in tone than normal because of the increase in contrast on reproduced.

Fees
Fees are usually by arrangement. Picture value can vary depending on newsworthy aspects, size used in the paper, and so on. Average fees are about £10–£15 per picture reproduced. Daily rates for freelance services are by arrangement—but can be anything from £15–£50 per day, depending on the nature of the assignment, whether unsociable hours are involved, etc. Expenses may or may not be inclusive, and usually have to be supported.

National newspapers

Most of the national newspapers in this country are based in or around Fleet Street, although some also have regional bases in places like Manchester and Scotland.

On any of the popular daily tabloid newspapers there are likely to be something like 15 to 20 staff photographers, most of whom would be based at the paper's headquarters, with perhaps a few in major provincial cities. The newspaper may rely on staff photographers to cover some of the major news stories of the day—but this isn't always possible, particularly if a story crops up at the other end of the country late in the day, and there isn't enough time to despatch a staff photographer.

For this reason, among others, newspapers rely heavily on freelances. Most of these are full-time professionals, either working for regional news agencies who supply newspapers with news and feature stories, or operating independently. Some of these may be ex-Fleet Street Photographers.

What makes news?

Every newspaper has its own idea of news. The editorial format of the paper usually dictates the style of stories it uses and how it chooses to present them. For example, a newspaper like the *Sun* is

The freelance should always expect the unexpected—and always carry a camera everywhere. The photographer who caught this lucky shot of a 'snow streaker' sold the picture to the *Daily Mirror*, as well as to a local paper and a photographic magazine, earning over £100. Not bad for an unplanned assignment.

Newspapers don't solely use 'hard news' pictures. This is a good example of a picture which might be seen in a popular tabloid. It combines topicality, humour and—who knows?—possibly a story.

more likely to use a story about a runaway vicar and his mistress over a full page, with pictures. The same story would probably not be seen in *The Times*—if it was, it would probably be a couple of lines tucked away at the back.

The best way to keep in touch with the sort of material newspapers use is to look at them regularly. Of course, you might not be able to buy them all every day, but your local library should have most on file. Flip through the pages, making notes if necessary on how many pictures are used in each paper every day. In some cases you may be able to sort out which pictures are by freelances (staff photographers, whose names you may soon become familiar with, usually have a credit, or by-line, under their pictures).

You might find that, despite the variety of pictures, they all tend to fall into categories: hard news, general news, court cases, celebrities, glamour, sport, humour, and so on. From your research, it should not be difficult to differentiate between the various newspapers and have a sort of 'profile' on their picture requirements.

What to do with a news picture
Assuming you have a hard news picture in your camera, what is the next step? Well, there are two basic options: sell exclusively to one newspaper (which might then syndicate the picture to other outlets later) or sell to a news agency, which may sell the picture to a selection of markets at home and abroad.

In the harsh, competitive world of newspaper work, where staff and full-time freelances are chasing every story they can, a part-time freelance may have little chance of having a picture published in a Fleet Street national. The only exception would be for a picture that is:

Exclusive
This picture might be of a major news event—plane crash, shoot-out, bank raid, or similar. Or it could be an off-beat photograph of someone famous—perhaps royalty or a show business personality.

Topical
A picture of this sort might illustrate a situation of topical newsworthy interest—for example, water shortages or very bad weather.

News 'filler'
Here the picture, rather than the story, is the most important aspect. It might only be supported by a short caption or story. Examples might include a beauty queen promoting fur coats in summer or a newly born zoo animal.

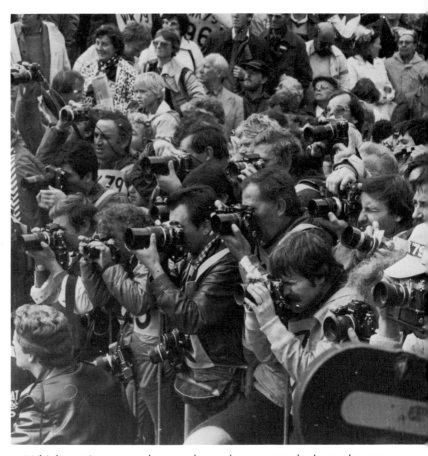

Which option you choose depends a great deal on the news value of the picture. If you have a one-off picture of a disaster or similar hard-news event, such a picture may have worldwide sales possibilities and an agency may be able to do more with it. On the other hand a single newspaper may pay more for exclusive first use of a picture and, since many have their own syndication outlets, there may be extra benefits. For other less important material, selling to an individual newspaper is often the best alternative.

The first thing to do when you think you have a news picture is *not to panic*. Make a note of the picture you have and any relevant details—names, locations, etc. Try and make your own assessment of the picture's worth and decide, from any of the information you may have accumulated, which paper to approach. Where this isn't possible, a gamble may have to be taken. Faced with a similar predicament, many freelances approach the newspaper they usually read, if it is likely they would use such a picture.

With the necessary information, and the film *unprocessed*, make for the nearest telephone and ring the newspaper (or agency) of your choice. Ask to speak to the picture editor, or assistant, explain

In some areas of news photography, seeing hordes of pressmen rubbing shoulders isn't uncommon. But it needn't always be this crowded—sometimes a freelance can be alone in capturing a news picture.

the picture(s) you have, the film used, details of your location, and so on. An experienced picture editor should tell you straight away if the picture is likely to be of any use and, depending on where you are, you may be asked to send the film from your nearest train station (usually by Red Star parcel service), or arrangements may be made to have the film picked up.

Under no circumstances process the film first—it may waste valuable time. Most newspapers are geared up for processing all sorts of film (black and white and colour) very quickly, so leave it to them. A picture editor will be able to tell you whether a print is preferable or not—in most cases, even if the film has been processed, you may still be asked for the negatives so that darkroom technicians can make a print according to the exact reproduction requirements of the newspaper.

In the case of a hard-news exclusive, a freelance is understandably reticent about parting with the film until a deal has been worked out with the newspaper or agency concerned. The chances are a picture editor is unlikely to suggest a fee arbitrarily without seeing the picture, so the photographer may have to go to the newspaper's office. If you are in a situation like this, it may be a case of taking the film yourself, waiting for it to be processed, and then negotiating with the picture editor about the picture's worth. Alternatively, the film may be despatched separately to the newspaper, while you follow on later—with any luck, the film will have been processed and evaluated by the time you arrive. If you take the latter course, ask the picture editor not to use the picture until you have arrived and a deal has been made.

National newspapers/summary

Coverage
The type of coverage is dependent on the type of newspaper. In most cases, it will include hard news, general news, matters of topical interest, celebrities, sport, and so on. Certain subjects related to popular tabloid newspapers (*Sun, Star*, etc.) may include 'glamour' and more off-beat stories.

Requirements
Usually black and white is required although, in the case of a hard-news exclusive, a newspaper may accept any type of film if it can be processed quickly. Check with the newspaper if you are in doubt. In the case of work already processed, black and white prints of around 6 × 8 in or 8 × 10 in are preferred for most general reproduction.

Fees
Fees are usually by arrangement, and often depend on the news value of the picture(s) or story 'tip-off'. For general news or 'filler' pictures, around £15 upwards is reasonable. For a hard-news picture, fees are negotiable—and can be up to £1000 or more, depending on subject and use. Percentage fees for syndication can be around 40–50 per cent to the photographer.

59

Good technical close-ups, like this one of a vintage car, are used regularly by the photographic press. This picture might also be bought by a classic car journal.

The photographic press

There are more photographic magazines published in Britain than in any other country. During one recent period, the number included at least five monthlies, two weeklies and two weekly 'part-work' publications. Photographic enthusiasts are much better served with reading matter than their counterparts abroad where, in most countries, the average is usually one or two monthly magazines. A weekly is almost unheard of.

The number of magazines indicates the level of enthusiasm for photography here and ensures a good showing of photography at all levels. By their very nature, these magazines are involved in 'show-casing' photographs and photographers. For the non-professional enthusiasts particularly, there is the chance for their pictures to reach a very wide audience. One weekly magazine, for example, has almost one million readers and publishes around 1000 amateur pictures each year.

Because the photographic magazines have such an interest in amateur work, the part-time freelance has the best possible chance of selling pictures to these publications. For many photographers the first showing of pictures in a photographic magazine has led to further freelancing opportunities and, in some cases, to a full-time career in photography. So the photographic press is a key area of the market that every freelance should try.

What they use

Photography is a very wide subject to deal with and each magazine has its own special area and style of coverage. General magazines, like *Amateur Photographer* and *Practical Photography*, may include equipment tests, advice on technique, portfolios, and so on. Other magazines have a more specific coverage—*Camera Choice*, for example, might use pictures and stories related to equipment and its uses, while *Camera* and *Creative Photography* are more likely to accept lavish portfolios from photographers.

To most photographic magazines, the difference between amateurs and professionals is often irrelevant—all are photographers. This is why you are likely to see David Bailey's pictures next to a portfolio from a club amateur. The magazines are in business to promote interest in photography at *all* levels.

For most publications the sort of photographs used include:

Cover pictures Every magazine tries to stand out against the competition on the newsagents' shelves, and the cover picture can help enormously. The cover shot is designed to attract the casual reader (regular readers would probably buy the journal anyway) who will, hopefully, pick up the publication, scan quickly through the editorial pages, and buy it.

An editor may have three basic sources of cover material.

Photographer's portfolio A shot may be selected for the cover, with

An evocative portrait which has been featured in many photographic magazines. A strong subject and good technique in shooting and printing the image, are the essential ingredients for success here.

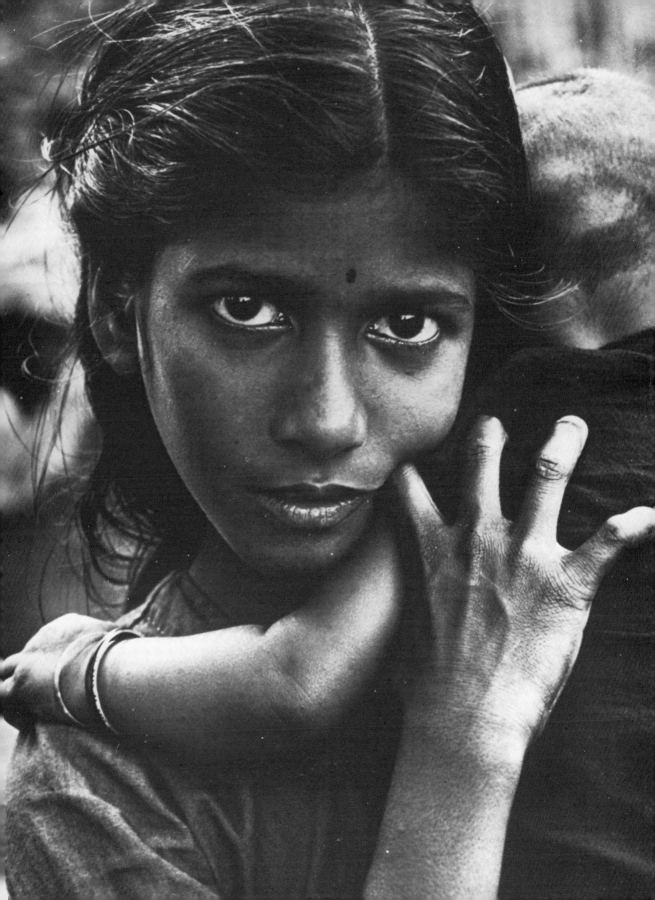

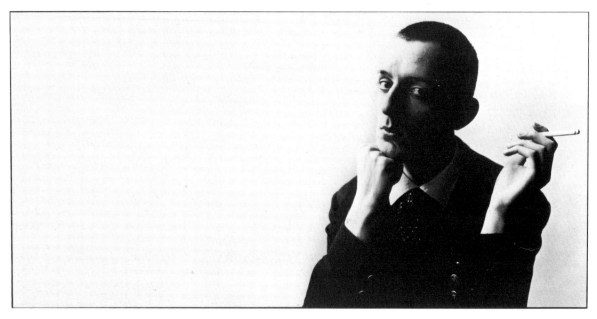

Entering competitions is a good way of having pictures published in a photographic magazine, in addition to possibly winning a prize. This picture was a prizewinner in a recent portrait competition.
Rolleicord, $\frac{1}{2}$ sec f/16, FP4 film, using natural daylight.

the remainder used as a portfolio feature. Here the cover shot acts as a 'taster' for what is inside the issue.

Commissioned A cover shot may be specially taken by a commissioned photographer to highlight something in the issue—a major camera test or a feature on taking pictures in autumn, for example.

'Stock' file The editor may keep a supply of possible cover pictures 'on stock' for use in the future. The right cover shots do not always come in to the editor at the right time and are often kept aside for later use. These sort of pictures do not always relate directly to anything inside the publication and tend to be of general subjects—for example, glamour, wildlife, portraits or photographic effects.

Wherever the cover picture comes from, it usually has to fit into the magazine's normal style and format and, in order to attract attention, it must have eye-catching impact.

Transparency format for covers usually varies between 35 mm and 120 rollfilm sizes (6 × 4.5 cm, 6 × 6 cm, 6 × 7 cm). A preference may sometimes be shown by an editor to one of the rollfilm formats because of the quality required when the shot is blown-up to the cover size. However, a good quality 35 mm transparency is unlikely to be disregarded because it is a smaller format. Since the majority of slides submitted to an editor are likely to be on 35 mm, it would be foolish to limit options to the larger formats only.

There are a few prime essentials for a cover shot. First, it has to be the *right subject matter*, fitting in with the general style of the publication. Look at a few issues over a period of time to see the sort of pictures used on the cover. Second, it must be the *right shape*. Most magazines are an upright A4 size and the cover picture may

have to fill the entire area—leaving sufficient space for the magazine's title and 'cover lines', promoting what is inside the issue—or it may be used on part of the cover area, leaving space for this information. Third, the cover shot must be technically of the *best quality possible*. Specifically, this means it should be sharp, correctly exposed, and colours should be vivid and clear. A fuzzy, flat-looking image will never be used.

Single pictures Photographic magazines often use individual pictures to make certain points about technique. Perhaps four or five different pictures (colour or black and white), by different photographers, might be used to illustrate a technical article on a particular subject, such as portraiture or landscape work. Most magazines keep a file of such pictures for this very purpose. When submitting material to photographic magazines make sure that you include separate details of how the picture(s) may have been taken, and include as much technical information as possible.

Portfolios A set of photographs is quite often used with a related story. This might be a piece written by the photographer, explaining approach and technique. Or, on the basis of looking at the pictures, the magazine may decide to interview the photographer and write the story. More often than not, a portfolio is likely to concentrate on a particular theme or style of photography, and this may be what the editor is looking for. A good portfolio should 'hold together', meaning that the photographer's work should be identifiable and cohesive. A random set of pictures without any strong link, either in subject matter or approach, is very likely to be returned to the photographer, perhaps with the editor selecting certain individual shots for 'one-off' use with a variety of articles.

Competitions

Most photographic magazines run competitions, where photographers can enter pictures on a variety of subjects, possibly winning cash or equipment prizes, and having their pictures published.

Sometimes a magazine may ask to keep non-winning entries for later use in the publication, or it may ask a photographer for more material for a possible portfolio feature. For these reasons, it is always worth entering (see *How to win competitions*, p.136).

The photographic press/summary

Coverage
Various aspects of photography—including equipment, technique, history and portfolios. Check each magazine to see specific areas of interest.

Requirements
This depends on the individual magazine. Most look for black and white prints (usually glossy, 6×8 in or 8×10 in sizes) and colour transparencies—35 mm, 120 rollfilm formats (and sometimes larger) *not* glass mounted. Single pictures or portfolios may be accepted—up to about 20 pictures are usually sufficient for an initial submission.

Fees
These are usually by arrangement. Some editors pay a set fee for cover pictures of around £50–£100. Black and white rates can vary depending on whether a single picture or portfolio is used. Expect around £15 or more for single b & w picture and £50–£150 for a portfolio, depending on the number of pictures or pages used. Colour rates can be twice as much as for black and white. Editors may quote set rates for pictures, although negotiation can take place on exclusive or special-interest material.

General-interest magazines

Many magazines and journals on the bookstalls cover a wide area of general interest—unlike specialist publications, which tend to concentrate on one particular subject or area of interest.

Each general-interest magazine has its own area and style of coverage to suit a particular readership. While there are variations within the market, most exist to:

● Follow up news stories in depth
● Publish major features and interviews
● Entertain the reader with 'lightweight' articles and stories on many aspects of general interest
● Produce material in colour (a luxury not afforded to most newspapers)

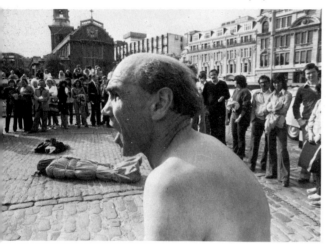

This sequence of pictures of an escapist act outside the Tower of London has just the right kind of picture feature appeal which many general interest magazines look for. The pictures speak for themselves and the magazine need only add a headline and some humorous captions, if the photographer has not already done so.

Types

Sometimes a general-interest magazine is allied to a newspaper. For example, many Sunday newspapers have their own 'free' supplements —the *Sunday Times Magazine*, *Telegraph Sunday Magazine* and *Observer Magazine* are examples. Journals like this act as an extension to a newspaper's coverage, helping to attract readers by offering a complete Sunday reading 'package', and attracting extra colour advertising revenue.

There are also many independently sold magazines that exist on their own editorial merits. Publications like *Revue* and *Weekend* include a diverse, and often light-hearted, array of stories and pictures. Here the entertainment content, rather than hard-news information, is the prime attraction. As a result, magazines like this enjoy a large and varied readership.

Women's magazines, although aimed mainly at a female readership, also have a sizeable male following, and cover areas of general interest. Indeed, some of the women's magazines, such as *Woman* and *Woman's Own*, are among the biggest-selling journals in this

particular general field. For the freelance, they offer the chance to have pictures seen by up to two million readers.

What they use

It is difficult to be too specific about the material used by each general-interest publication, since they all have their own individual outlook and requirements. But if you look through a few copies of the various magazines it isn't too difficult to see a certain 'pattern' running through most of the output.

Most magazines are, by their very nature, visually orientated. They are designed to catch the reader's eye by good use of design and by good use of *pictures*. Many can give plenty of space to photographs and picture-related features that, for example, a newspaper cannot.

How pictures are used varies from journal to journal, but the pattern usually involves the use of:

Single pictures These are usually of an off-beat or humorous subject. Usually black and white, they appear on a letters page or in similar space where a picture is needed to add visual interest to the text. Each picture is self-contained, ie, it requires no explanatory story, although a short caption may be necessary in some cases. The freelance may submit a one-off print, or several different prints for use over a period of time. Once a picture has been used by one magazine it may be possible to sell the same shot to other publications. Ideally such shots should be 'timeless'. In other words it should be difficult to date the picture. It will then be possible to sell the picture again and again, often over a number of years, for maximum profit.

Cover pictures While many general magazine cover photographs are likely to be taken by a specially commissioned photographer, or supplied by an agency, there are some freelance opportunities in this area on certain publications. Most magazines, like *Revue*, make use of

'glamour' photographs, often backed up by pictures of the same girl inside the issue. Quality is often the most important aspect of cover photography. The requirements are usually a clear, sharp image with good colour saturation. Many magazines only use larger format transparencies (120 rollfilm 6 × 6 cm, 6 × 7 cm or 6 × 4.5 cm), although some will accept a first-class 35 mm slide. The important point is that the photograph should fit the magazine's style and format, bearing in mind that the journal's title and other information has to be included somewhere on the cover.

Quality in the image is all-important when submitting cover pictures. Bear in mind also that, in most cases, the image should be upright, like the shot of the girl here.

Photographic features

Most features are likely to be written by journalists on a magazine, or by outside freelances. Since story and pictures are usually closely allied, there may be little chance of a freelance supplying pictures unless he or she has been commissioned. In some cases a photographer and journalist might produce features together, or a photographer with some writing experience might do so. Sometimes it may be possible to sell a feature made up of pictures—perhaps a humorous sequence—with short explanatory captions. Check magazine contents to see the style of features used and decide if it is within your range to submit such work.

Try and submit photo features with a theme. Here the photographer followed a cycle rally, obvious by the way the saddles dominate the picture.

General-interest magazines/summary

Coverage
A wide variety of topics that appeal to a broad readership. Examples include news follow-ups, humour, gossip, celebrity stories and interviews, in-depth features, unusual stories, etc. Depends largely on the style and format of the journal concerned.

Requirements
Black and white glossy prints (6 ×8 in, 8 ×10 in in most cases, sometimes larger) are usually required. With colour transparencies submit 120 roll-film or larger sheet film formats. Some accept 35 mm transparencies. Do not send glass-mounted slides. Single pictures, or portfolios with special interest, may be accepted.

Fees
This depends on the type of magazine and material used. Negotiable on special features, especially if they are newsworthy. Single black and white pictures £10–£15 or more, £50–£100 for a portfolio depending on pictures and pages used. In some cases it is a good idea to approach the magazine editor with portfolio ideas before submitting any images.

Specialist magazines

By far the widest and most potentially rewarding area in magazine publishing is in the specialist field. Here, journals cover an incredibly wide number of different subjects, from gardening to politics, from sport to science. If there is a popular special-interest topic, the chances are there is a magazine published on it somewhere. Most of them use pictures—which is good news for the freelance, because few of these specialist magazines have their own staff photographers.

Develop your interest

If you happen to enjoy another hobby or interest outside photography, this might be a useful route into the specialist magazine market. Many enthusiasts use photography to record, or help with,

Impressive 'wheelie'. This unusual angle on a sport would almost certainly be used by a special motorcycle magazine.
Canon A-1, 400 mm f/4.5 lens, 1/500 sec f/8, XP1 film.

A colourful flower picture like this might be used by one of the many gardening publications. Make sure you include a caption detailing the correct variety name of the species photographed.

A picture like this might sell to a county magazine, or an equestrian journal, or even a magazine covering sport and leisure. *Leica M4-2, 50 mm f/2 lens, FP4 film.*

their other interests. Steam train fans, for example, take up photography to keep a visual record of old engines for posterity. Sometimes, the photographs are good enough to be bought by magazines serving this area of interest.

Quite often an editor will appreciate using photographers who, because of their interest in a subject, can produce photographs that reflect a knowledgeable insight into that particular area. An inexperienced photographer might be able to take similar pictures, but may not be able to supply the relevant background information for captions or a story. A freelance with 'inside knowledge' of a hobby or interest can carve out a niche in specialist publishing and might have pictures used often by a particular magazine. The advantages of continuous publication are obvious and, for some freelances, working for a specific market has been a stepping stone towards success in a wider market.

Finding specialist markets

If you are involved in a special interest you may already be aware of the magazines that cover that area, and the sort of photography used. Alternatively, you may need to do a bit of market research before submitting any work.

Computer magazines can make use of pictures showing the applications of modern equipment. Here the photographer has shown the computer in a home environment.

There are basically two easy ways of finding particular specialist periodicals. First, visit a large newsagents (W H Smith or John Menzies, for example) and browse through the magazines you are interested in—they are usually well displayed and magazines covering a specific topic (say, motoring) are kept together. Buy the ones you are interested in submitting pictures to and look through them carefully to see the type of material used. Second, buy a copy of the *Writers' & Artists' Yearbook* (published annually by A & C Black at around £3.00). This is an indispensable list of newspapers and magazines and their exact requirements. Unfortunately the listing is alphabetical and not in subject categories, so careful browsing may be needed to compile a shortlist of publications to consider.

With the shortlist, the next step is to decide where the pictures you intend to supply will come from. Some photographers can be lucky enough to have built up a good selection of photographs on a subject, and might be able to submit them straight away. If you are in this position it might be a good idea to send a letter initially to the editor(s) to find out what sort of material is in demand.

If you don't have a supply of 'stock' pictures it is obviously essential to select certain aspects of the special interest or hobby that might be interesting photographically, and build up a selection of pictures

Many freelances keep travel pictures like this 'on stock' for possible sales later. Apart from having the flavour of an African village, there is also an element of humour with the woman carrying a bottle on her head.

Market areas

While it is difficult to list all of the specialist publications on the market—mainly because of the vast number and sometimes transient nature of this particular area—it is fairly easy to identify some of the main subject categories and outlets for certain kinds of photography.

Subject	General photographic use	Examples of subject magazines
Hobbies	People involved in activity Instructive 'how-to' pictures Shots illustrative of hobby attractions	Garden News Yachting World Stamp Magazine Steam World
Sport	Sporting action People involved in sport Behind-the-scenes action Sporting personalities Unusual sport	Angling Times Tennis World Sport & Recreation Adventure Sport
Motoring	Shots of new cars or motorbikes Mechanical close-ups Motor sports Unusual customising Aspects of driving Motoring history	Motor Motor Cycle News Car Custom Car Classic Car
Photography	(See The photographic press, p. 60)	
Music	Bands and artists playing live Off-stage pictures of above Aspects of music 'culture'	NME Melody Maker Disc The Face
Travel	Locations at home and abroad Exciting aspects of travel Unusual locations	Travel News
Places	Building and architecture Scenery Aspects of local interest	Country Life Town & Country Planning This England Sussex Life
Living	Various lifestyles House profiles Fashion	Interiors Honey Good Housekeeping
Politics	People involved at various levels Activity (rallies, speeches)	New Society New Statesman
Religion	Various denominations and how they work and live	Church News Christian Record
Science & Technology	Aspects of science, technology, people involved.	Science Digest New Scientist

'Craze' publications

While most specialist publications stay on the shelves for a long time (indeed some have become institutions) some come on to the market to cater for a current 'craze'— and promptly disappear when interest wanes. A typical example of this occurred a couple of years ago when skateboarding was all the rage. Countless magazines were produced on the subject but most—if not all—disappeared after only a few months.

Sometimes it is well worthwhile for a freelance to 'cash-in' on such crazes and supply photographs on a speculative basis. The only problem is timing— these magazines appear very quickly, but only after a craze has started to take off. As a photographer, you have to keep your ear to the ground and get some pictures together quickly, then submit your material as soon as you can.

One word of warning. Some magazines are likely to be published by 'fly by night' operators who may take your pictures but not pay for them. Some freelances have lost their material too. Deal only with reputable publishing companies—some of the larger ones include IPC, Haymarket, Link House, Spotlight and EMAP.

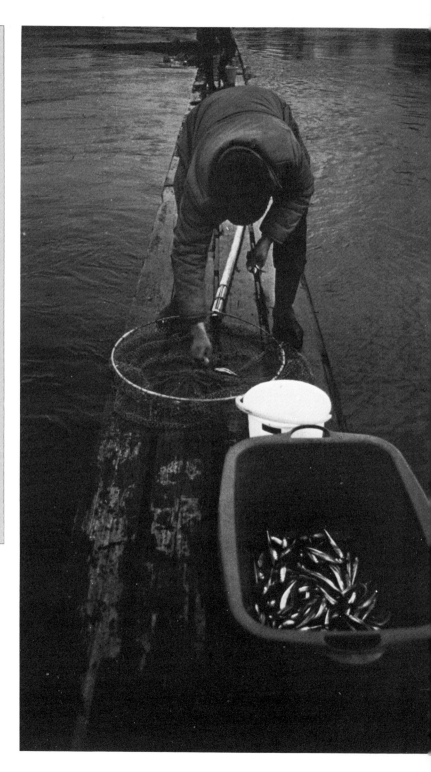

Using a wideangle lens, the photographer has been able to move in close and capture the fish and the fisherman in this tightly-composed shot. Caption details might include the fisherman's name, what he is fishing for, the location and other information relevant to the magazine the picture is being sent to.

for future submission. It helps to look at what material has been published recently and avoid shooting themes that have already been covered. Fresh ideas are what an editor is looking for, so make sure you don't copy—otherwise your pictures might be returned sooner than expected.

What they look for

Each magazine obviously has its own requirements and, by carefully looking at the contents, you should be able to gauge exactly what to send in for maximum effect.

The first thing you should remember is to keep the photographs *relevant*. There is obviously no point in sending jogging pictures to a gardening magazine.

While a lot of magazines are likely to accept pictures only for individual use on the cover or inside, the demand is often for illustrated articles. You stand a much better chance of publication if you can submit both photographs and a story, or at least enough information about the subject to enable a journalist on the magazine to write a few words.

Remember, when you are 'on the spot' taking pictures it is much better to gather all the necessary back-up information for the pictures there and then. Having done that use the information for captions, explaining what the pictures are about. It might only take a little extra time and effort to produce a short story of, say, a few hundred words to supplement the shots (see *Write on*, p. 146).

Every editor will be looking for some originality in your pictures, so don't copy what you have seen published previously. Concentrate on presenting fresh ideas, and perhaps a novel slant on a subject. Offer a good variety of shots, too, making the best use of different camera angles, lighting, and any special techniques that might appeal (use of special effects, for instance).

Specialist magazines/summary

Coverage
The types of picture needed will be specific to individual magazine. They usually relate directly to a definite topic.

Requirements
Depends on the publication. Where black and white is used, glossy prints (6 ×8 in, 8 ×10 in, sometimes larger) may be acceptable. For colour, 120 or 35 mm transparencies (not glass mounted) should be sent. Single pictures, portfolios with explanatory captions or a supplementary story where necessary.

Fees
This depends on the size and circulation of the magazine. Most larger publications may pay between £10–£15 per black and white picture, and £50–£100 for an illustrated story. Smaller journals, which may exist on a tight budget, may have a rate of £10 plus per page. Fees may be negotiable. Colour fees are usually double those for black and white.

Trade magazines

While they may not be well known to the average reader, trade magazines can be a worthwhile outlet for pictures. Some enjoy very high sales—*Farmer's Weekly*, for example, has a circulation that many specialist publishers in more general areas might envy.

Some trade magazines can be spotted in newsagents, but a great many are 'closed circulation'—mailed directly to subscribers who are in that particular trade or industry. The best way to find out about them is to consult a copy of *The Writers' & Artists' Yearbook* mentioned earlier.

If you happen to be involved with a particular industry, and know of in-house company journals or general trade magazines, it may be worth approaching them with some pictures, perhaps backed up with a story or outline idea for a feature. Many of these magazines are interested in the day-to-day running of businesses and may value a set of pictures from someone with inside knowledge of a particular area. A farmer, for example, might spare some time to photograph the activities on the farm, perhaps to illustrate how it is operated and how problems are overcome.

This kind of direct feedback to magazines is usually appreciated, particularly from out-of-the-way places where coverage may be difficult to obtain through normal sources.

Requirements can be for black and white or colour transparencies, depending on the journal, and fees vary from very low (especially on small circulation journals) to about on par with most generally available specialist publications. Individual editors will be able to advise you on these matters.

Cards, calendars and posters

A peaceful water scene which is almost timeless—it could have been taken anywhere, at any time. This sort of image can have great appeal in the card and calendar market.

Many companies producing greetings cards, calendars and posters use photographs and, despite the more recent movement towards using artwork, there is still a market for the freelance to service.

Walk into a shop and look at typical cards, calendars and posters and study the type of photography used. The first thing that may strike you straight away is the excellent photographic quality. Beautifully sharp, colourful pictures are the norm, since the prime purpose of photographs like this is to attract and please the eye.

The key to supplying this market successfully is to provide material of the same high quality. Many companies use large-format transparencies, usually 4 × 5 in, but they also consider 120, or even good quality 35 mm, in some cases. It really depends on the company, and the sort of material they are producing.

Since there are not too many companies operating in this market that use photographs, it can be a little difficult to get into. Because of the nature of the products they quite often have to operate a long time in advance—sometimes two or three years ahead of the publication of a calendar, for instance. Poster companies tend to

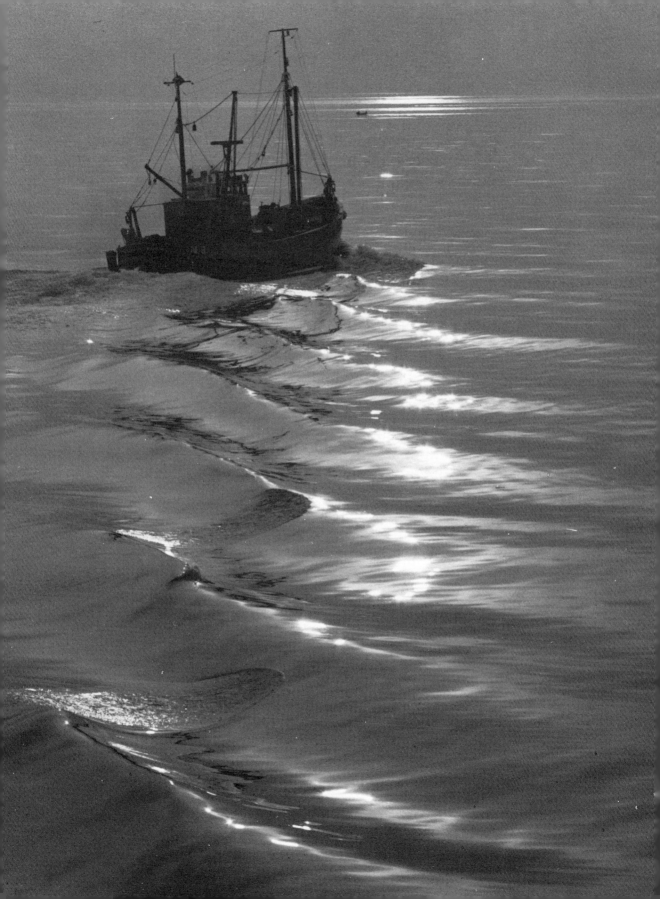

work more quickly since their output usually has to be fairly timely—material can 'date' very quickly.

Subjects

The range of subjects in this market is very wide. Anything from scenic views, shots of cuddly animals, child portraits, sports action, unusual subjects, humour, glamour and many more. If you browse through some examples in a shop you can see the scope.

Some companies tend to specialise in certain subjects. For instance, *Whitehorn Press* in Manchester looks for views of the West Midlands and north of England for their scenic calendars. A poster company like *Athena International* in Hertfordshire looks for a variety of subjects, but mainly humour. A selective list of companies in the market is included later on in *The Freelancer's Directory*, p. 166.

I cannot stress enough the importance of studying examples of the material used before submitting anything. If you think you have the right shots, or think you can take pictures that will be suitable, make sure you send only the very best-quality photographs. The demand is for pin-sharp, colourful transparencies that are correctly exposed. Composition can be important, particularly on greetings cards where a message will have to be incorporated over the picture. Bear this in mind—sometimes a transparency with a bit of 'breathing space' is more acceptable than one that is too tightly cropped.

Company calendars

Sometimes companies produce their own calendars for promotional purposes. This happens a lot in the motoring trade, where companies like *Unipart* and *Motorway* produce glamour calendars.

Professional photographers are usually commissioned for this kind of work. In some cases, a company will make up a calendar with photographs supplied by an agency—if a freelance happens to be with an agency, pictures may be used for this kind of product (see *Picture libraries and agencies*, p. 80).

Cards, calendars and posters/summary

Coverage
A very extensive, worldwide market exists. Home market, or worldwide market in some cases.

Requirements
High-quality transparencies are essential, usually a minimum size of 4 ×5 in or good 120 (6 ×6 cm, 6 ×7 cm). 35 mm of highest quality may be acceptable in some cases. Submit a minimum of 5, or a maximum of 20, transparencies initially.

Fees
This varies on the type of product, distribution, etc. Around £18–£30 is usual for greetings cards or £50 upwards for posters.

Books

The book market is huge and diverse, using up millions of photographs every year. Yet for the freelance marketing his or her own work, it is incredibly difficult to break into this potentially lucrative market.

The reason? Well, unlike magazines and other regularly published journals, books are usually 'one-off' affairs. A photographer is unlikely to know what books the various publishers are working on, when they will be published, and if any photographs are needed. Photographs submitted to a particular publisher on a speculative basis might just be what their picture researcher is looking for—if the freelance is incredibly lucky.

Most publishers do not keep photographs on file unless they have been commissioned for specific use in the near future. When pictures are needed for a book, a researcher will either approach a picture library or agency, or commission a photographer(s) to take the photographs specially.

Therefore, publication in books relies heavily on the photographer marketing his or her pictures through an agency or library. To be commissioned, the freelance must be known to the particular publisher, perhaps through work already published.

A few books on the market each year are designed to showcase the work of photographers and it may be worth submitting material for possible publication to these. One is the *Photography Yearbook* (edited by Reg Mason, published by Argus) and another is the *British Journal of Photography Annual* (edited by Geoffrey Crawley, published by Henry Greenwood Ltd). The books are read by photographers and, perhaps more importantly, by *buyers* of photography, including publishers, agencies, and magazines. So it can be worthwhile sending a submission—further details are available from the publishers.

The photography book market is very large and diverse, but it is difficult to market pictures to the publishers yourself. The best way to get into this market is via a picture agency or library. Photography books all make use of freelance photos.

Picture libraries and agencies

Some freelance photographers reach a stage where their photography is advancing, but the market for their pictures is not. At this point, consideration is often given to the use of a photographic agency or library.

Agencies and libraries have two basic functions: to help photographers distribute pictures to various markets, and to give the buyers in the market—newspaper, magazine and book publishers, and other users—access to a wide variety of photography. The agency or library acts as the 'middle man' between the photographer and the marketplace—the photographer benefits by selling work to a large, even worldwide, market, and the agency/library deducts a fee (usually around 50 per cent) from the sale. That may sound a lot, but the agent's expertise and knowledge of the market quite often results in the photographer selling many more pictures than would otherwise be possible. Sometimes a good picture can be sold again and again by an agent, making the photographer a great deal of money.

The differences between an agency and a library are quite small—some organisations even label themselves as both agency *and* library. If there is any difference, it is in how the pictures are marketed. An

General aspects of travel and tourism are of interest to some picture libraries. Characters like this Beefeater at the Tower of London can give a picture selling potential.

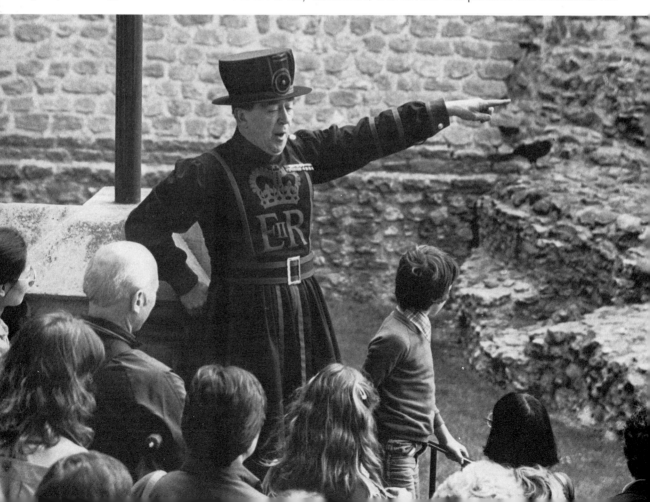

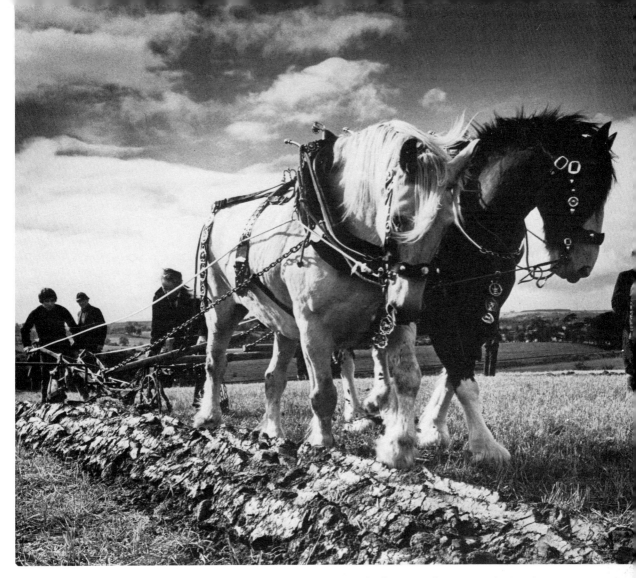

Look for old customs and traditions which libraries may have difficulty finding pictures of. This shot of a horse-drawn ploughing competition in Cumbria may be a useful and saleable addition to a library's files. *Pentax, 35 mm lens, 1/125 sec f/11 orange filter, FP4 film.*

agent representing several photographers may be in business to market and sell their work as quickly—and *profitably*—as possible. Libraries usually have a more long-term approach, often holding thousands of transparencies and prints within categorised areas so that picture researchers or editors can find specific subject matter easily. In the case of the latter it is more the photograph, rather than the photographer, that is marketed.

How do agencies and libraries operate?

Many picture agencies and libraries exist to service the publishing industry—magazines, newspapers, books, posters, and so on. The size and scope of the market, with thousands of different subjects covered, lead many agencies to specialise in order to corner a particular area of this potentially vast market.

Picture editors and researchers, looking for a particular type of photograph, usually go to an agency or library specialising in that

Libraries have a wide range of categories for pictures. This shot might be filed under 'People', or 'Scotland', or even 'Music'. Try and categorise your own pictures before selecting a suitable library looking for those subjects.
Olympus OM2, yellow filter, Tri-X film.

field. For example, a visit would be made to the *A to Z Botanical Collection* for a botany transparency, or to *Aerofilms* for an historical aviation photograph.

Other agencies and libraries stock a wider and more general selection of photographs to feed a variety of different markets. Such an agency might have categories ranging from news and current affairs, to personalities and glamour photography.

Depending on the subject area and the particular strength of the agency, it can be more profitable to stay within a specialist field, although in some cases more photographs may be sold by an agent with a wider market approach.

Most agencies hold thousands of transparencies, and sometimes prints. But it is essential for the agency to hold a large stock and to keep it up-dated, so that practically any picture need can be fulfilled. Obviously photographs do not make any profit, either for the agency or the photographer, if they are simply lying around in a filing cabinet. So many agencies have their own sales teams, sometimes spread out all over the world, who follow up existing customer contacts and find new outlets for pictures. It is this kind of distribution the photographer is paying a fee for—in most cases, well worth it.

Finding an agency or library

Finding an agency or library should not prove too difficult. Most are listed in publications like the *Writers' & Artists' Yearbook*, and there is also a selective list later on in this book, p. 166. Most also belong to the British Association of Picture Libraries and Agencies (BAPLA) and they may be able to supply a list of their members.

Having a list of agencies and libraries is one thing—finding the one that is right for *you* is quite another. Many are quite helpful in supplying information to photographers regarding their specific picture requirements and it is essential that prospective submissions are tailored within these guidelines. Sometimes just the name of the agency reflects the type of material it is likely to want to see—for example, the *A to Z Botanical Collection*.

Many of the well-run agencies and libraries prepare a special photographers' information leaflet. This usually details what the agency does, the markets it services, the type, size and number of photographs required for a submission, and so on. It can save both you and the agency a great deal of time and effort if *you* check the requirements beforehand.

With a shortlist of possible agencies that might be interested in your work, it is then a matter of putting together a selection of material and submitting it. Try one agency at a time (if there are more than one) and remember it isn't always the 'big-name' agencies that are best. Sometimes a smaller concern, with fewer photographers to represent, might be able to devote more time to marketing your pictures, so bear this in mind.

When making a submission to an agency select only the very best shots. The photographer here might have taken a whole sequence of shots of this wintry landscape before submitting this final selection.

Making a submission

Before sending any material to an agency take special note of any instructions (written or verbal) given on exactly what is required and—perhaps more importantly—what is *not* required. It is clearly a waste of time if you submit material they are unlikely to want—unless, of course, there are no definite guidelines. In which case edit your own material as critically as possible.

When sorting through your slides and/or prints, put yourself in an editor's place. Ask yourself questions like 'Is this picture really good enough?' and 'Would I use a picture like this?' When examining the pictures, you might want to sort them into three separate piles:
Rejects—the pictures not to be submitted
Possibles—for closer inspection later
Definites—pictures for submission.

Picture editing, even by the photographer, is always a subjective process. In some cases, it might be a good idea to ask for a second opinion, perhaps from a fellow photographer or—if you're lucky—someone in the publishing business who is used to selecting pictures. But bear in mind that these opinions will also be subjective. In the end it is only the agency you are submitting to that will really know what is required.

For this reason, some agencies insist on seeing *all* of a photographer's work—a picture that seems boring to the person who took it might have greater marketing potential than a more aesthetic shot in the photographer's collection. That doesn't mean that only boring pictures sell—on the contrary. Many agencies look for bright, sometimes unusual, photographic approaches. However, sometimes the 'straight' approach to a subject can mean a picture has more chance of selling. Most agencies ask for a minimum number of transparencies in an initial submission—this can be anything from 50 to 500 images. There are various reasons why they require what might appear to be quite a large number of pictures. Administration costs often mean it simply is not worthwhile for an agency to take on a photographer offering only a small amount of work. Also, it is impossible to judge fully a photographer's worth on only a small number of slides, and the chances of sales from a small selection are minimal. A freelance has a much better chance of selling pictures through an agency or library if a healthy initial portfolio is supplied.

So what key ingredients does an agency look for in pictures?
Quality Technically, photographs should always be of the highest quality. That means they should be perfectly sharp, correctly exposed, and they should not be scratched or damaged in any way. An unsharp, badly exposed picture will never sell no matter how good the subject matter is—the only exception might be an exclusive news picture where the event captured is more important than any technical considerations. The artistic quality of a photograph can also be very important—the approach to lighting, composition and so on can make the difference when an agency is selecting pictures.

Travel photography for books, magazines, etc, involves more than just pretty sunsets. Activity, like in this Paris street scene, can often reflect much more about a particular place.

Marketability As mentioned earlier, the market possibilities of photographs are best judged by the agencies, since they know the buying trends among picture users. However, by looking through books, magazines and other publications very carefully, a freelance can get some idea of whether his or her photographs might be as marketable as those already being used.

Quantity As well as expecting a healthy initial submission from a photographer, an agency will also expect further regular input. It is essential for the agent to keep stocks up to date and to introduce new subjects to sell in the market. While some pictures are likely to sell again and again, new pictures are the lifeblood of any library, and it is essential for the photographer to keep the picture reserve 'topped-up' with new material. This continuous input also increases the chance of selling pictures—and making a profit.

Captions Sometimes the information supplied with a photograph can be as important as the picture itself. This is particularly true in specialist areas, such as natural history. Here, photographs may have to be captioned very fully so that particular species may be identified. It may be incomplete to have a caption saying 'Two butterflies feeding

How carefully you compose a photograph can make the difference between a marketable, or an unmarketable, result. The high viewpoint in this picture of two Chelsea pensioners shows the interesting shape of their headwear, and the intimacy of their conversation. The picture has some immediate impact, and would sell better than perhaps a straight-on portrait of the couple.

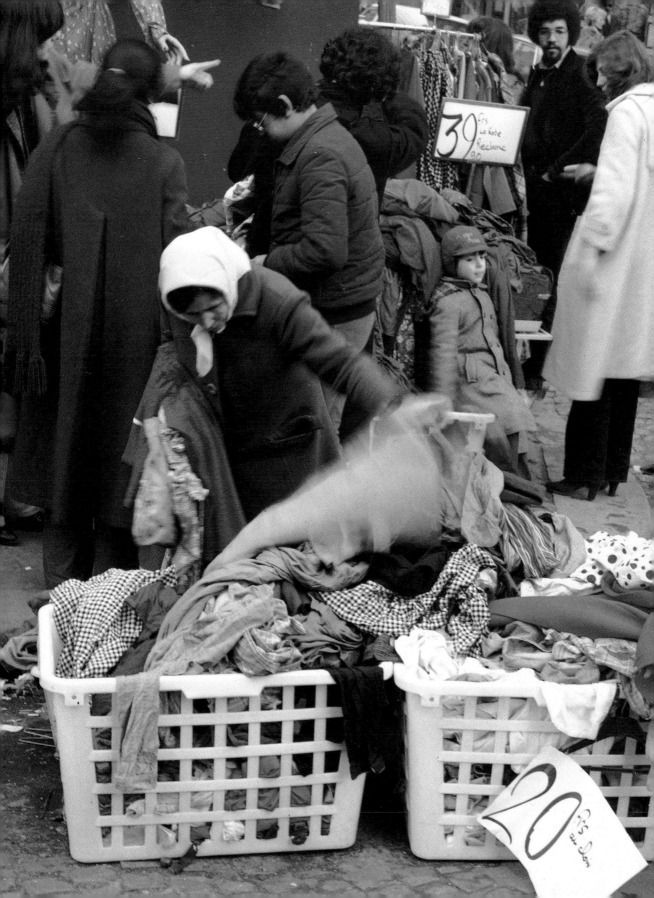

The spectacular Niagara Falls. Note how the small sightseers' boat gives some scale to the picture.

Just bored silly? An amusing picture which could be supplemented by an amusing caption if the photographer thinks it necessary.

on a flower' when more detail like 'Two tortoiseshell butterflies (*Aglais urticae*) feed on the nectar of a flower' is really needed. Of course, not all pictures need to be captioned as fully and there may be restrictions on how much information can be detailed on the transparency mount itself.

Sometimes separate caption material will have to be supplied. Technical details, such as camera, exposure, and so on, are not often necessary unless the particular agency specifies this. Much more important may be an accurate description of the subject matter itself, so that captions can be written.

Presentation

When submitting material to any agency or library, presentation is all important. Slides should be placed in transparent filing sheets (these hold around 20 35 mm transparencies each) so that they can be easily packaged, viewed and possibly filed by the agency. *Never send slides in boxes*—it is difficult and time consuming to open each box and look at individual slides. Many agencies simply would not bother, and would return the package unopened.

As mentioned earlier, captions are important. Each slide should carry your name (and address if necessary) along with any relevant picture details. Sometimes this can be written on the transparency mount or the back of the print, but it is better to write the information on an adhesive label and stick this on.

Whenever you submit material, in person or by post, always provide return postage and send by recorded or registered post. *Never* send slides in glass mounts in case of possible damage.

Terms

Most agencies and libraries have their own approaches to handling photographers' work, although many work in roughly the same way. After an initial submission has been accepted, photographs will be kept on file for a minimum of two to four years. All picture sales must be viewed in the long term and it is only fair on both agency and photographer if enough time is allowed to market the photographs properly—and to make the most of pictures that are likely to sell again and again.

After that, the freelance may be asked to submit an update to the portfolio, usually every six months or so. Material that isn't selling can be returned to you, providing return postage is supplied.

Financially, the fee paid for a photograph by a client is either split 50/50 between agency and photographer, or 60/40 in the photographer's favour. In some cases, this can be negotiated. Payment is usually made upon receipt of a cheque from the client, and a six-monthly statement is issued informing the photographer of any pictures sold.

When using agencies and libraries photographers are often confused about the rights to their pictures. As far as copyright is concerned, the photographer should always retain this—*beware of any agencies that seek to 'buy-off' your copyright.*

An agency might ask you to allow it to market your pictures *exclusively*. This can be alright in some cases, particularly in specialist photography, where sales by the photographer or another agency are unlikely. But many agencies allow photographers the freedom to place pictures elsewhere, providing that the pictures are not similar to those already being marketed.

A picture like this may reach several different markets, so be prepared to let the agency or library have your pictures for a period of time so that the picture can be widely marketed.

Picture libraries and agencies/summary

Coverage
Picture sales are mainly to the publishing markets—newspapers, magazines, books, posters, calendars, etc. Also, television and audio-visual production companies are approached. Larger concerns may have a worldwide market.

Requirements
High-quality transparencies only should be submitted. Minimum size of 120 (6 ×6 cm, 6 ×7 cm) is often preferred, although many agencies will consider 35 mm—some even accept 35 mm *only*. Minimum initial submission should be between 50–200 transparencies, plus further submissions of around 50 plus at regular intervals. Colour prints are not usually accepted. In cases where black and white prints are required, print sizes should be a minimum of 8 ×10 in—negatives may be required for production of further prints.

Fees
These can vary between £50 and £500 per sale, depending on the client. Average fee is usually around £35–£50 for colour and around half that for black and white.

PART 2:
On Assignment

Subjects

MARKETS
People
First choice
Most magazines
Second choice
Picture agencies/libraries
Alternatives
Local portraiture

There are always plenty of subjects to photograph. The challenge to the freelance is to find subjects that will make *saleable* pictures. Photographing the texture of a brick wall might be artistically stimulating to the photographer, but the subject matter is likely to be a non-starter as far as selling the picture is concerned. But if the wall features some humorous graffiti, the same picture immediately has more selling potential.

The photographer, therefore, has to be very selective about what is photographed, since the whole idea is to make pictures pay—or most of them, anyway.

Photographing people

Most photographers take pictures of people. What the freelance has to do is take pictures of people that will *sell*.

How do you do that? Well, the first step is to look into your own picture file to see what sort of 'people photographs' you already have. The chances are there might be family pictures, formal and informal portraits, candid shots, people on the street, people at work and play, and so on.

By carefully looking through your pictures, perhaps putting them into different distinct categories, it may be possible to identify a few markets. Let's say, for example, you have a file of family pictures, many of which seem irrelevant for anything else but the family album. Look again and ask yourself: is there a good portrait that might help me attract outside portrait work in the area?; or could that portrait be used in, say, a photographic magazine, perhaps to illustrate a particular technique of lighting?; or would a family-interest journal use a colour transparency showing kids at play?

This method of 'market identification' is something that any freelance should do regularly. Picture agencies and libraries work on this basis, and always try and place a particular picture in as many different markets (some of them seemingly unlikely) as they can. They work on the assumption that a photograph that sits in a filing system, without being sold to as many outlets as possible, is a dead weight. The photographer, when assessing his or her own work, *must* think the same way.

Make a list of the most likely sellers in your 'people' file alongside some of the possible outlets or uses. If you can't immediately place certain pictures with markets, don't worry—keep them aside for review later on, because a likely marketing idea might occur to you.

Formal or informal

How good or bad your pictures of people are can depend a great deal on whether or not your subjects are aware of the camera. One of the toughest ways to photograph someone is in a formal situation, perhaps in a studio, where the subject is patently aware of 'being photographed' and not at their most relaxed.

An excellent character portrait where the subject being photographed seems quite unaware of the camera.

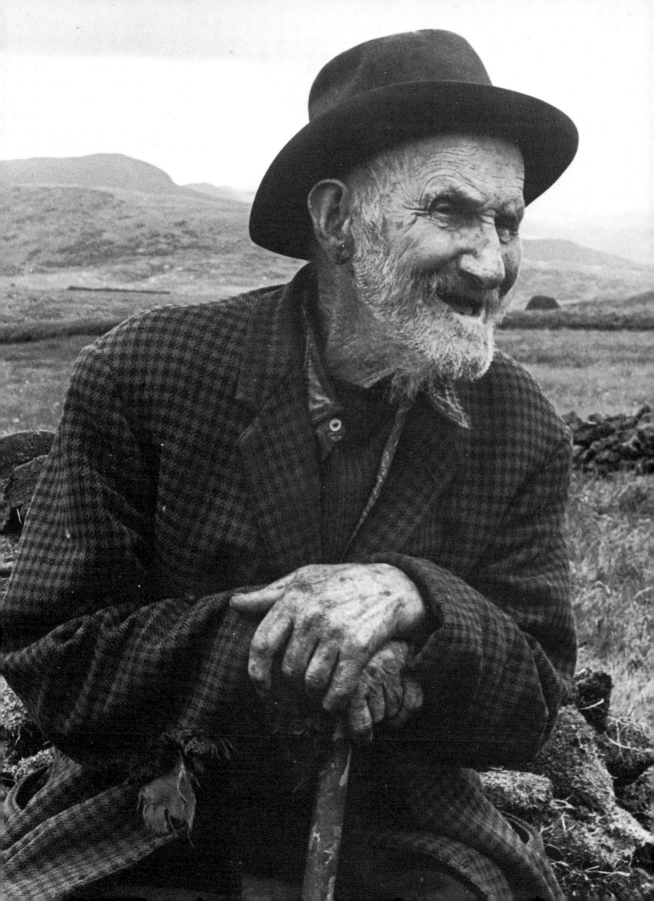

Don't always go for close-ups when photographing people. Here the photographer has taken a wide-angle approach to the shot of the cowboys at a rodeo and captured some of the atmosphere of the event in doing so.

For the photographer who has to work in this kind of controlled situation, it helps to try and turn formal into informal—by *distraction*. The whole idea is to give the person being photographed something to think about other than the camera pointing at them. This can involve keeping a conversation going on a topic of interest or playing some background music. It is also a good idea for the photographer to hold the camera and wander around with it, rather than leave it perched constantly on a tripod, aimed straight at the subject's face— nothing can be more off-putting.

With today's modern easily portable equipment, there is no need for photographs of people to be taken in the confines of a studio. People generally prefer to be photographed in familiar surroundings and a more informal approach often results in a much more pleasing set of photographs.

Useful ingredients

There is no so-called 'ideal' way of photographing someone—a great deal depends on the subject, the situation at the time (backgrounds, lighting, etc.) and the photographer's individual style and approach. Look at the work of several portrait photographers and you can gain some understanding of just how many different ways there are of shooting a portrait.

How you take portraits is entirely a matter of personal preference. But, if the pictures are for possible publication, I think there are a few useful ingredients worth including:

Character Always try to draw out a person's character when taking pictures. This may not be particularly easy, and you may need to spend time coaxing some expression. Or sometimes, character can be seen etched in the lines on a person's face.

Personality Quite often a subject may have a bright happy personality which can be expressed either facially or through some activity. Personality is very important since it can help to enliven what might be an otherwise dull 'mug shot'—so be prepared to encourage the sitter's own *natural* personality to come through.

Impact How much 'impact' a portrait has is entirely subjective, and may depend on the viewer. Sometimes the impact may already exist in the person's face, or in what they are seen doing. Occasionally, the photographer can increase the impact, perhaps by shooting from an unusually low angle to create a different effect. The picture editor will be looking for a portrait that will 'leap out of the page' and immediately catch the reader's eye.

This candid portrait, taken in New York, was shot from a distance with a long lens, allowing the photographer to capture natural expression and to eliminate any distracting background detail.
Minolta SRT 101b, 300 mm lens, 1/250 sec f/5.6, Tri-X film.

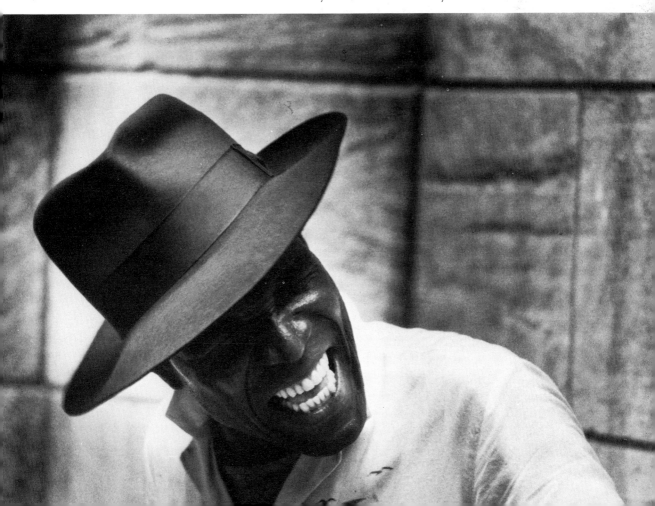

Most young children dislike posing for
photographs. Here the young child and baby
are too wrapped up in play to notice the
camera, and a good informal portrait has
resulted.

Photographing children

Children can make the most natural and pleasing subjects—provided
the photographer approaches them in the right way.

For a start, most kids dislike having formal pictures taken. Cameras,
lights and various adults coaxing smiles, can be too much to bear for
a youngster. Quite often, the informal approach is preferable and, of
course, a great deal will depend on the age of the child being
photographed. Very young children may well be oblivious to the
camera because they don't know what it is. An older child can be
more inquisitive (or selfconscious) and may want to play with the
camera first—weigh up the risks before parting with it, though! Once
discarded, you can probably proceed with the photography, since
the camera will be of little further interest to the child.

It can be a lot easier to photograph children if they are involved in
some activity, like playing with toys or drawing. If a child's mind is
fixed on completing a task, he or she is unlikely to be distracted by
you taking a few pictures.

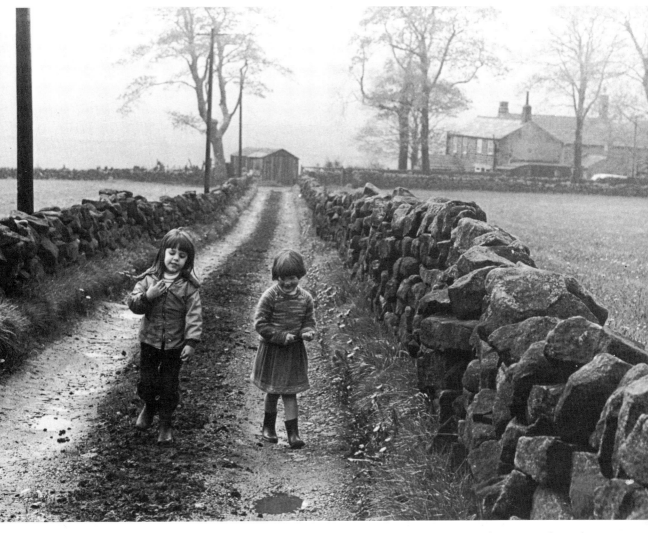

Children in their own environment will often look more natural and relaxed than in the more formal setting of a studio.

For the best candid-type shots, it is easier if you can shoot from a distance, using a long telephoto or zoom lens. Try and use natural daylight, as this will be much less distracting than flash, which always grabs the subject's attention.

Children are capable of a variety of different expressions, ranging from giggly laughter to relentless crying. This range of expression can probably be caught over a period of time, building into an interesting sequence of shots.

When thinking about the possible market for kids' pictures, look at various publications to see what sort of shots are being used. The photographer should avoid too many 'coy' shots—pictures of kids involved in something active are often much more interesting and, therefore, saleable.

An example of a famous face in the crowd—Bertrand Russell—at a peace demo in the sixties.

Famous faces

A lot of part-time freelances look enviously on their Fleet Street counterparts, mainly because they always have the opportunity to photograph famous people for their newspapers.

Of course, it is part-and-parcel of the job for a top press photographer to take pictures of royalty, film stars, celebrities, and other well-known people. But it need not be beyond the realms of possibility for a keen freelance to secure pictures of some well-known faces.

In many areas, events are staged that attract the presence of some well-known person. For example, the opening of a new shopping centre might well be performed by the Queen, or another member of the royal family. At such an event, the press and TV cameras might have a privileged position to record the opening, while the 'unofficial' freelance may have to be content with taking shots from the crowd. This need not always be a disadvantage—by arriving early before the crowds and choosing a good position, some perfectly good shots can be taken.

Where the exact movements of the royal visitor may be unknown beforehand, the photographer must be prepared to work quickly. Stuck in a crowd, it might be impossible to move around to take pictures, so the freelance may have to rely on taking a lot of shots in succession in one spot. A zoom lens (say, 80–210 mm) is useful to frame the subject in most cases, and a motordrive or autowinder fitted to the camera helps when shooting a fast sequence of pictures. Focusing and exposure measurement might be possible beforehand, saving valuable time when the action starts.

Sporting events, galas, festivals, fêtes and carnivals all attract well-known faces from time to time—particularly when they have been organised for charity. Stars from sport, television or from the film world quite often attend to add their support to a good cause and they are usually quite happy to let photographers take their pictures at these events.

These sort of events are usually well publicised, either in the local or national press, or on posters, and a freelance with a keen interest in photographing famous faces should keep an eye out for notices.

In some cases, the press photographers coax the person involved into doing something unusual for the cameras, to make a more interesting picture than just a straight mug shot. For the freelance who isn't used to doing this kind of work, leave the professionals to arrange the 'set-up' pictures, and perhaps take a few shots yourself— *without* interfering with what they are doing. But watch how they do it. More experience in this field will help you to tackle it with confidence in the future.

Go for lively active pictures if you possibly can, rather than just candid facial shots. If you are intending to sell pictures to local newspapers and magazines try and include some local people with the visiting celebrity.

In this shot the Prime Minister is the key subject, but a better picture would have resulted if the man's face had been visible also.

Including local people talking to a royal visitor can make pictures more appealing to local press, trade magazines, and so on.

Avoid the obvious venues to take photographs. Here the photographer has found more to Paris than the Eiffel Tower.

Travel

From a freelance point of view, travel photography has to be more than snaps of the Eiffel Tower, or Buckingham Palace or the Taj Mahal—they can be left to the picture postcard experts. There are many more aspects that a freelance can be concerned with that will yield more interesting, and profitable, pictures.

The important thing to remember about travel, either at home or abroad, is that first impressions can often steer the photographer away from other aspects of a particular place. By all means shoot the interesting architecture or scenic views that may be familiar on the tourist track. But buyers of travel pictures—agencies/libraries, brochure manufacturers and magazines may be more interested in some of the *non-tourist* aspects. These can include how the people live and work, the general lifestyle, art and culture.

There is no definitive approach to travel photography. Some freelances might set out with a definite goal in mind, perhaps to record how people in another area live, or even to depict unusual architecture in detail. Other photographers, faced with the 'unknown quantity' of a strange country, might have to keep more of an open mind about what should be photographed until arrival.

Whatever approach you decide to adopt, be prepared to make the most of your time in an area. Some places are at their very best around dawn, when very few people are around and the light has a distinctive quality, or around the end of the day when there can be a spectacular sunset.

With some careful planning, the freelance may also be able to arrange a trip to a country when some special event, such as a carnival, is being held. If the number of picture-taking assignments can be planned or organised beforehand, the freelance can make the best use of the expense money spent on a trip. In some cases, it can be a good idea to outline some proposals to a few publications to see if any are willing to commission any pictures from you before you go. Or they might be prepared to offset some of the film costs if you offer them 'first refusal' on your pictures. Details of itinerary and what you intend to cover should be supplied.

Away from your home base, as you are when travelling, you must ensure that you are as self-contained as possible in terms of film and equipment. Film is not usually impossible to replenish if you run out, but it might be difficult to find your favourite brand, so take more stock than you will probably need. Decisions about equipment can be more problematic, and a lot depends on the type of photography you are interested in. It is easy for the freelance to try and cover himself by taking every conceivable piece of equipment for fear of missing a 'once in a lifetime' shot. A close look at the work of many well-published travel photographers, however, will reveal just how often a 50 mm or 135 mm lens is used.

Tips for travelling abroad

Travel light Do not take too much equipment. Make the best use of one or two lenses (zoom lenses are most useful) and avoid bulky accessories.

Take enough film In most cases it can be cheaper to buy film here than abroad. Processing is best left until you return, although some countries do offer fast and competitive service. Check beforehand if possible (foreign photographic magazines can help).

Pack equipment properly Use protective camera and lens cases where feasible. When travelling by plane try and take equipment with you as hand luggage.

Look after film In hot places try and keep film cool. A hotel may be able to keep most of it in a fridge while you take a few rolls out with you, or take a special cool-box.

Avoid putting exposed film through airport X ray machines—while many are low-dosage and should not affect film, it is a wise precaution to ask for a hand search, which should be allowed. Take film out of the camera in case it is opened for inspection.

Even a busy city like Venice has its quiet moments. Early morning can be the best time to take pictures, or the end of the day when the crowds have disappeared.

Buildings and architecture

The photography of buildings and architecture can be a fascinating area for the freelance to explore. Start by looking at the possibilities in your own area. Could you photograph a pub and sell the pictures to the landlord? Would the local church vicar be interested in some interior and/or exterior shots of the building? Perhaps an historic society would be interested in shots of local landmarks? Do some research at your local library, or consult tourist board literature. There may be a number of possible sites, but you may have to apply for special permission to photograph some—*always* check first.

Local libraries and museums often keep their own files of photographs of local places of interest, and it is likely that they would be interested in having copies of shots you may have taken. Some photographers have even been able to mount exhibitions of photographs depicting landmarks in an area, and some local authorities might be keen to help with such activity.

On a wider scale, picture libraries and agencies who deal in shots of buildings and architecture rely on freelance contributions from many different areas to ensure good geographical coverage. A photographer who spends a lot of time photographing buildings in an area is likely to have a good selection that may fill gaps in the agency's files. County magazines, tourist guides and other publications might also be interested in shots of local architecture.

Approach

The important thing to remember when photographing any building is to avoid the obvious shot. By all means take a straightforward picture of the building 'for the record', but try taking pictures at different angles, perhaps fitting a special lens (such as a wide-angle).

As well as looking at the whole building, don't be afraid to move in close to record detail, such as a delicately shaped window or an engraving in the stone. In most architectural shots, backgrounds are unlikely to prove too much problem, but look out for any unwanted distractions, like a tall industrial chimney apparently rising out of the roof of an historic house.

Foreground is much more important—what you include in front of the building can make or break the picture. Avoid 'clutter' if possible, such as parked cars, dustbins, and so on. Sometimes the introduction of extra foreground detail, such as an overhanging tree branch, can enhance an otherwise mundane building profile. Quite a few pictures may have to be taken before you get the one you want.

The time that you actually decide to photograph architecture can be very important. A stately home photographed in spring sunshine is likely to look very different when shot in winter snow. The time of day you take pictures will also determine the direction of the light—important when you want to emphasise structural detail. Sometimes a picture of a floodlit building can be much more effective than one taken in normal daylight.

Right:
In some cases, the interior of a building can be just as visual as the exterior. This picture of Winchester Cathedral shows excellent detail and has good visual impact.

Opposite page:
A careful composition including both old and new elements of architecture.

The photo-journalist might expect to produce
feature-type pictures like this one. Since
photo-journalism is largely about telling a
story by pictures, it is important that the
character of the subject(s) comes through.

Photo-journalism

Photo-journalism cuts across a very wide spectrum of photography,
from news to sport and from royalty to fashion. A press photographer,
or photo-journalist, because of the varying nature of the work, usually
becomes a 'jack-of-all-trades'. He might have to turn his hand to
photographing a major news event, or photograph a visiting poli-
tician, or cover a sporting event—sometimes during *one day*.

Versatility is the key to successful photo-journalism—you have
to discipline yourself into getting a good, publishable picture from
practically any subject. As the title implies, a photo-journalist should
be able to tell a story, or at least part of a story, in pictures. To work
in this field the photographer will need some photographic know-
how, an 'eye' for a good picture, confidence and determination—

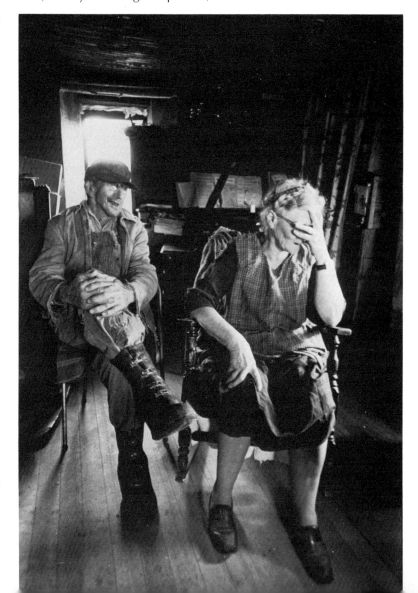

Many photo-journalists produce feature-type
material that may be of interest to various
outlets. Coverage of traditional events, like
this morris dancing display, can produce
saleable pictures.

Photo-journalism can involve coverage of local events, like the shot here of hop-pickers.

Assignments in troubled areas may not appeal to many freelances, but such work has to be undertaken by some photographers—usually professionals. This picture of a hijacked lorry was taken in Northern Ireland.

and a certain amount of luck. What *isn't* needed is tons of equipment—quite often, a photo-journalist needs to be able to move around quickly and unobtrusively. Therefore, it is better to have just a camera body and perhaps one or two useful lenses.

Finding an idea

Unlike the newspaper staff photographer, who might get most assignments via the paper's news or picture desk, the freelance photo-journalist is on his own. Therefore, picture stories either have to be found and even, in some cases, created.

How do you find ideas for pictures? There are two basic methods:
Read a lot On the surface, most local papers may not seem very exciting—but it is surprising just how many stories can be tucked away inside that can produce good pictures that perhaps the paper has missed out on, or ignored. The advertising columns or notices can be the best source of picture ideas. For example, you might find

107

A good knowledge of a sport can help the photographer to decide when and where to take the best pictures. Here the scrambler was captured on a bend, with the mud flying from the wheels adding to the excitement of the picture.
Nikon F3, 500 mm mirror lens, HP5 film.

out that two twin sisters are getting married on the same day, or that someone is selling a boa constrictor, or that someone has an unusual hobby. Take a notebook and scour through your local paper and follow up on any items that appear picture-worthy.

Personal contact It is an old journalists' adage that the local pub is the best source of stories. When people meet and chat sometimes snippets of local gossip can lead to good news stories and pictures. In fact, such information can arise simply by people talking to one another anywhere, and it is very important for the freelance to keep in touch with the locals and chase any worthwhile leads.

As well as finding stories that are already there, the freelance can sometimes create a picture idea. An example might be a picture linked to a seasonal event, like Christmas or Easter. What about a Santa Claus delivering presents door-to-door on a new estate of houses without chimneys, or a little girl with an Easter chick from the local farm perched on her finger? Note down as many ideas as come into your head, no matter how weird and wonderful they are. You can then go through the list later and decide which ideas are practicable, and who might be interested in the pictures.

News

One of the top freelance photo-journalists in the country, Terry Fincher, once described news photography as being 'like a wonderful Irish stew—all the ingredients imaginable are thrown in!' How true that description is.

News photography goes on at all levels, from local to international. A local freelance might be producing pictures for the local paper, whereas a Fleet Street operator will be more concerned with publication in daily national papers. But because news can happen anywhere and at anytime, even the local photographer can find himself taking pictures of a news event of national, or even international, interest.

Pick up a few different newspapers and magazines and you can see the breadth of news coverage. A great deal is obviously related to individual publications and the sort of news stories they carry. A magazine, for instance, will have a very different news and picture output when compared to, say, a local paper.

Features

Unlike news work, where often the story can be told in a single picture, feature photography involves a more in-depth approach, perhaps including a sequence of pictures.

A photo-feature can well have a news angle, of course. It might be a local celebrity profile, with a series of portraits, or a feature on the local football club, with shots of players on and off the field, groundsmen, fans, and so on. The photo-feature gives the freelance more breathing space than a quick-shot news picture. There is also the assignment discipline of providing an interesting, and often varied, selection of pictures on a theme.

MARKETS
Sports
First choice
Publications on specialist sports
Second choice
Local press
Alternatives
Sporting organisations and clubs, competitors, photographic magazines, sports picture agencies

Sports

Sports photography is as exciting as it is challenging. Sport itself covers a wide and diverse range of activities, from badminton to football, from swimming to basketball. Within this very wide scope, there is plenty of opportunity for the freelance to operate.

A freelance sports photographer can actually have a lot in common with an athlete. In order to get to know a sport, and how to cover it, a freelance has to do some 'training' on a local level, taking pictures at local sporting events of his or her choice. In this way the freelance can become 'match fit', knowing what equipment to use, the right positions to shoot from, how to anticipate good shots and how to avoid mistakes made at previous events. Like the athlete, the freelance has to aim at improving technique all the time, and use the resulting pictures to 'qualify' for even bigger events in the future.

This gradual build up is important for any potential sports freelance. An apprenticeship is essential to help the photographer learn the craft of sports photography, as well as compile a portfolio of winning pictures that will hopefully secure further work in the future. It also takes time and tenacity to build up a string of contacts—from sporting organisations, managers and competitors, to sporting editors and other picture buyers—who will all be vital to your existence as a sports freelance. How long does the apprenticeship last? Well, as with any such skill, you never stop learning.

One way to start your sporting activity is to approach a local club and offer to take some pictures. They will probably be delighted with your interest and they may be able to find use for your pictures, perhaps as publicity material. Competitors might also want to buy pictures of themselves in action. Approach the local paper with pictures of current sporting events—they might be interested, particularly in more obscure sports that are not often covered.

One well-known sports photographer started by offering to cover the local football team's matches every Saturday—home and away—for the local paper. After a while he was asked to cover other important matches and, through constant hard work and determination, he established one of the most successful sports agencies in the country. *So it can be done.*

The market for sports pictures has grown rapidly over recent years, with many specialist publications—covering everything from golf to fishing—appearing on the newsagents' shelves. This is good news for the freelance since most of these magazines use plenty of pictures and, for those operating in specialist areas, they can provide an opportunity for regular output. With few exceptions, these magazines rely solely on submissions from freelance contributors. A photographer who can provide good, up-to-date material, is likely to be welcomed by any specialist sports magazine editor.

There are also sports picture agencies serving newspapers, magazines, books and posters. Most have their own photographers, occasionally using freelance material of lesser known sports.

Right:
The grit and determination of the competing runners comes through in this tightly composed picture, taken at an athletics meeting. The use of a long lens has made close-up detail possible, with the background thrown out of focus.

Opposite page:
'Reach for the sky.' A clever composition where the pole-vaulter is photographed superbly in isolation, without any background distraction to spoil the impact.
Cosina CS2, 35 mm lens, FP4 film.

Opposite page:
A great climbing picture, capturing the skill and daring of the climber and the breathtaking Snowdonia landscape.

Below:
High-flying action as this water-skier rises into the air. The peculiar angle of the skis adds to the impact of the shot.

Adventure

The freelance who really wants to be stretched beyond so-called 'run-of-the-mill' work can go into one of the adventure activities, like mountaineering, ballooning, hang-gliding, and diving.

There are two ways you might start. If you are already involved in some adventure activity, with photography perhaps as a second interest, you are in a unique position to produce very out-of-the-ordinary shots. For example, if your interest is mountaineering, the chances of you taking some great shots on various climbs must be better than those of a photographer who has never climbed before. Therefore, you can channel all of your knowledge of the sport into producing good pictures.

If you are a photographer first, but have a secondary interest in one of these activities that you wish to take pictures of, it might be necessary to do your homework first. The first stage might be to contact the secretary of a local club or organisation who can help and advise on the likely photographic problems involved. Incidentally, they may be interested in having some pictures of their activities, and may be quite keen to get you involved.

If possible, read up on the subject, talk to as many participants as possible, and decide whether photography is feasible. In some cases it will be advisable—even essential—to take a training course first, particularly if you might want to take hang-gliding pictures while in flight yourself, for example. *Never rush into any dangerous activity without proper training, just for the sake of a few pictures.* If you take the matter seriously, the chances are you will be safer—and get better pictures in the end.

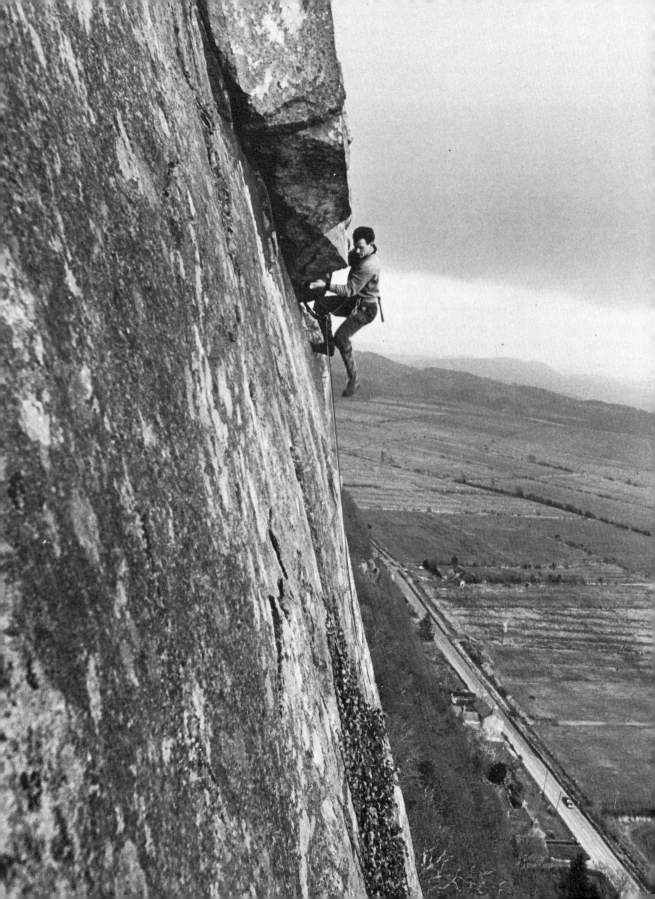

MARKETS

Animals

First choice
Agencies/libraries dealing in
animal photographs

Second choice
Specialist publications (wildlife
magazines, club or society
journals)

Alternatives
General-interest magazines
(especially for one-off humorous
pictures), photographic
magazines, calendar and poster
companies, greetings card
manufacturers. Market
possibilities also include
photographing domestic animals
and selling pictures direct to
owners

Animals

In the freelance market there are probably more pictures of animals sold than of practically any other subject. Animal photographs can be found in magazines, books, on posters and calendars—and even on chocolate boxes and biscuit tins. Of course, animals come in all shapes and sizes, and many freelances have an interest in photographing specific types of animal.

Domestic

Some freelances make a reasonable income from photographing domestic pets for their owners. This type of 'pet portraiture' is particularly popular among breeders, owners of show animals and kennel keepers. Sometimes the freelance photographer can make some useful contacts through local clubs or societies, or by attending shows and competitions attended by owners with their animals.

Most domestic animals are best photographed at home—unfamiliar surroundings can make the subject nervous and the photography difficult. Sometimes an enclosed outdoor location, like a garden, can be the best and most natural surroundings for the animal, and some pleasing results are possible. Depending on the size of the pet, the photographer may have to shoot from a low angle and be prepared to move around, so the camera is best hand held rather than mounted on a tripod. For small animals, a camera with a waist-level viewfinder can be useful. Indoors, a formal set-up can be used with flash as the main lighting—in most cases this should not be disturbing to the animal and will be infinitely preferable to using hot tungsten lamps.

Whatever the situation you shoot in, spend some time beforehand with the animal and let it get used to you before taking any pictures. Always have the owner, or someone else, to look after the animal and keep it in place while you take the pictures. Make use of 'props'—a ball of string or a ball, for example—to keep it occupied and help achieve a range of expressions. Remember bright, lively—and often humorous—pictures will always sell.

Zoos and parks

Photographing wild animals in natural surroundings is often out of the question for many freelances—so the best compromise can be a trip to the zoo.

Many wild and exotic species, from all over the world, can be photographed quite easily at many zoos. In some cases, the introduction of more open enclosures, rather than wire cages, has meant much easier viewing—and better pictures.

In most enclosures the public obviously has to be kept at a reasonably safe distance from the animals, so the photographer is well advised to take a long telephoto or a zoom lens, in order to take pictures in close-up detail. Active animals make far better pictures than sleeping ones, so choose the time of your visit carefully—the monkeys' feeding time or elephants' bath time, for example.

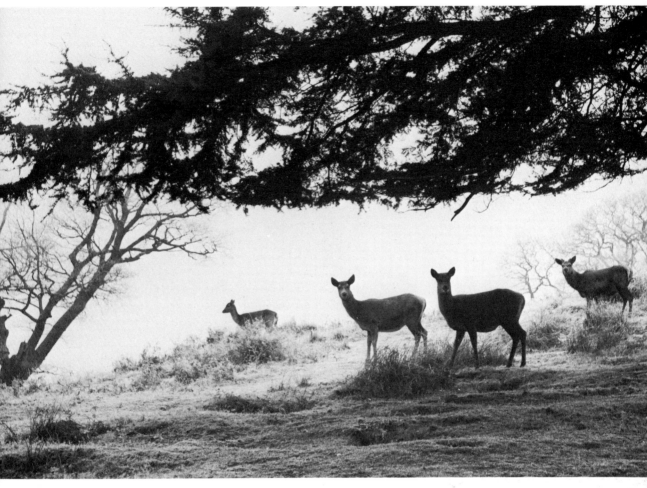

Above:
These red deer were photographed in natural surroundings in the quiet early morning, with mist and frost adding extra atmosphere.
Rolleiflex, 80 mm lens, 1/250 sec f/5.6, Tri-X film.

Opposite page:
Zoo pictures can be a problem when there are cages. The problem was overcome here by placing the lens against the wire fencing and using a wide aperture, thus making the wire so out of focus that it was unnoticeable in the final result.
Canon A-1, 250 mm lens, 1/125 sec f/5.6, Tri-X film.

Where cages are used, you can avoid including the wire in your pictures by using a long lens close to the wire and a wide aperture, making sure the subject is a reasonable distance from the wire. By focusing on the subject, the wire will be so out of focus as to be almost unnoticeable in the final photograph.

Most zoos don't permit the use of flash in case this disturbs some of the animals.

To capture pictures of wild animals in more natural surroundings, it can be worth visiting a wildlife safari park. There are several dotted around the country and subjects include monkeys, zebra, lions, tigers, camels, and some also have aquatic animals. The problem here is that the photographer might have to take pictures through the car windows, since it is usually forbidden to open them with wild animals around. Try and clean all the windows thoroughly before you enter the park and, when taking pictures, reflections can be avoided by placing the lens against the glass (it helps if a lens hood is fitted).

115

Nature

Nature photography is possibly one of the most specialised areas for a freelance to operate in. Because of the skill and technique needed for some aspects of this work, it does not seem an immediately attractive proposition for earning spare-time cash.

Certainly, many of the top nature photographers have spent many years perfecting their skill, and then *graduated* to selling their work. In such cases, freelancing is almost an afterthought. So what the specialist nature photographer has to do is work hard at the photography side first, and develop the necessary techniques involved *before* trying to sell any work. This will take time and practice, but it can be worthwhile in the end.

Quality

If you look at the work of top nature photographers, like Stephen Dalton or Heather Angel, the first thing that is immediately striking is the *quality* of the photographs. They are always pin-sharp, show excellent colour rendition, and the detail is so fine that whatever has been photographed seems to leap out from the page.

Of course, such photographers have worked long and hard at their craft, often using, and even designing and building, specialised equipment—but not always. Quality photographs of certain subjects are quite possible using little else than the standard lens on a camera.

Many nature photographers produce better results within a controlled studio-type environment. The iguana here was in a glass enclosure and photographed using flash. *Yashica FR, 85 mm lens, electronic flash.*

This picture of a butterfly on a finger gives an indication of scale although, in most cases, it would be better to photograph such an insect in a more natural environment (feeding, flying, etc.).

Subject

Nature photography can be broken down into many subject areas, including landscape, trees, flowers, animals, birds and insects. Many photographers choose to specialise in one subject, while others prefer to cast their nets wider afield to include other subjects.

Which course you take is a matter of personal preference. The important thing is to *know your subject*. Some advance knowledge, gleaned from books, magazines, or photographers already working in this area, can help a great deal when planning when and where to shoot. You will also be able to differentiate between species if necessary, and this can help when labelling pictures. Most picture libraries that consider taking your work will insist on subjects being identified, so bear in mind this very important aspect when compiling your portfolio for submission.

MARKETS

Landscapes
First choice
Photographic magazines

Second choice
Picture libraries/agencies

Alternatives
Card and calendar
manufacturers, books, poster
companies, Sunday
supplements, local magazines

Landscape

It is probably true to say that anyone can take a snapshot of a landscape view—you are sure to have done so yourself when travelling around on holiday or business.

But as a freelance trying to sell landscape work, a great deal more thought has to be given to the subject and how it is tackled. There is no point in simply taking the camera out, pointing it at the view, and hoping for a great landscape picture—in most cases, that approach simply won't work. More care will have to be taken if the pictures are to stand any chance of selling.

Subject

What landscape area you choose to photograph is very important. A shot of a bland, uninteresting plateau might have very little impact photographically, despite the efforts of the photographer to make it more interesting.

Look for *shape* in a landscape. Note how the land lies, and how trees and bushes blend. What you will be looking for in most cases is a blend of many different elements that will work together to produce an interesting and cohesive landscape shot.

When shooting in black and white, bear in mind that the colours you see in a landscape will be converted to various shades of grey in the final picture. Therefore, the subtle colour differences between various greens and browns may well be lost, and the final picture can be too much of one particular tone. Look for variation and outstanding shapes, such as trees, to break up the tones and give depth to the shot.

In colour, the problem can be creating a landscape picture that is not too chaotic—for example, when there is too much of one colour, or there are colours that do not blend. Of course, there are situations where this is desirable because it does look odd. Either way, the photographer should look carefully at the results later and see which landscapes have worked successfully on film, and which haven't.

Viewpoint

There is a temptation to shoot a landscape as you first see it, but that viewpoint may not necessarily be the best photographically. When taking pictures in a valley, for instance, ask yourself if there is a better viewpoint, perhaps from a nearby hill looking down.

Sometimes, the foreground detail—like a ragged bush or an old fence—can detract from the main view, so a change of viewpoint might help to eliminate the problem. Or the photographer can use a longer lens to take in more distant detail of the landscape. Backgrounds can be just as important—watch out for annoying telephone or electricity wires 'cutting through' the shot, and avoid any other distractions that do not fit in with the overall composition. In many cases, a simple, uncluttered picture works best, and will usually have more chance of selling.

Ominous cloud formations, emphasised by the use of a filter over the camera lens, compliment this moody picture of a snow-capped summit.
Bronica EC, 75 mm lens, yellow filter, $\frac{1}{2}$ sec f/22, FP4 film.

This landscape in China has several 'layers' to it, making it much more interesting visually. The man with the animal crossing the water also adds to the picture and gives it some scale.

A gentle waterscape taken with the sun low in the sky (note the highlights on the water).

Timing

Invariably in landscape photography it isn't always what you photograph, it is also *when*. Choosing the right time to take a photograph of a view is important, and can determine the final impact of the picture. For example, a scene photographed in spring sunshine will look very different in winter snow. And the early morning mist rising over a field will give a very different impression when compared with the same view photographed in noon sunshine. And since the colour temperature of the light can change drastically during the day, a photographer will have to take this into account when shooting, depending on the rendition required.

Human interest

A lot of photographers make the mistake of creating landscapes that appear totally lifeless. As a freelance you should try and make your landscape pictures *live*—and the easiest way to do this is to include someone in the shot.

This might be someone riding across the brow of a hill, or a farmer ploughing a field, or someone walking in silhouette against a warm sunset . . . in fact, anything that gives the shot some human interest. This might not work with *all* landscapes, and you may feel a particular view is best left without any human intrusion. If in doubt, try shots with and without someone included and see which works best. But you may find the addition of a subject will help the picture sell.

The photographer took this New York cityscape in the early morning, with the Statue of Liberty dominating the Manhattan skyline.

Lighting and film

With all stage photography, problems often arise over the type of lighting and film to use. Avoid flash if you can, particularly at live shows where this can be a distraction for both performers and audience.

Most stage lighting is more than adequate for today's modern fast films. A 400 ASA or even 1000 ASA film is the best choice, and this might be uprated in very low light. When shooting colour, bear in mind that many theatres use tungsten lighting. If so, a tungsten-balanced film will be needed—or you can use a daylight-balanced film with a correction filter. In some cases it will be worthwhile experimenting with mismatched film and light source in order to secure out-of-the-ordinary shots, but not on an important assignment.

At this wrestling event, the ropes are a distraction in the picture. In most cases the photographer can shoot under the bottom rope for unobstructed shots.

This picture was taken under normal stage lighting. Quite often a slow shutter speed has to be used in certain low-light conditions and, by capturing the dancer at the top of the jump, the photographer has minimised the risk of a blurred image.

Stage photography

One of the attractions of stage photography lies in capturing some of the visual excitement of a show—live performances can generate some excellent photographic opportunities.

So how can the freelance get into it? Well, it helps if you can identify a particular area of stage photography that you would be most interested in covering—perhaps rock music concerts, stage plays, or musicals. Then see if you can make a start on a local level by approaching bands, theatre companies or operatic societies that may be prepared to let you follow their activities and take pictures. Ask friends or colleagues involved in local entertainment if they can secure any picture-taking opportunities for you.

In many cases, a positive response may be forthcoming because publicity, especially through pictures, is an essential part of the entertainment world, at *any* level. If you can take reasonably good shots, and make them available for publicising a particular stage show, you should have little problem working in this area.

Plays and shows

If you want to cover local stage productions, approach the organisations involved—you may be able to find out details from the theatres concerned, or your local library should have a list of them. Ask the producer, or person in charge, if you can come along to rehearsals and take some pictures—you might even ask if they need any for posters, programmes or foyer displays. Players themselves may be interested in purchasing photographs for their portfolios.

At first, most productions are unlikely to be very visually exciting—rehearsals might take place in a drab backroom somewhere. The

Not all stage photography is done in theatres. This picture of a brass band concert was taken outside using natural daylight.

costume rehearsal is usually the best time to take pictures or, better still, a special photo-call can be arranged where the photographer can take all the necessary shots in front of, and even on, the stage. Special moments from the production might also be 'mocked-up' for the benefit of the camera.

Concerts

In the case of most live music shows, the photographer may not be able to take any pictures at a rehearsal and may have to take all the shots 'on the night', usually down in the orchestra pit in front of the stage.

With many well-known acts, the biggest problem is getting permission to take pictures in the first place. For various reasons, concert promoters often restrict the number of photographers at a show to the local and national press, music papers, and possibly one or two recognised freelances. A great deal depends on the act, the promoter concerned and the venue.

You should be able to approach the promoter (the theatre may be able to supply details) for a photographer's pass, but be prepared to be persuasive—they might even want to see pictures already taken, or some evidence of previous work in the concert field. In some cases, you may just receive a polite *No*—some promoters are often inundated with requests from photographers, particularly for some of the bigger concerts. Keep to the smaller, less-well-known artists and venues at first, and gradually build up your own portfolio and contacts in the music promotion business—they might be of help later on.

Circus action like this can easily be captured from the edge of the parade ring.

Humour

For a freelance who is interested in selling 'one-off' pictures, rather than portfolios, humour can be one of the best subject areas to try.

So what makes a humorous picture? Well, it might be an odd road sign, or an animal seemingly 'pulling a face', or someone streaking in the snow . . . in fact, anything that is funny or unusual enough to make people smile.

Many magazines and newspapers use funny pictures, often as light relief amongst all the normal written matter. In most cases, the picture is 'self-contained'—it tells its own story without the need for explanatory words (except perhaps a short caption).

There are two basic ways of taking humorous pictures—by chance or by planning. A lot of funny things happen quite by chance, and it is up to the photographer to catch the moment there and then. The only preparation the photographer can make is to take a camera, ready-loaded with film *everywhere*, so that any funny or unusual happening is not missed. Of course, the photographer must also keep a watchful eye on everything going on—sometimes the funniest things are not always the most obvious.

But it is possible for the photographer to plan humorous shots rather than rely on waiting for them to happen. Try going to events where some humour is likely—kids' parties, carnivals, street fairs, fêtes, and other similar activities can all yield their funny moments. Bear in mind that children in particular are often the best source of

A good humorous picture should tell its own story instantly. Funny pictures like this can be timeless and could sell successfully to a variety of publications, time after time. The only aspect that could 'date' this picture is the newspaper on the bed.

SHEEPSKIN
RUGS
JACKETS
SUEDES ETC

OPEN →

A funny situation that any photographer might stumble upon. Keep your eyes open for unusual signs like this. Sometimes if a picture isn't immediately obvious, or does not happen naturally, consider setting one up with a humorous theme.

humour because they often seem to do funny things quite naturally. Sometimes a freelance can set up a humorous shot by applying a bit of imagination.

The first requirement is a good idea. The photographer might think some aspect of news, like very bad weather or a train strike, can provide the possibility of a funny picture for a newspaper or magazine. For example, one freelance realised that many of his neighbours would have trouble getting to work during heavy snow, so he arranged for one of them to try skiing—that picture made the front page of his local evening paper, and he received £25 for his idea plus the very valuable publicity.

The second requirement is to make the set-up shot seem as natural and unposed as possible. This can be done by asking the subject to act as if unaware of the camera so that the shots look candid. It can help if the photographer uses a long telephoto lens, thus candidly 'dropping in' on the shot from a distance.

Photographs of people involved in various activities might be found at a local arts and crafts centre or college.

Look for leisure activities 'in the field'. This lady was spotted painting a landscape while the photographer was touring the Cotswolds. *Leica M4-2, 50 mm f/2 lens, FP4 film.*

Hobbies

Most people have a hobby or part-time activity they enjoy. Just as your interest might be photography, others may be involved in stamp collecting, sailing, hang-gliding or gardening.

Of course, nearly every major hobby or pastime attracts a large following, and clubs, organisations, and even magazines, arise out of this interest. Therefore, the opportunities may be there for the freelance to sell pictures to some of these outlets.

Your own hobby

You may not need to look any further than your own hobby or interest for freelancing possibilities. If photography is your main pastime, perhaps you have some interesting photographs showing ideas on technique that could be passed on to a photographic magazine or book publisher. I recall one freelance who was involved in building his own darkroom at home—he took pictures of the project taking shape at each stage and submitted a photo-story to *Amateur Photographer*. It was published and the fee he received helped to subsidise the project.

If you have an additional interest, such as old steam locomotives, photography is an ideal way of enhancing that interest. In this particular area, a lot of people combine photography with a detailed knowledge of steam trains to produce pictures that might be suitable for magazines, books or posters.

Get involved

There are likely to be plenty of opportunities in your own area for photographing people involved in various hobbies. Try approaching a few clubs or societies, and ask if they would like any photographs taken, perhaps for publicity or other uses. Libraries usually have a list of such organisations.

Also, look out for individuals who perhaps have unusual hobbies that might be newsworthy. One freelance managed to find someone in his area who kept pet lions, and the pictures he took sold to local and national press, and to a few magazines, including *Titbits*.

The important thing for any freelance to do when photographing other people's hobbies is to *get involved*, and to show those concerned that you have a real *interest* in what they are doing—otherwise they might think you are trying to 'cash-in' on what they may consider to be a worthwhile pastime. Beware of trivialising anything—some hobbies are naturally humorous, and this can be reflected in your pictures. Providing you don't give people the impression you are trying to make their hobby look silly, you should always receive welcome cooperation.

And if you do manage to sell some photographs for publication, always try and provide a few free prints to the people who helped you with the pictures. This shows you appreciate their cooperation, and creates goodwill for any future ideas you may have.

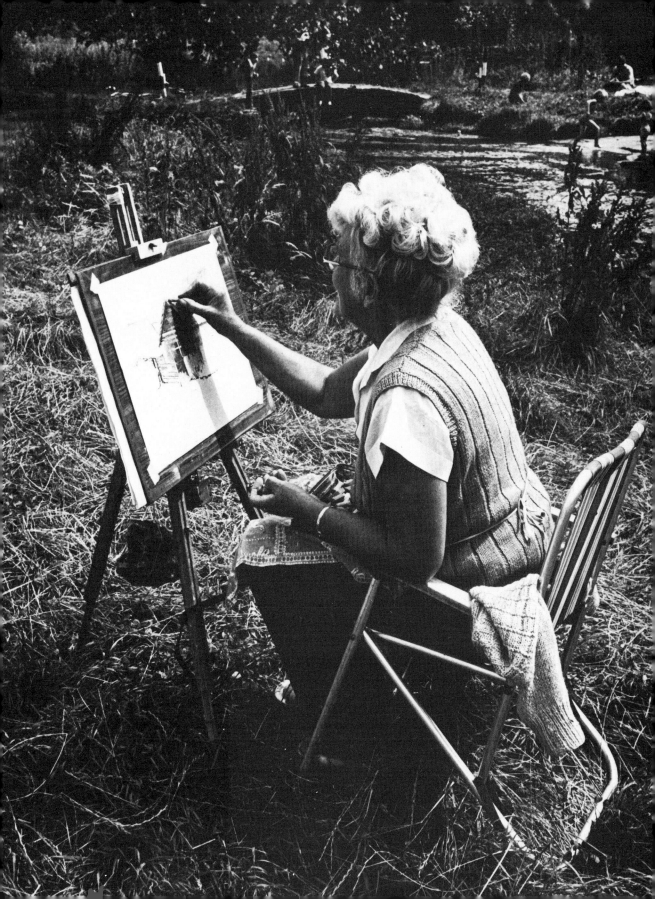

Glamour photography

To many freelances, the prospect of tackling glamour seems . . . well, *glamorous*. But while it might be easy to imagine yourself shooting a spread for *Playboy* in your own studio, or photographing girls for a glamour calendar in some far-off exotic location, the reality of doing this kind of work is usually somewhat different.

Good glamour photography simply cannot be created overnight. As with many other areas of photography, you have to put a lot in to get anything out. No single element makes a good glamour picture—what is needed is a combination of different elements which must blend to achieve the required result.

Experience It is perhaps no surprise that some of the best glamour photographers have worked for a number of years to achieve their success. Every freelance in this field must gain the necessary experience and, more importantly, learn from mistakes—and you can expect to make plenty of those.

Models Finding the right model for a set of pictures is half the battle in glamour work. Depending on your requirements this might be a full-time professional, on hire from an agency, or a beginner who shows some potential. Professional models are usually easy to work with, since they have a good knowledge of poses, and so on. However, there is something to be said for the novice model and inexperienced photographer learning together. This is mutually beneficial since the photographer is able to practise technique, while the model may be able to pose in return for some pictures for her portfolio.

Always ask the model to complete a model release form, giving permission for the pictures to be published later.

Location While it might be very nice to fly off to Jamaica with six models for a glamour assignment, most glamour photographers have to be content to shoot nearer to home—often in a studio, or outdoors (on a good day). Studios are a favoured choice—some freelances set up a temporary studio at home, perhaps in a spare room, or a more permanent studio can be established in a garage or outhouse. Otherwise, there may be a studio for hire in your own area—the cost is likely to be around £10 per hour, and some studios have resident models. Clubs or groups of photographers may be able to hire at a discount rate. Either way, look for a studio that offers good lighting and other back-up facilities, including changeable backgrounds, accessories and props.

Quality Every glamour shot you take should be of the best quality possible—this will be particularly important when trying to sell to men's magazines. Pictures should be sharp, show accurate skin tones, and the poses should not look artificial unless this is specifically intended for a particular effect.

Marketability Remember that glamour does not necessarily mean *nude*—in fact, the latter will be the hardest to sell. Even pictures of topless girls may have limited potential when compared to shots of girls in swimsuits or semi-revealing outfits.

Not all glamour shots need to be full-length, as this portrait shows. The use of backlighting has helped to eliminate awkward shadows on the face.

Special freelance projects

This section presents an outline of 10 assignments that have some marketing potential for the freelance photographer. No matter how good you are as a photographer, there are two extra requirements you may need as a freelance: *ideas* and *motivation*. To help with both, the following 10 Special Freelance Projects may help you to get started.

I have avoided some of the more obvious money-making areas, like wedding photography, and have dealt only with some photographic 'themes' that are intended as food for thought. There are no big-money earners in the list—but, in some cases, the potential is there for further success.

Along with a brief description of each project, there is also advice on how much time may be involved, the equipment to use, the possible markets to sell to, and so on. Bear in mind each idea is outlined briefly—it is up to you to apply it to your own circumstances, adapting the recommendations where necessary.

You might decide to follow one or two of the projects as they have been outlined here, or use them as a basis for your own ideas. Either way, the intention should be to discipline your approach as a photographer, and to look for the best freelancing potential within the projects you decide to adopt. Good luck!

Project 1: My home town

- *Brief:* Document your own town, city or village. Concentrate on the lifestyle of the local people, as well as on the visual aspects of the place itself.

- *Time required:* Project can be tackled in a single weekend, or stretched over a period of time depending on the photographer's requirements.

- *Equipment:* Project can be handled with minimal equipment—a 35 mm compact, or SLR with one lens may be all that is needed. For shooting candids from a distance, try a long telephoto or zoom lens. Flash may be needed for indoor work where there is insufficient natural daylight.

- *Film:* Black and white Medium (125 ASA) to fast (400 ASA) Colour transparency 200 or 400 ASA daylight

- *Markets:*
 Local paper
 Local exhibitions
 County magazines
 Photographic magazines
 Some general-interest publications (if area is of particular interest)
 Picture agencies/libraries (certain areas or types of pictures)

Look for shots like this one taken at a local cattle market, for your special project.

Project 2: A day in the life of...

- *Brief:* Select a local person as the subject for a photo-feature. Examples might include a farmer, postman, local businessman, or anyone involved in an activity that can yield an interesting and varied set of photographs.
- *Time required:* Usually one day, but can be done over a longer period to encapsulate the full range of a person's activity (for various reasons, it may be difficult to take all the pictures needed in a single day). Choose carefully when you take the pictures, bearing in mind the possible newsworthiness of the pictures, for example, photograph a sheep farmer during a busy period, such as lambing or shearing.
- *Equipment:* Minimal. A camera with standard and perhaps a wide-angle lens, should be all that is required. Use additional lenses for any special shots as necessary. Flash may be needed in some cases.
- *Film:* Black and white Medium (125 ASA) to fast (400 ASA) Colour transparency 200 or 400 ASA daylight
- *Markets:*
 Local paper
 Local exhibitions
 County magazines
 Photographic magazines
 Special-interest publications (for example, farming shots for agricultural magazines)
 Picture agencies interested in photo-features

Project 3: Sports meeting

- *Brief:* Select a forthcoming sports meeting (athletics, for example) for coverage. Where necessary, check with organisers beforehand if freelances are allowed to take pictures, and obtain any special passes.
- *Time required:* Duration of meeting (probably half a day in most cases).
- *Equipment:* Depends on sport. Most action is likely to be happening some distance from the camera, so consider long telephoto or zoom lenses. An autowinder or motordrive will help in capturing fast action sequence shots. Two camera bodies might be useful, fitted with different lenses, or loaded with both colour and black and white film.
- *Film:* Black and white Fast 400 ASA (can be uprated to higher speeds if required) Colour transparency Fast 200 or 400 ASA daylight (tungsten in some floodlit situations)
- *Markets:*
 Local paper
 Sporting publications
 Photographic magazines
 Sports picture agencies (major events only)

Project 4: Market day

- *Brief:* Select a lively market and visit it on a busy day. Arrive early in the morning for shots of stallholders setting up. Shoot general pictures, close-ups of stall characters, buyers wheeling-and-dealing, for example.
- *Time required:* Usually one day. In some cases, several visits may be necessary to obtain sufficient variety of pictures.
- *Equipment:* Can be handled with a 35 mm compact camera or SLR with standard lens, although a short telephoto or zoom lens is useful for candid shots.
- *Film:* Black and white Medium (125 ASA) to fast (400 ASA) Colour transparency 200 or 400 ASA daylight
- *Markets:*
 Local paper
 County magazines
 Photographic magazines
 Some general-interest publications
 Picture agencies/libraries interested in 'people' shots

Project 5: Summer event

- *Brief:* Select a large local event (for example, a carnival) and set about covering the day's happenings and people involved. Arrive early before the crowds to shoot group pictures and any special set-up shots. Check with organisers beforehand if possible if special admission is required.
- *Time required:* Duration of event (usually one day).
- *Equipment:* 35 mm SLR (or large-format SLR or TLR) with standard lens. Wide-angle lens useful for large group shots, and short telephoto or zoom lens for candids. Flash may be used for 'fill-in' lighting when strong sunlight causes harsh shadows.
- *Film:* Black and white Medium (125 ASA) Colour transparency 64 or 200 ASA daylight Colour print 100 ASA
- *Markets:* Provide prints for people photographed Event organisers (publicity, brochures, etc.) Local paper (black and white only) General-interest publications (for humorous shots)

Project 6: People and their pets

- *Brief:* Find people in your area with interesting and unusual pets for possible newsworthy pictures, or compile a photo-feature on one particular aspect, animal humour, for example.
- *Time required:* Can be done over a period of weeks or months.
- *Equipment:* Depends on type of photography involved. A 35 mm camera (or large format) with a standard lens may be all that is required, fitted with a flashgun. For candid shots (for example, people exercising their pets) use a longer lens.
- *Film:* Black and white Slow (50 ASA) or medium (125 ASA) Colour transparency Slow (64 ASA) or medium (200 ASA) Colour print 100 ASA
- *Markets:* Animal and pet publications Club magazines Local paper General-interest magazines (photo-features and humour) Photographic magazines Pet owners

Project 7: The funny side of life

- *Brief:* Look for humorous situations that might make interesting and saleable pictures. Can be of practically any subject, but preferably containing some human element.
- *Time required:* Can be considered as a long-term project, unless humorous situations can be 'created' for the camera within a short time.
- *Equipment:* Depending on the subject. In most cases, only the minimum of equipment (35 mm compact, or SLR with standard lens) may be needed.
- *Film:* Black and white Medium (125 ASA) in most cases Colour transparency Slow (64 ASA) or medium (200 ASA)
- *Markets:* General-interest publications Photographic magazines Specialist publications (if pictures relate to subject area) Local and, sometimes, national press Agencies/libraries interested in humour

Project 8: Industry and the community

- *Brief:* To document local industry (factories, for example) and how the local community is involved and affected. Could involve general environmental photography, or how local company employees live and work.
- *Time required:* Long-term project, possibly spread over some months.
- *Equipment:* Minimal. In most cases an SLR with standard lens, and possibly a flashgun, might be all that is needed. Consider using special long lenses and possibly special effects filters for environmental shots.
- *Film:* Black and white Slow (50 ASA) or medium (125 ASA) Colour transparency Slow (64 ASA) or medium (200 ASA)
- *Markets:* Local paper County magazines Industrial publications (including in-house magazines) Some general-interest publications Local exhibitions Photographic magazines

Project 9: Local pubs

- *Brief:* Photograph local public houses, particularly old or historic buildings. General exterior shots, plus details of interest (pub signs, plaques, unusual interiors, for example). Check with landlord first.
- *Time required:* Depending on number of venues. Could possibly be spread over a few weeks.
- *Equipment:* 35 mm compact or SLR with standard lens. Flashgun for interiors. Tripod for night shots under floodlighting.
- *Film:* Black and white Slow (50 ASA) or medium (125 ASA) Colour transparency Slow (64 ASA) or medium (200 ASA) Colour print 100 ASA
- *Markets:* Pub landlords Breweries Trade magazines Local paper County magazines Tourist boards General-interest magazines

Project 10: Children at play

- *Brief:* Photograph children in a variety of active situations—in the home, at school, in playing fields, for example. Concentrate on capturing candid expression rather than posed pictures.
- *Time required:* Could be done over a few days or weeks, depending on local possibilities and picture requirements.
- *Equipment:* Ideally, an SLR with a telephoto or zoom for taking candid shots from a distance.
- *Film:* Black and white Medium (125 ASA) or fast (400 ASA) Colour transparency Medium (200 ASA) or fast (400 ASA) Colour print 100 ASA or fast 400 ASA
- *Markets:* Women's magazines Sport and recreation magazines (depending on activity photographed) Photographic magazines Picture agencies/libraries interested in shots of active children Card, calendar and poster manufacturers

How to win competitions

One of the easiest ways for a photographer to earn money from pictures is to enter them in photographic competitions.

There are dozens of competitions being run every year, not just in the photographic press, but in general and special-interest publications and newspapers. Many companies also use photographic competitions to promote their products, so you are likely to find details of contests on the back of cereal packets or lemonade bottles.

For some photographers, entering competitions is a full-time operation. Every time a new contest is launched they look through their files of pictures to see if they have anything suitable for an entry. If they don't, some pictures may be taken specially.

There is no one 'secret' to winning competitions, since a number of different factors are involved.

Finding contests

The first task is to find the right competitions to enter. The photographic magazines run regular competitions, sometimes in conjunction with photographic equipment manufacturers. Quite often, the prizes may consist of cameras, or other equipment, although other prizes, such as cash or holidays, may also be offered.

In the photographic press, each competition is likely to be tied to a particular photographic theme—for example, portraiture or sports. But over a period of a year, many magazines run a variety of different themes, so there is every chance of entering at least one, if not more. The fact that these competitions are restricted to a theme can mean there will be a restricted number of entries also—so you may have a better chance of winning than in more general competitions.

Outside of the photographic press, competitions can spring up in many areas. A women's magazine, for example, might launch a 'Holiday moments' contest to promote a film processing service, or liaise with a baby food manufacturer on a 'Baby face' competition. Although these sort of competitions attract a high number of entries in many cases, they are likely to be snapshots—and most of them will be quite poor. A photographer who can produce a good-quality enlargement of a picture, which fits well into the theme of the contest, stands an excellent chance of winning a prize.

On a local level, you might find competitions in the local newspaper or county magazines. Local councils and other organisations also run contests from time to time.

Don't be tempted to enter every single contest just for the sake of it. Look carefully at the contest theme, and the requirements, and see if you have any suitable material on file that will fit the bill. For photographers who have a general approach to subjects, there is likely to be a good cross-section of pictures on file to choose from. Photographers who specialise may be restricted to entering specific-theme contests, where practised skill in one area is likely to be of more use anyway.

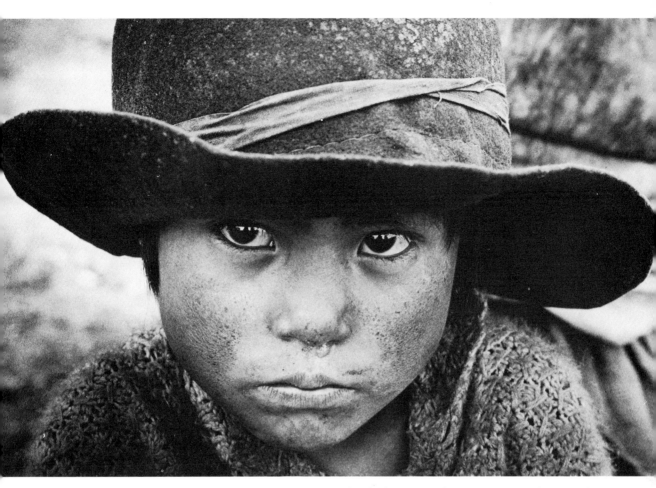

This is the £1000 winner of a recent portrait competition. While driving through a Peruvian village the photographer stopped to photograph some of the people on the roadside—this was one of the results from only six shots taken.

Finding contests should be no problem—you just have to keep your eyes open, and pick up tips from friends or fellow enthusiasts where possible.

Entering contests

There are a few photographers who regularly win prizes in photographic competitions—some have done so for many years. Why?

Are they fantastic photographers?
In some cases, yes—but not always.
Does a particular photographer's name guarantee a winning place?
No. In most cases, the judges don't know who took what picture until the decision has been made.
Do the judges always go for the same sort of winning picture?
Not usually. Judges vary from competition to competition, so the chances of a continuously biased preference are minimal.

So why do they keep winning? Well, in most cases, it is because they bother to *enter* in the first place. Too many photographers look at winning competition entries by other photographers and say: 'But I have pictures at home that are ten times better than those . . . I could

have won this contest easily.' Of coure, if those photographers had bothered to send their pictures in, instead of leaving them in a cupboard at home, they probably could win.

But winning should not be everything. Certainly it is nice to win a camera, or a holiday abroad—but you should not be too materialistic about it. The idea of any photographic competition is for the entrants to *compete* and, hopefully, enjoy doing so. Winning should be the bonus. By just taking part, it is surprising how much incentive is

An amusing competition winner that could also be an editor's dream. The picture can easily be cropped at the top left or bottom right corner to include a story and/or caption while still retaining all the visual impact.

given to your photographic activities. Winning prizes won't improve your pictures—but achieving a 'goal' set by a competition theme can.

Making a submission

Assuming you have found a competition that interests you, what next? Well, there are a few important, common-sense steps to take before you submit any pictures, and they can be taken more or less in sequence for every competition.

● **Read the competition details** When a competition is launched, the organisers usually spell out the theme, and what they will be looking for. In most cases, they may be looking for creative, or unusual pictures, or an approach that may be somewhat different from the norm. If the contest pictures are to be of something in particular, say, 'Happy children', keep your pictures on that theme, and don't be tempted to veer away from it. Try and put yourself in the organiser's position—what would *you* be looking for in the entries? Pick up on any clues that may be given in the entry details.

● **Read the rules** Every competition has a set of rules by which the entrant *must* abide—otherwise instant disqualification is possible. An example set of rules is included on p. 143 for reference. Read the rules carefully and follow them to the letter.

● **Decide on picture source** There are basically two ways of supplying pictures for a competition: from your own stock file of pictures or by taking photographs specially. Obviously it pays to go to your picture file first to see if there are any suitable entries there—this will be easier if you have already categorised your pictures into various subject areas (portraits, children, action, etc.). If you decide to take pictures specially for the competition, jot down the important details (type of picture or whether slides or prints are required) and compile a shortlist of ideas on what to shoot. Try and be as imaginative as possible and, where there is no set theme, concentrate on areas where you will be able to get the most successful results.

When the entries arrive on the judging table, a certain amount of sifting is done to reduce the number of pictures to a final shortlist. In most cases, the judges will be looking for certain points, some of which are listed here. These are not in any special order of preference, but they might give some insight into some of the general requirements.

● **Presentation** Many photographers put a lot of time and effort into taking pictures, then spoil the impact by bad presentation. Examples of this include prints that have dust marks or scratches, prints that curl up at the edges because the photographer has not packed them properly, transparencies mounted in tatty cardboard mounts, and so on. It is very important for the entrant to ensure prints are correctly trimmed (and spotted where necessary) and transparencies properly mounted (plastic mounts, without glass, are best). Material can be damaged in the post, so use a stiff envelope or jiffy bag to protect the pictures.

ON ASSIGNMENT

As well as capturing the subject well, a competition entry should be technically good. Sharp focus, correct composition and pleasing colour rendition are helpful winning ingredients.

In many cases, a competition may be announced in which the organisers may have a good idea of the style of entries they wish to attract and eventually win. When the *New Musical Express* organised a competition for photographers to depict youth music and culture, this was the successful winning entry.

● **Picture quality** Always try and send the best-quality photographs you have. Avoid pictures that are unsharp, badly under- or over-exposed, or poorly printed. In most competitions the subject matter is obviously the most important aspect, but the pictures must be of sufficient technical quality to be worthy of a prize.

● **Theme** Always stick to the theme of a competition—you would be surprised how many photographers ignore this important point and send in pictures that are totally irrelevant. By all means be imaginative within the context of the competition, but just make sure your approach does not wander in the wrong direction—the judges may find it hard to understand what you have tried to achieve, and disqualify your pictures as a result.

● **Consistency** In cases where the photographer is asked to submit a

Many competitions require photographs with a natural history subject, eg, animals, birds, and other wildlife. This shot is well composed, showing the swan to good advantage, and could well qualify for a competition prize.

variety of pictures on a theme, it is essential that the pictures blend well together. This might involve consistency in approach to the subject, use of a particular style of lighting, similarity in printing technique, and so on. If the prizes are to be awarded for a portfolio, the judges will be looking for a consistent, even identifiable, selection from each photographer. So try and keep a strong link between all the pictures if this is required.

Example rules

Rules are likely to vary between competitions, but the ones listed here are largely typical of those used in most amateur contests in photographic magazines.

1 This competition is open to *bona fide* amateur photographers only (ie, those who do not make a full-time living out of photography).

2 Up to three black and white prints can be entered. Maximum print size 8 × 10 in. Prints should be unmounted.

3 For the colour section, up to three colour transparencies can be entered. Minimum size 35 mm, maximum size 4 × 5 in. Do not send glass-mounted slides.

4 Photographers may enter both sections (ie, three black and white prints and three colour transparencies may be submitted).

5 Copyright of all entries remains with the photographer. The organisers reserve the right to publish any prize-winning entry free of charge. Any non-prize-winning entry published will receive a standard reproduction fee.

6 All black and white entries will not be returned. Photographers who wish to have colour entries returned must supply a stamped addressed envelope.

7 All entries must be clearly labelled with the photographer's name and address (and telephone number where possible).

8 While every care will be taken, the organisers cannot be held responsible for loss or damage to prints and transparencies while in their possession.

9 The prizes will be as stated and cannot, under any circumstances, be exchanged.

10 The decision of the judges will be final, and no correspondence will be entered into.

11 The closing date for entries is 30 August 1985.

12 Entries should be sent to: (address).

What the judges look for

The most important thing to remember about photographic competition judging is that it is usually purely subjective. When entering a contest, it is the opinion of the judge(s) that will put your pictures either on the winning list or the reject pile.

It is quite difficult to define what the judges will be looking for because competitions, and judges, can vary so much. Most judges are very fair and take plenty of time to assess the entries on their own merits, within the context of each competition. Personal preferences inevitably creep in sooner or later, usually towards the final stages of judging. Faced with two equally good transparencies battling for a first prize, the judges might undoubtedly make a subjective decision.

Rules analysis

Reading the rules is one thing—understanding and following them can be quite another. Some photographers choose to ignore certain rules because they don't think they apply to them, or because they seem to hinder their entries.

Reading through the example rules, there are some common

problems that crop up which the entrant should always make every effort to avoid.

1 This rule immediately restricts the entrants. Part-time freelances, who perhaps have another full-time job, or do not make all of their income from photography, would still be eligible to enter. Watch out for junior competitions where age limits may apply.

2 Always send the maximum number of prints allowed—in this case, three. You stand a much better chance of winning. But only do so if the pictures are all up to standard—two bad prints can affect the chances of the other potential winner. Try and send in the maximum print size if the picture is up to it, and do not mount prints if this is requested.

3 Again, send the maximum number of transparencies. Send in plastic mounts only—glass mounts often get damaged in the post.

4 Enter both sections if possible—you can only increase your chances of winning.

5 All *bona fide* competitions allow the photographer to retain copyright—avoid any that don't. If non-prize-winning entries are not published with the competition results, a magazine may hold on to the black and white entries for possible future use, and pay the photographers concerned later on publication.

6 Black and white pictures are not usually returned since the assumption is made that the photographer has the negatives, and can produce more prints anyway. Organisers cannot be expected to pay for the return of photographers' colour transparencies, so they *must* supply stamped addressed envelopes.

7 During the judging the various prints and/or slides will all be laid out for inspection together, so it is essential that each individual picture is identified. Stick-on labels, with the photographer's details, are recommended for this.

8 This sounds like a get-out clause for the organisers but, with entries as high as 1000, it is possible—though rare—for pictures to go astray. Transparencies are usually of most concern, since an original is impossible to replace. Although expensive, important slides should be duplicated—the photographer can then either send the original or the 'dupe' in to the contest. Even if one is lost, there is at least one transparency in the photographer's possession.

9 Some winners have been known to resist accepting a prize of, say, a camera, and ask for some other model, or cash instead. Always accept the prize being offered in good faith—what you do with it afterwards is, of course, up to you.

10 Few decisions have been challenged although, in most contests, any reasonable complaint will be looked into.

11 Don't ignore the closing date. Even the best pictures in the world will be disqualified if they arrive a day after the closing date.

12 Take careful note of the address to send the entries to—this might be different from the normal magazine address. Mark the envelope clearly with the competition name.

This popular picture has won the photographer four cameras and various other prizes in various competitions.

PART 3:
Freelancing: More Than Taking Pictures

Write on

When you submit work to a publication, pictures alone may not be enough—some words, in the form of captions or a story, may need to be added as well.

Not every photographer is likely to be a literary genius. But it will certainly improve your chances of publication if you can include a few explanatory words with your photographs—after all, how many photographs have you seen published entirely without words?

Gathering information

In order to supply the necessary information with pictures, the photographer first of all has to gather the facts. This might be as simple as identifying a particular landscape or taking someone's name for a

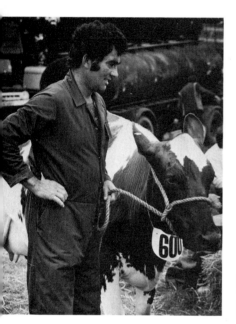

Captions

When sending pictures to a magazine or similar publication, it makes the editor's job much easier if you have taken the trouble to caption each picture fully and accurately.

How you actually caption photographs can depend on the area of the market you are submitting to. For example, a photographic magazine will want to know something about the subject photographed, along with some technical details (camera, film and exposure). When photographing an athletics meeting, details of the event (when, where), names of athletes photographed (plus team, nationality), type of event (200 metres, marathon), should be provided.

In some cases, details can be written on a small label and attached to each slide or print. But it is better to type these details on a separate caption sheet, numbering each caption against the appropriately numbered picture.

When writing a caption, try to ensure the following five questions are always answered:

Who? What? Where? When? Why?

If you can answer these questions when captioning a picture, it will help the reader to understand what the picture illustrates. When you photograph someone, the caption should explain *who* the person is, *what* that person is doing, *where* it is being done, *when* it was done, and *why*.

The photograph here, if used in a local newspaper, might require the following caption:

'John Smith (*who?*) leads a cow into the parade ring (*what?*) for competition judging (*why?*) at the Norfolk agricultural show (*where?*) held last weekend (*when?*).'

If the same picture is to be used in a photographic magazine, say, for an article on photographing people, a different sort of caption would need to be written:

'This informal portrait (*what?*) of a cowman (*who?*) at a recent (*when?*) agricultural show (*where?*) demonstrates how a long telephoto lens can capture candid expression (*why?*).'

This caption is less specific about the subject, but includes detail relevant to the particular type of publication it is submitted to. Always try to include the sort of detail a particular publication is likely to need—if in doubt, have a look at the sort of captions they use beforehand.

caption. In some cases, there may be only one chance to find these things out, ie, when the photograph is taken. And it is *up to the photographer* to gather this information on the spot, as it might be difficult to follow up on later.

Story

Few photographers are aware of how much easier it is to sell photographs that are supported by a story.

Put yourself in an editor's position for a moment. You have X-number of pages in your magazine to fill by way of contributed material from outside sources. Some photographs arrive on your desk—they are captioned, but there is no accompanying story. There is no time to go back to the photographer to ask for more details, and the timely content of the pictures means that they cannot be used in a future issue. The pictures are returned unused, the editor has to look elsewhere, and the photographer is disappointed.

But this situation could have been different had the photographer provided a short story, perhaps only a few hundred words, to accompany the photographs. This is where the journalistic side of photojournalism comes in.

What is important in most cases is the ability to explain what the photographs are about in a reasonably logical way, within the context required by a particular publication, and possibly expand on a theme that is likely to be of interest to its readership. When submitting to a photographic magazine, for instance, emphasis might be placed on the theme of the pictures, with details on any special techniques involved. Or if the pictures have a newsworthy aspect, try and link both story and pictures together as a sort of photo-feature.

Obviously, as a freelance, your emphasis is likely to be more on the photography than the writing—after all, it is difficult to become a journalist overnight. But always investigate the possibilities of adding words before sending pictures or, in some cases, send an outline synopsis of ideas for a story with the photographs so that an editor has some notion of what you are trying to do. Taking this trouble can mean the difference between pictures being published or being returned to you unused.

Keeping a picture file

Taking pictures is obviously important to the freelance—but looking after them once they have been taken is of equal value.

Regular freelancing can lead to a steady accumulation of photographs—this is particularly so when a freelance takes pictures over a period of time on a speculative basis, perhaps to sell later on. So it is essential for the photographer to store those prints or slides carefully, and to be able to locate them quickly and easily as market opportunities arise. That means keeping a good, up-to-date picture file.

To many freelances, filing and indexing photographs can seem like a chore. But it has to be done. Pictures just thrown into a desk drawer can easily be damaged, forgotten about, or even lost. Losing pictures will negate any effort put into taking them in the first place—and money can be lost through those shots not being available for presentation and possible sale.

The time and effort needed to keep track of your pictures will probably be proportional to the amount of photography you undertake. For example, the occasional 'weekend freelance' might only shoot one or two films a week, and may only need to set aside perhaps one evening a month to file recent pictures. The busier freelance will have to attend to the filing more regularly (or ask someone else to help) to prevent material piling up.

Print storage

Keeping prints should not be too much of a problem. If you print to a standard size—say, 8 × 10 in or 6 × 8 in—storage will be much easier than with extra-large blow-ups.

The 8 × 10 in size is widely used by freelances for various reasons:

- A wide variety of paper grades and surfaces is available.
- It can be easily kept in standard filing cabinets or box files.
- It is easy to handle and view.
- Postage and packaging are easier than for much larger prints.
- The size is widely acceptable for reproduction (magazines, newspapers, or books).
- It is large enough for visual impact.

How prints are stored depends on how many there are, the type of paper used, and the physical environment of the storage area. Most photographers who print their own material use resin-coated paper. This dries flat, without curling at the edges (unlike some bromide papers) and prints can be kept flat in boxes (many photographers use old print paper boxes), or in box files, or in a filing cabinet, under relevant category headings.

Larger prints can be either laid out flat, possibly sandwiched between two pieces of stiff card and weighted down to prevent curling, or they can be curled-up and kept in cardboard tubes if storage space is a problem. For long-term storage, prints (and all photographic emulsions) should be kept out of direct sunlight and

away from excessive heat (perhaps from a nearby boiler) or humidity, and not too near chemical fumes (perhaps from film or print solutions in the darkroom or even domestic bleach and cleaners).

Negative storage

While print storage is fairly straightforward, more care and attention have to be applied to the filing of negatives, since they are more prone to loss or damage. And if something happens to the negative a picture can be lost completely.

Most outside processors return negatives in special semi-opaque sleeves, each one holding one film cut into strips. These sleeves are also available for the photographer who does his or her own processing. The sleeves protect the negatives from dust, dirt and handling marks and abrasions when viewing. These sleeves can be kept in custom book files, which hold a number of sleeves easily and safely. In most cases, it is best not to file negatives flat together, otherwise damage can occur.

To help with location of negatives, some photographers make a contact print from a set of negatives, and file that with them, since it is easier to view and identify the images from a print.

Transparency storage

Transparencies processed by outside laboratories are normally returned in individual plastic or cardboard mounts. Photographers who process their own films, or specifically ask laboratories to return their images unmounted, can buy a variety of different mounts.

The plastic types are best because they tend to be more hard wearing and provide better protection. When buying mounts try to avoid those with glass inserts. While they offer slightly better protection, particularly when slides are in a projector, they can be hazardous if the freelance sends them through the post. Even with careful packing, glass mounts can easily be damaged during handling —a cracked glass mount can easily ruin a transparency, or cut the fingers of someone opening the package.

In ordinary plastic mounts, the slides can be placed in special protective individual sleeves, or transparent wallets, for extra protection. Wallets are available to fit into a standard filing cabinet, and usually hold up to 20 35 mm transparencies (sleeves for larger formats are also available). Wallets can also be folded safely and sent through the post, where a magazine or newspaper editor can view the whole selection and file transparencies.

Transparencies can also be kept in slide trays which fit straight on to a projector for easy viewing. While this is not as convenient as viewing slides in a wallet (only one slide can be projected at a time) the trays offer good protection and can be stacked for space-saving storage. Buy trays that have covers to prevent dust and dirt damage.

Transparencies can be loaded into plastic wallets which can be kept together in binders like this.

Indexing

Once you have settled on a storage system for prints/negatives/ transparencies, you will obviously need to find particular images easily and quickly. If you only have a few dozen transparencies this should not be too much of a problem—but, as your collection grows, images will have to be indexed in some way so that they can be located. There are a few ways of doing this.

Categories Pictures can be divided into individual subject categories, for example, portraits, animals, sport or humour. For specialist photography, a main category can be broken down into sub-sections. In a nature file, for example, photographs of individual species may be filed separately. The categories can be filed in order of preference, or alphabetically, as required.

Places Some photographers file photographs under the title of the place where they were taken. Under 'Amsterdam', for instance, pictures of tulips, canals, bridges, people and other subjects may be filed together. This system can work, providing the photographer can locate particular subjects easily.

Chronological Filing pictures in chronological order, for example, 1983 Jan–Dec, is a useful way of keeping track of when pictures were taken. The problem with this system is, however, will you remember in five years time the approximate date of the images you are just now filing? Knowing when a picture was taken can help a photographer to trace a particular shot.

These are three basic ways of indexing. Each can be applied individually, or a combination of all three might be used. For example, a picture of a bulb grower taken in Amsterdam during a two-week trip might be categorised like this:

Main place category—Amsterdam
Subject category —People
Date taken —May 10 1982

Other subject categories can be filed under 'Amsterdam' in the order they were taken to keep a complete chronological record.

The photographer can keep track of pictures more easily by numbering them. You can set up your own individualised numbering system to suit your personal requirements.

Letters and numbers can also be used to identify certain images, perhaps in conjunction with a cross-reference book or card index system. The first notation might be your own initials, followed by the 'job number' you have allocated to a particular assignment, the image number, and the year taken. This might be:

BM/1/4/83

where **BM** are the photographer's initials
1 is the first job to be categorised
4 is the fourth transparency taken for that job
83 is the year

The same notation can also be recorded in a book or on a card index so that individual transparencies can be booked out when

submitted to a publication. With this cross-reference system, you can always keep a track of where individual images are.

Labelling

One of the best ways to include written information on transparencies and prints is to use sticky labels. If you write on transparency mounts (particularly on plastic ones) the details might easily rub off or become blurred. On prints (especially those on single-weight paper), ink can show through the surface and spoil the picture.

When labelling pictures it is essential to include your name—an address and telephone number is useful, but not always essential if the photographer submits a batch of pictures with a covering letter with those details included.

Also include any relevant information on the picture label. A shot of the Eiffel Tower in Paris might carry a label simply reading 'Eiffel Tower, Paris, 1983'. In more specialist work, such as nature photography, a detailed label will be essential to help identify a particular species of insect or bird.

Many picture libraries, for example, would not accept a shot of a butterfly labelled simply 'Butterfly on flower'. The photographer would be expected to know, or find out, the species of butterfly, and possibly the type of flower, and include these details on the picture. A more complete label might read 'Large White butterfly (*Pieris brassicae*) feeding among daisies'. It is also a good idea to include the location of the photograph if you are submitting it to a specialist library or magazine.

Technical details (camera, lens and exposure) can be included for the photographer's own information, but may not be required by most outlets using pictures. The information can be supplied on a separate sheet of paper if necessary.

Sellers and non-sellers

Some freelances find it useful to separate 'sellers' (pictures that are likely to sell) from 'non-sellers' (pictures that are less likely to find an immediate market).

It might be difficult initially to define what sort of shots are sellers or non-sellers, but experience will soon indicate the pictures that are likely to find markets quickly. Regular sellers might include humour, personalities, and other pictures of special reader interest that publications tend to buy. Slow, non-sellers might include general landscapes, or pictures without any particular visual interest or impact.

Pictures may be non-sellers because they cannot be sold at a particular time, but can become sellers later on. One freelance took a great many skateboarding shots during a trip to America a few years ago, but could not sell them in the UK on his return. When the skateboarding craze took off here, he managed to sell most of them to the various 'craze' magazines that sprang up at the time. So remember, some non-sellers might not be really dead, just dormant.

The business side

Money matters
As mentioned earlier, anyone earning money from photography should seek professional advice on the financial aspects involved. Unfortunately, there is insufficient space in this book to deal with the relevant matters in any great detail—and anyway, there are entire books written on the subject, as well as various booklets on individual topics, such as income tax.

The aspects that you have to look into as a freelance will depend on your own individual circumstances—how much you earn or your employment status, for example—but here is an outline guide of the many points that may require attention:

Income tax The tax system in this country is very complex, and advice is essential if you want to clarify your own situation on any extra earnings from photography. Your local Inland Revenue office can help.

Value Added Tax (VAT) Initially, you may not be earning enough as a full-time freelance to qualify for VAT payments. But, if your business grows, this may become a factor, and your accountant will advise you on this. Your local VAT office can also advise you further.

National Insurance There are various National Insurance classifications, and the local Department of Health and Social Security can advise you on the requirements. They should be notified if you start your own full-time business.

Accounts For any financial organising it is important to keep a record of income and spending. An accountant can advise on how to do your own accounting, or do the accounting for you. Accounts are very important when dealing with the Inland Revenue.

Many freelances start off without knowing very much about the business side of photography. So what exactly is involved?

Well, a great deal depends on how much freelancing you intend to do. The business side can range from simple matters such as writing letters, through to more complex areas such as keeping accounts. While some might apply only to full-time professionals, there are aspects that the part-time freelance needs to be aware of. Bear in mind that your freelance activity can increase as you go along, and it is better if you have some idea of the business side before it all gets on top of you.

First steps

The most important thing to remember as a freelance, amateur or professional, is that you will be providing a *service*. Whether you sell pictures to a magazine, or supply local wedding coverage, someone will be paying for your freelance abilities.

So it is essential, right from the start, to go into freelancing with a professional attitude. That means doing the best job you can on every assignment, providing the best pictures you can, presenting them properly, and treating clients or editors in as professional a way as possible. This is the essence of good manners, and good business—two essential ingredients.

The next important step for anyone wishing to earn money from photography is to *seek professional advice* first. The Inland Revenue particularly will become interested in your freelance activities, so make sure you seek advice on handling financial and similar business matters. People who can help include the bank manager, solicitor or accountant. This advice may not always be free, but it can help you avoid the shock of unexpected tax bills.

The next stage is to decide where you are going to operate from. Most freelances work from home initially, and only consider moving into an office or studio premises if the amount of work they are handling merits it.

Apart from being very convenient to work from home, it might also be possible to claim overheads, such as electricity and telephone charges, against income tax. But freelancing from home can have its problems. If you are living in rented accommodation, you may need to check with the landlord in case there are any restrictions on operating a business from the property.

When offering a local service, for example, home portraiture, remember that clients may be calling on you at various times and someone will need to be there to talk to them in person, or on the telephone. Some consideration may have to be given to neighbours in a residential area, too.

If you decide to set up a studio at home, these problems can increase, so check out all of these aspects beforehand. Some freelances get round the problems by hiring a studio when required,

sometimes sharing with another photographer and splitting the costs. This can be all right for the odd assignment, but may be largely impracticable in the long term if a lot of work is envisaged.

Promotion

Promoting yourself, and your work, is all part of the freelance business. An extensive portfolio of pictures is a good start, but consider other aspects, such as publicity material, personalised stationery, advertising, client recommendation, published work, and so on.

Good self-promotion relies on good presentation. When submitting to a publication, for instance, don't just throw a few old prints into an envelope in the hope that this will impress an editor—it won't. Pack them neatly, and include a covering letter, captions (and/or a story), and a stamped addressed envelope should the pictures not be accepted. Some editors are likely to discard badly packaged pictures without even looking at them, so bear that in mind.

On a local basis, a carefully prepared folder of prints can be shown to prospective clients, and letterheads or business cards are useful for handing out to potential customers.

But usually, the best promotion a photographer can have is pictures. If you don't have a studio, it is obviously difficult to display your work—but not impossible. Consider mounting your own display at a local library, or take part in a photographic exhibition. Some banks and estate agents occasionally allow picture displays in their windows, so try to persuade them to take some of your photographs. A business card, mounted with the pictures as illustration, can help you to attract additional work.

For social photography (weddings or evening functions, for example) it is important to advertise locally. You can produce your own cards (for newsagents' windows or clubs) or posters using one of your photographs as artwork. You can also advertise in the local press, usually in the classified sections, but you will have to do so practically every week to attract regular work. Some wedding photographers get over this expense by supplying wedding pictures regularly to the local paper, asking only for a credit line to help them attract more customers. A picture can be much more effective than a few lines tucked away in the ads section.

A home base

Some areas of freelance photography—glamour, portraiture, still-life and light commercial work, for example—call for easy access to a studio. For the freelance who is likely to need a studio only very occasionally, the best course is to hire one—there are many advertised in photographic magazines costing anything from a minimum of £7 per hour, including lighting, props and even darkroom space in some cases.

Home studio

If it becomes necessary to use a studio on a more regular basis, it is more economical to set one up at home. A permanent studio is usually best, and can probably be located in a spare room, garage or out-house. But where this is not possible, a living room or similar space may be used temporarily, bearing in mind that storage space will have to be found for the studio equipment when it is not in use.

Daylight studio
When thinking about a studio, many photographers naturally assume that a darkened room full of lamps is the only answer. It isn't. Many well-known photographers, including Lord Snowdon, have daylight studios where natural daylight, coming in through a window or skylight, is the prime light source. The effect, particularly in portraiture, is often very natural and pleasing.

The only problem with daylight is that it is directional and unpredictable. It is best to use some kind of diffusing screen over the window or skylight so that an even, almost shadowless, light is produced (fine net curtains can do the trick in some cases). The careful positioning of white card reflectors can also help to deflect the light to exactly where it is needed. Where this is difficult, a small flashgun can always be used to 'fill-in' any contrasty shadow areas.

Using a home daylight studio can be very economical. Reflectors are cheap and easy to make, as can be the diffusing material. The only other items needed, apart from the cameras and lenses, are an exposure meter (if not built-in to the camera), a small flashgun (or lamp) for fill-in lighting, and a sturdy tripod.

Artificial lighting
When natural daylight is not being used as a primary light source for studio work, it is best to exclude it entirely (probably by using black-out material over doors and windows, or by shooting at night) and use artificial light instead.

There are two kinds of artificial lighting used in photography—tungsten lamp lighting and electronic flash.

Tungsten lighting Special photoflood lamps can be used for studio lighting. Lighting stands, available in a variety of sizes, can be fitted with lampholders and reflectors, which vary depending on whether a wide spread of light, or a direct spotlight effect, is required. A basic

Backgrounds

For smaller subjects, a table-top studio may be all that is required. Here the background can easily be controlled, and the one chosen will depend very much on the subject. A small roll of background paper, rising up slightly at the back of the subject to give a more continuous background, can be employed. Alternatively, shoot from a high angle, using the surface the subject is placed upon as the backdrop.

For larger subjects, particularly full-length portraits, a roll of background paper, hanging on a wall or attached to a free-standing support, can be used. Papers of various sizes and colours are available and can be changed to suit the subject. Alternatively, use a white wall as a background, and direct different coloured lights on to it to change the colour of the backdrop as required.

tungsten light set-up, consisting of three lamps—a main light, fill-in light and spotlight—can cost from around £60, depending on the sizes of the stands and reflectors.

The advantage of tungsten lighting is that the photographer can move the lamps around to suit the subject, and can see the effect that will result in the final pictures (unlike with flash, the effect of which cannot be fully judged until the results are seen). The disadvantages are that the lamps can get very hot after prolonged periods of use and, unless the studio is well ventilated, both photographer and subject can become over-heated! Also, while there is no problem when using tungsten lighting with black and white film, care has to be taken to use the correct colour film (Ektachrome Tungsten) or a compensating filter (80B) over the camera lens when using daylight colour film—otherwise the effects will be too orange.

Flash

Flash is by far the most popular lighting source for home studio work. Many freelances may already own a hand-held flashgun and this may be perfectly adequate for most general subjects, perhaps used in conjunction with separate flash units. Attached to these units can be small 'slave' photocells, which pick up the light from the main flash (fired by the camera) and trigger-off the extra flashguns at the same instant.

One innovation in studio lighting in recent times is the AICO slave flash. This unit works from the mains and can screw into a lighting stand like a photoflood lamp. It will fire simultaneously with the camera flash, and recharges in about 7 seconds ready for the next shot. It costs around £18 per unit.

Where a more professional studio set-up is required, there are various studio mains-powered flash units. These units are fitted on to special stands and include a tungsten modelling light. This enables the photographer to judge the lighting angles before the main flash is fired. The lighting can be fired directly at the subject—most units have a control for varying the strength of the light output—or softened using a diffuser kit, or 'bounced' off a white or silver umbrella for a soft, even effect.

Professional units, such as Bowens, are custom-built for heavy studio work, and are powerful enough for most situations—but they are relatively expensive. Courtenay make a range of budget-priced equipment that a freelance would do well to look at. A typical set-up, including two flash heads, stands, reflector brollies, and flash meter (essential for correct flash exposures), could cost just over £300.

Home processing

Assuming you do not wish to use process-paid film, or use independent laboratories, the next alternative is to process your own. Some photographic clubs and colleges may have darkrooms you can make

Laboratories

The case for

- Most offer reasonable quality service at competitive prices
- Discounts may be available on some services
- Extra services (framing, special papers, etc.) may be available
- Turnround is usually fast
- Most belong to the *Association of Photographic Laboratories*, a governing body which supervises standards of quality and service throughout the processing industry

The case against

- Photographer loses creative control over processing
- Quality can be inconsistent between various laboratories
- Some laboratories cannot offer personal service because of volume of work handled
- Turnround can vary, particularly in 'peak' summer months
- Occasionally material can be badly processed, or mislaid
- Postal handling increases marginally the risk of material going astray

use of, and it is worth checking this option before spending money on equipment for a home darkroom. The only problem with outside darkroom space is the time it is likely to be free (this may be restricting), the amount of equipment available (it might not be sufficient for your requirements) and the desirability of sharing with other photographers. The latter can be a good or bad thing, depending on the situation and the people concerned.

Assuming you want to set up your own darkroom there are two prime considerations: available space and the investment required.

Finding space

Ideally, a busy freelance should have a permanent darkroom which can be set up in a spare room, under the stairs, in a basement or attic, or in a garage or out-house. The main requirements are that the space can be adequately blacked-out (special material is available to cover doors and windows and masking tape can cover any light 'cracks') and that there should be reasonable ventilation to ensure chemical smells do not build up. Ventilation can be provided by an extractor fan or by a double-vent in a door or wall. Either way, the arrangements should be made light-proof.

An electricity supply is essential for enlargers, safelights, motorised processing drums, driers and glazers. If a supply is not within the darkroom area, an extension lead may be used to bring in a supply from outside. Consult a qualified electrician if in doubt.

A water supply is useful, but not entirely essential, providing a nearby kitchen or bathroom can be used for washing films and prints. A plumber will be able to advise on installing a system if necessary.

If permanent space is not available a temporary darkroom may be the answer. But I would advise you to weigh up how this can be best operated, bearing in mind your and your family's living conditions.

Obviously the chosen area will have to be blacked out easily — a bathroom is usually best for this. A firm board can be placed over the sink or bath to support the 'wet' side of the processing (trays, tanks, drums) and a small table can support the 'dry' side (enlarger, drier, print trimmer). *Note: For reasons of safety, always keep electrical equipment away from wet areas.*

Special purpose-made darkrooms can be bought, which can be easily stored away after use. The Sutton Foldaway Darkroom for instance is a complete darkroom unit which extends out when required, and folds away to the size of an average closet after use. A ready-built version costs around £425, which is quite an investment, but plans are available at around £10 for a do-it-yourself version. Also available are darkroom tents, which consist of a rigid tubular frame supporting a black zip-up surround. Such a tent is large enough for most darkroom activities, although some photographers may find it too small for continuous work. The tent can be easily dismantled and stored away.

Home processing

The case for
- Creative control over results
- Extends photographic abilities beyond taking pictures
- Processing can be done immediately
- Can be economical when sufficient films and prints are processed

The case against
- Cost of setting up darkroom
- Finding space for equipment
- Time taken for processing
- Can take time to perfect processing techniques
- Continual costs of papers and chemicals

Budgeting

The amount of equipment that can be bought is enormous. But the whole idea of freelancing is to offset the cost of hardware and materials, and hopefully make some kind of profit.

In order to do that, you must plan your buying strategy properly. You might decide to buy all of the equipment you need straight away, either by using current resources, or by obtaining a loan. Financial advice, from an accountant, bank manager or similar, is strongly advised in this case. Buying a lot of equipment at once can be a good idea from the point of view of beating rising costs, and it may be possible to secure a good discount by buying in bulk from one retail outlet.

The alternative, and more flexible, route taken by most freelances is to invest in the basic camera equipment needed, and buy other items, such as accessories and darkroom equipment, over a period of time. Sometimes it is hard to predict what can be bought within a particular time scale since the income needed to buy equipment may rely on the freelance's ability to sell his or her pictures or services as a photographer.

Obviously some kind of budget plan, listing items needed in order of priority and how much they cost, can be a good idea. Depending on your photographic requirements, you may decide to spend more money initially on darkroom equipment, rather than on extra lenses or accessories, or *vice versa*.

Don't always consider buying new. There is a lot of good second-hand equipment on the market, and it may be quite possible to make large savings in this way. Money saved by buying a bargain can always be used to purchase extra film, processing materials, or any helpful accessory.

Cost of setting up

How much equipment you have to buy for a home darkroom depends on whether you intend to process black and white, colour, or both. Generally speaking, black and white processing requires the minimum amount of equipment (but the largest amount of space), and costs of papers and chemicals are cheaper than for colour. Having said that, if a freelance takes the time and trouble to set up a black and white darkroom, colour processing should also be considered—if not immediately, then at least for the future—in order to make the darkroom investment as worthwhile as possible. Graduating from black and white printing to colour printing need not cost that much more in terms of extra equipment, but papers and chemicals can be a lot more expensive. Progressing from black and white film processing to colour transparency film processing need not involve the purchase of any extra equipment, but only a different set of chemicals. And, of course, no enlarger is needed to process transparencies.

Films

With so many films on the retail shelves, choosing the right one can seem like a difficult task. What you have to decide on initially is the type of photographs you wish to produce. If colour prints are required, use a colour negative/print film. If, on the other hand, colour transparencies are needed, use a colour transparency film (prints can be made later from this film). If black and white prints are required, use a black and white negative/print film (using special paper, though, black and white prints can be made from some colour films).

When you know the type of film you need, it is then up to you to choose a particular brand. This decision may be affected by factors such as the 'speed' (ASA rating) of the film, whether you want to buy a process-paid or non-process-paid film (in the case of transparency film, Kodachrome or Ektachrome), or the format of the film (some types are not available in 120 rollfilm size, for example).

The film charts included in this chapter list a selection of types of film, with details of speed rating and sizes available. But bear in mind that any information given can only tell half the story of a film's capabilities — you will have to try one or two different emulsions, or perhaps consult fellow enthusiasts about their film choice, before deciding. Certain films are designed for specific applications, so expect to use a few different types for varying assignments.

Black and white

As a photographer, you may have already tried several types of black and white film and settled on the one or more emulsions that suit your requirements.

You don't necessarily have to make any switch from one film to another when taking up freelance work and, in most cases, it is better to stay with the film(s) you are familiar with.

There are certain black and white films that are useful for different types of photography. Emulsions range from slow to fast, and the choice depends on the quality of result required and the lighting conditions.

Slow film (around ASA 50) Films rated at this speed, such as Ilford Pan F, have a fine-grain emulsion, and thus give very good resolution. They are ideal for work in which a good quality image is the prime consideration, such as in landscape photography or portraiture. Because such films have a slow rating, they have to be used in reasonably good light.

Medium-speed film (around ASA 125) The most popular film in this speed range is Ilford FP4. This is regarded by many photographers as a good 'compromise' film since the emulsion produces acceptably fine results, and can also be used in a reasonably wide range of lighting conditions. It can be applied successfully to many different photographic subjects.

Fast film (around ASA 400) Films at this speed, such as Kodak Tri-X or Ilford HP5, are used widely by freelances who have to undertake

When shooting candids, try to move in as close to the subject as possible, or use a longer focal length lens to record close-up detail from a distance. Here the main subjects have been lost because the camera is too far away.

Sometimes small problems can spoil good pictures. Here the setting and composition are good, but shooting into the sun has caused 'flare' on the lens. A lens hood would have solved the problem.

assignments in often uncertain lighting conditions. Fast films have a wide latitude and can be used in situations ranging from bright sunlight to dull light. In low light particularly, using a fast film enables the photographer to select a reasonably fast shutter speed—essential for something like sports photography.

Black and white film

Film name *(process paid)	ASA speed	35 mm 20 exp	35 mm 36 exp	120	Others
Agfaortho 25	25		●	●	bulk 10 m
Agfapan 25 Professional	25		●		bulk 17 m 4 ×5 in
Agfapan 100 Professional	100	●	●	●	bulk 17, 30 m 4 ×5 in
Agfapan 400 Professional	400	●	●	●	as above
*Agfa Dia Direct	32 (slides)		●		
Agfapan Vario-XL	50–1600		●	●	
Barfen BMS 125	125		●		bulk 7.5, 15, 30 m
Boots 125	125	●	●	●	
Ilford Pan F	50	●	●	●	5, 17, 30 m 935
Ilford FP4	125	●	●	●	as above +220
Ilford HP5	400	●	●	●	as above
Ilford HP5 Autowinder	400		●		72 exp cassette
Ilford XP-1	400 (official rating, variable)		●	●	5, 17, 30 m
Ilford Line	10 (approx)				sheet film
Ilford Ortho	80 (approx)				sheet film
Kodak Panatomic-X	32		●	●	bulk 50 ft
Kodak Panatomic-X Professional	32			●	
Kodak Verichrome Pan	125			●	110, 126, 620, 127
Kodak Plus-X Pan	125	●	●	●	bulk 50, 100 ft
Kodak Tri-X Pan	400	●	●	●	bulk 50 ft
Kodak Royal-X Pan	1250			●	
Orwo NP22	125		●		

Uprating

While all of these films are rated at a particular speed, it is possible to change that rating when the lighting situation dictates, and compensate later at the film development stage. For example, a photographer shooting outdoors with Ilford FP4 (ASA 125) may suddenly be confronted by bad weather. Faced with a choice between taking no more pictures or using an unacceptably slow shutter speed (or too wide an aperture), the photographer can 'uprate' the film to, say, 400 ASA (approximately $1\frac{1}{2}$ stops extra) and increase the development in the darkroom later to produce an acceptable negative for printing. The results may be slightly more grainy because of the increased development time, but such a compromise may be necessary in order to secure some kind of result.

Variable-speed film

Advances in film emulsion technology have produced at least two films which, in my opinion, are ideal for most freelances. The films—Ilford XP-1 and Agfa Vario-XL—are both nominally rated at 400 ASA, but they can be rated at practically *any* speed (faster or slower) without any significant change in image quality. Different frames on the same film may even be rated at different speeds—the first half of the film may be rated at 400 ASA, for example, and the last half at 800 ASA. The negatives on the latter half of the film will be slightly more dense than the other negatives, but nonetheless printable—a flexibility not afforded by the conventional films mentioned earlier.

Colour

When working in colour you will have to decide between using either a colour negative film (for producing colour prints) or a colour transparency film (for producing transparencies, or slides). The decision may revolve around the sort of photographs you wish to produce, and the markets you wish to supply.

For example, wedding photographers usually have to supply colour prints to clients, so they would probably choose a colour print film for most of their work. A sports photographer supplying a magazine with pictures would probably use a colour transparency film since most publications prefer to reproduce from colour slides.

Colour negative

There are many colour print films available made by manufacturers such as Kodak, Agfa, Fuji, 3M and Sakura. While all the films have slightly different colour characteristics, most share a similar film speed rating (ASA 100) and process (Kodak's C41 process). Some of the manufacturers, led by Kodak, also produce a faster ASA 400 colour print film for low-light photography.

The decision about which colour negative film to use is usually subjective, and largely dependent on the results you (or your client)

Colour negative film

Film name	ASA speed	35 mm 20/24 exp	35 mm 36 exp	120	Others
Agfacolor CNS (process N)	80	•	•	•	127, 126, 110, rapid bulk 30 m
Agfacolor CNS400 (process C41)	400	•	•		110
Agfacolor N100S	100			•	
Agfacolor N80L	80			•	
Barfen CN100	100		•		bulk 5, 7.5, 10, 15, 30 m
Boots Colourprint 2	100	•	•		110, 126
Boots Colourprint 400	400	•	•		as above
Dixons Colourprint 100	100	•	•		as above
Dixons Colourprint 400	400	•			as above
Fujicolor FII	100	•	•	•	110, 126
Fujicolor 400	400	•	•	•	110
Kodacolor II	100	•	•	•	110, 126, 127, 620
Kodacolor 400	400	•	•	•	110
Kodak Vericolor Professional	100	•	•	•	
Sakuracolor II	100	•	•	•	110, 126
Sakuracolor 400	400	•	•	•	110
3M Professional	100		•	•	
3M Professional	400		•		
Tudorcolor II	100	•	•		110, 126, 127

prefer. Buying, and trying, different films is really the only way of assessing the merits of each emulsion. But bear in mind that the actual processing of the film plays a great part in this final assessment. There are countless colour print processing laboratories offering services ranging from fast two-hour turn-round machine printing, to more expensive high-quality hand printing. Some photographers also process and print their own film.

Apart from the standard ASA 100 colour negative films there is also a specialist professional print film, Kodak Vericolor II. This is regarded by many as a better-quality film than Kodacolor II and, indeed, it is used by many professional photographers, particularly

Finding a laboratory

It isn't difficult to find a processing laboratory—there are usually plenty of them advertised in photographic magazines. Actually finding the *right* one is, of course, a different matter.

Most photographers try a few laboratories out and stay with the one that provides the best service and price. Try and do this before taking on any serious work. Talk to a few photographer friends if possible, find out which laboratories they are using, and look at the results. Ask about service, price, quality . . . the more initial enquiries made, the more economical it can be for you to find a suitable laboratory for your work.

If, however, you choose to use a film like Kodachrome or Agfa CT18 (CT21) the problem of finding a processing laboratory is resolved—the film is returned to the relevant manufacturer for processing. Quality and service is usually good for this kind of manufacturer service, although it can fluctuate during 'peak' summer months when a vast amount of amateur film is being handled for processing.

Most processing is 'fast turnround' these days, which means that your films should only take days to come back from the laboratory. In some cases, particularly with colour transparency film, same-day processing, with 24-hour turnround, is possible, often at no extra cost. But while speed is important in some areas of freelancing, quality can be the most important aspect. It is one thing getting a print back quickly, and quite another if it is shabby and of poor quality. Sometimes a slower turnround allows the processor to exercise better quality control and you benefit in the long run.

those taking wedding photographs. It is slightly more expensive but, in my opinion, it is worth paying extra for.

Colour transparency

There are two ways of buying colour transparency film. The first is to buy a *process-paid* film, such as Kodachrome 25 or Agfa CT18,

Colour transparency film

Film name *(process paid)	ASA speed	35 mm 20 exp	35 mm 36 exp	120	Others
*Agfachrome CT18	50	●	●	●	110, 126 127, rapid
*Agfachrome CT21	100		●		
Agfachrome 100	100		●		
Agfachrome R100S	100			●	
Agfachrome 50S	50		●		bulk 30 m
Agfachrome 50L	50		●		bulk 30 m
Barfen CR100	100		●		bulk 7.5, 10, 15, 30 m
Dixons Colourslide	100		●		
Fujichrome RD	100	●	●		
Fujichrome RH	400	●	●		
Kodacolour 1000	1000	To be announced			
*Kodachrome 25	25	●	●		
*Kodachrome 64	64	●	●		110, 126
*Kodak Ektachrome 64	64	●	●	●	
Kodak Ektachrome 200	200	●	●	●	
Kodak Ektachrome 160 Tungsten	160	●	●	●	
Kodak Ektachrome 400	400	●	●	●	
*ORWO UT20	80		●		
TFM R21B	100	●	●		bulk 10, 30 m
Sakurachrome 100	100	●	●		10, 30 m
3M Professional	100, 400		●		
3M Pro 640 Tungsten	640		●		
Tudorchrome 100	100	●	●		

where the cost of the film *and* the processing is included in the price. After exposure the film is sent to the manufacturer (a special envelope is supplied) who then returns a box of processed and mounted 35 mm transparencies. The second way is to buy *non-process-paid* film, such as Ektachrome 64—here, the cost of the *film only* is paid for and processing can be performed either by the photographer, or by an outside laboratory (at extra cost).

There are fewer process-paid films than non-process-paid films on the market, and some freelances may find this a restricting factor. In terms of cost there is little difference between the two alternatives, depending on how much film you buy and how it is processed, so usually it is best to look for an emulsion that produces the kind of colour results you are after.

Again, only experimentation will help you decide the relevant merits of each type of film. Largely it can be a matter of film speed (Kodachrome 25 may be too slow for some photography, and a faster emulsion, such as Ektachrome 200, might be required). Or it might be colour quality that is the deciding factor—some photographers find certain films more pleasing than others.

Special films

While conventional emulsions are quite adequate for most freelancing situations, there are special films on the market which may find occasional use. It is worth knowing about these should a special assignment call for their use.

Black and white
Copying film This can be used when copying black and white photographs, drawings, or most line artwork. A special high-contrast film, commonly known as 'line' film, is available. This produces very dense whites and blacks, with no middle grey tones. Useful for copying text or line drawings. Also produces a 'pen-and-ink' effect from conventional images.
Infrared film This film has a sensitivity range which extends into the infrared region of the spectrum. Useful for photographing animals at night using invisible infrared light (from flash or lamps), or looking at land variations in aerial photography. This film should be used in conjunction with an infrared transmitting filter to eliminate other colour wavelengths.

Colour
Infrared film Infrared Ektachrome is a transparency film sensitive to blue, green and infrared. It gives various colour distortions which can be varied using different colour filters.
Duping film A low-contrast film designed specially for copying, or 'duping', transparencies.

The Freelance's Directory

PHOTOGRAPHIC MAGAZINES

Amateur Photographer
Surrey House, 1 Throwley Way, Sutton,
Surrey SM1 4QQ. Tel: 01-643 8040
Editor: Roy Green

British Journal of Photography
28 Great James St, London WC1N 3HL. Tel:
01-404 4202
Editor: Geoffrey Crawley

Camera & Creative Photography
EMAP National Publications Ltd, Bushfield
House, Orton Centre, Peterborough
PE2 0UW. Tel: (0733) 237111
Editor: Malc Birkitt

Camera Choice
Surrey House, 1 Throwley Way, Sutton,
Surrey SM1 4QQ. Tel: 01-643 8040
Editor: Stephen Bayley

Camera Weekly
Haymarket Publishing Ltd, 38–42 Hampton
Rd, Teddington, Middx TW11 0JE. Tel:
01-977 8787
Editor: George Hughes

Hot Shoe
Grosvenor Publications Ltd, 17 South Molton
St, London W1.
Publisher/editor: Robert Prior

Photography Magazine
Model & Allied Publications Ltd, PO Box 35,
Wolsey Hse, Wolsey Rd, Hemel Hempstead,
Herts, HP2 4SS. Tel: (0442) 41221
Editor: John Wade

Practical Photography
EMAP National Publications Ltd, Bushfield
House, Orton Centre, Peterborough
PE2 0UW. Tel: (0733) 237111
Editor: Richard Hopkins

SLR Camera
Haymarket Publishing Ltd, 38–42 Hampton
Rd, Teddington, Middx TW11 0JE. Tel:
01-977 8787

The Photographer
UTP House, 1 Gayford Rd, London W12. Tel:
01-743 8618
Editor: Christopher Wordsworth

Which Camera?
Haymarket Publishing Ltd, 38–42 Hampton
Rd, Teddington, Middx TW11 0JE. Tel:
01-977 8787

PHOTOGRAPHIC ANNUALS

British Journal of Photography Annual
Henry Greenwood & Co Ltd, 28 Great James
Street, London WC1N 3HL
Tel: 01-404 4202

Photography Year
Time-Life Books, c/o Time-Life International
Ltd, Time & Life Building, New Bond St,
London W1Y 0AA
Tel: 01-499 4080

Photography Yearbook
Fountain Press, Argus Books, 14 St James Rd,
Watford, Herts

PICTURE LIBRARIES AND AGENCIES
*Member of BAPLA (British Association of
Picture Libraries and Agencies).*

Adams Picture Library*
17–18 Rathbone Place, London W1
Tel: 01-636 1468
Contact: Ted Isaac
Markets: All
Formats accepted: 35 mm, 120, 4 ×5 in, larger
formats
B/W accepted: No
Approach: Submit material by mail, or
personal visit can be arranged
Agency fee: 50 per cent
Subjects: Most areas and subjects. Looking
for still life, scenes as used in calendars and
cards.
Other details: Cardboard mounts preferred
with photographer's name and reference
number, plus accompanying list with brief
description of each transparency. Subjects
sometimes needed at short notice, and
photographers may be contacted by phone.

Alan Hutchison Library Ltd*
31 Kildare Terrace, London W2 5JT
Tel: 01-229 7386
Contact: Vanessa Fletcher
Markets: Publishers, calendars, advertising,
audio-visual, television
Formats accepted: 35 mm (Kodachrome
preferred)
B/W accepted: Yes. Minimum print size
6 ×8 in
Approach: Contact before sending material
Agency fee: 50 per cent
Subjects: Third World, especially Africa—also
Australia
Other details: Initial portfolio of 700
transparencies required.

Ancient Art & Architecture Collection*
6 Kenton Rd, Harrow-on-the-Hill, Middx
HA1 2BL
Tel: 01-422 1214
Contact: Mr R. Sheridan
Markets: Publishing, TV, audio visual
Formats accepted: 120, 4 ×5 in Kodachrome,
larger formats (no negative colour)
B/W accepted: No
Approach: Submit material by mail
Agency fee: 50 per cent
Subjects: Historical subjects from earliest
archaeological times up to about the 18th
century, including works of art and artefacts
which can be used to illustrate the
civilisations of the ancient world. Also
monumental buildings (churches, temples,
homes of the famous).

Other details: Material must be of the highest
technical standard. All photographs
submitted must be accompanied by a
stamped, addressed envelope. Pictures
should be fully captioned separately with
accurate details including names, dates,
places, etc.

Aquila Photographics
PO Box 1, Studley, Warwickshire B80 7JG
Tel: (052785) 2357
Contact: Alan Richards
Markets: Any requiring natural history
photographs
Formats accepted: 35 mm, 6 ×6 cm and
6 ×4.5 cm
B/W accepted: Yes. Minimum 6 ×8 in
Approach: Write before sending material
Agency fee: 40 per cent
Subjects: All aspects of natural history
Other details: Technical excellence and artistic
quality required in transparencies, ie, they
must be sharp, correctly exposed and
composed to best advantage.
Transparencies should be in card mounts
with English name of subject, its scientific
name, and the photographer's name. Prints
should be glossy and labelled similarly on
the back. Initial submission at least 100
(slides or prints). Photographer free to place
pictures elsewhere. Payment every six
months.

Art Directors Photo Library*
Image House, 86 Haverstock Hill, London
NW3
Tel: 01-722 1729
Contact: Jack Stanley
Markets: Advertising, publishing, audio visual,
editorial (magazines, calendars, record
sleeves, supplements, etc.)
Formats accepted: 35 mm, 120, 4 ×5 in, larger
formats preferred
B/W accepted: No
Approach: Contact before sending material
Agency free: 50 per cent
Subjects: All.
Other details: Be prepared to bring along all
the transparencies you have, even those you
don't think are suitable. Holiday snaps may
be of more value than you think. No
minimum number of pictures required.

A–Z Botanical Collection*
Holmwood House, Mid Holmwood, Dorking,
Surrey RH5 4HE
Tel: Dorking (0306) 888130
Contact: Mark MacAndrew
Markets: Publishers, advertising agencies,
television, audio-visual, educational
Formats accepted: 120 (6 ×6 cm, 6 ×7 cm),
4 ×5 in, larger formats
B/W accepted: No
Approach: Contact before sending material
Agency fee: 50 per cent
Subjects: All botanical subjects—not just
flowers. Most UK subjects adequately
covered, but overseas items needed most.
Other details: Captions for pictures must be
Latin botanical name. Good small garden
scenes always needed. No minimum
submission required.

Barnaby's Picture Library*
19 Rathbone St, London W1P 1AF
Tel: 01-636 6128
Contact: Mrs Mary Buckland
Markets: All
Formats accepted: 35 mm, 120, 4 ×5 in, larger formats
B/W accepted: Yes. Minimum 8 ×10 in.
Approach: Initial material by mail (enclose return postage)
Agency fee: 50 per cent
Subjects: All subjects
Other details: Minimum 200 pictures required. Prints should have name, negative number and caption (prints non-returnable). 35 mm transparencies should be card mounted, other size transparencies supplied in individual sleeves. No glass mounts. Send colour by recorded or registered post. Material retained exclusively.

Bips-Bernsen's International Press Service Ltd
2 Barbon Close, Great Ormond St, London WC1N 3JS
Tel: 01-405 2723
Contact: Teo Bernsen
Markets: Worldwide
Formats accepted: 35 mm, 6 ×6 cm and 6 ×4.5 cm
B/W accepted: Not larger than 8 ×10 in
Approach: Contact before sending material
Agency fee: 50 per cent
Subjects: General, human interest, education, popular science, unusual cars/motorbikes, inventions, popular technology, medical.
Other details: Preference given to buying all rights of material. Also assign photographers to cover subjects for a fee, with expenses reimbursed.

Bruce Coleman Ltd*
17 Windsor St, Uxbridge, Middx UB8 1AB
Tel: Uxbridge (0895) 57094
Contact: Ms Diana Korchien, picture editor
Markets: Books, encyclopaedias, advertising, calendars, postcards, posters, audio-visual, television, record sleeves, editorial
Formats accepted: 35 mm (Kodachrome preferred), 120 (6 ×6 cm only), 4 ×5 in
B/W accepted: No
Approach: Contact before sending material. Write including a stamped, addressed envelope (no telephone queries)
Agency fee: 50 per cent
Subjects: Natural history, scenic views, geographical, travel, architecture, science, medical, cities, towns, villages, county scenes
Other details: Initial submission of 500 transparencies, with a guarantee of 100 new transparencies annually.

Colour Library International*
86 Epsom Rd, Guildford, Surrey GU1 2BX
Tel: (0483) 579191
Contact: (see Keystone Press Agency)

Elisabeth Photo Library (London) Ltd*
51 Cleveland St, London W1A 4ER
Tel: 01-580 7285
Contact: E. G. Templeton
Markets: Publishing, television and radio, audio-visual, tourism, calendars, greetings cards, etc.
Formats accepted: 35 mm (Kodachrome preferred), 120, 4 ×5 in
B/W accepted: No
Approach: Contact before sending material, or arrange personal visit
Agency fee: 60 per cent
Subjects: Most subjects.
Other details: Pictures should be very sharp. Series of pictures with text acceptable for features. 300 pictures required initially.

Feature-Pix Colour Library (Travel Photographic Services Ltd)*
21 Great Chapel St, London W1V 3AQ
Tel: 01-437 2121
Contact: Gerry Brenes or Ricky Strange
Markets: Travel (brochures, magazines, airlines, travel companies, etc)
Formats accepted: 6 ×6 cm, 6 ×7 cm, 4 ×5 in
B/W accepted: No
Approach: Write before submitting, or arrange personal visit
Agency fee: 50 per cent
Subjects: Holiday destinations, plus emotive pictures of families, couples, girls, children on holiday. Pictures should include people where possible
Other details: Insist on exclusive representation for travel market. No minimum number of photographs required.

Frank Lane Agency*
Drummoyne, Southill Lane, Pinner, Middx HA5 2EQ
Tel: 01-866 2336
Contact: Jean Lane
Markets: Publishing, advertising, calendars, greetings cards, audio-visual
Formats accepted: 35 mm, 120, 4 ×5 in
B/W accepted: Yes. Minimum print size 5 ×7 in
Approach: Submit by mail, or arrange personal visit
Agency fee: 50 per cent
Subjects: Natural history, weather, geological activity, insects, marine, seasons, botanical subjects, underwater, zoos, etc.
Other details: 50 pictures required initially, with further work submitted on a regular basis. Prepared to take on small number of photographers who can work to a high standard.

Geoslides (Photography)
4 Christian Fields, London SW16 3JZ
Tel: 01-764 6292
Contact: Library director
Markets: Book and magazine publishers, advertising, television, calendars, industry (especially travel and educational)
Formats accepted: 35 mm (Kodachrome preferred), 120, 4 ×5 in, larger formats
B/W accepted: Yes. Minimum print size 6 ×8 in
Approach: Contact before sending material
Agency fee: 50 per cent

Subjects: Must be subjects from Africa, Asia, Arctic, sub-Arctic, Antarctica. Also specialist geomorphological material elsewhere in the world.
Other details: Geoslides do not usually hold photographers' material in stock, but call relevant material into the library in response to clients' requirements. Thus the photographer may continue to use and market the photographs independently, with the advantage of library representation. Photographers should have their own stock of at least 500 pictures.

The J. Allan Cash Photo Library*
74 South Ealing Rd, London W5 4QB
Tel: 01-840 4141
Contact: Alan Greeley
Markets: Publishing, educational, television, press, advertising, travel industry, brochures, etc.
Formats accepted: 35 mm (selectively, Kodachrome preferred), 120, 4 ×5 in, larger formats
B/W accepted: Yes. Minimum print size 8 ×10 in.
Approach: Contact before sending material
Agency fee: 50 per cent
Subjects: All types of pictures in many subject areas
Other details: About 100 pictures required initially if accepted. Regular submissions required. For further information photographers should include a stamped, addressed envelope. Material held for minimum of 3 years; 12 months' notice of withdrawal required.

Keystone Press Agency Ltd*
Bath House, 52/62 Holborn Viaduct, London EC1A 2FE
Tel: 01-248 2398
Contact: C. Lawson
Markets: Most markets supplied
Formats accepted: 120, 4 ×5 in, 35 mm larger formats
B/W accepted: Yes
Approach: Contact before sending material
Agency fee: 50 per cent
Subjects: Travel, glamour, animals, landscape, sport, royalty, etc
Other details: Minimum of 100 transparencies required initially, with further regular input.

Natural Science Photos*
33 Woodland Drive, Watford WD1 3BY, Herts
Tel: Watford (92) 45265
Contact: P. H. or Mrs S. L. Ward
Markets: Book publishers, magazines, filmstrip companies, audio-visual, advertising, television. Britain and overseas
Formats accepted: 35 mm (Kodachrome preferred), 120, 4 ×5 in, larger formats
B/W accepted: No
Approach: Contact before submitting material
Agency fee: 33 per cent
Subjects: Natural science: all types of wildlife from micro-organisms to macro. All aspects of botany, geography, mineralogy. Now accepting material on freshwater and sea angling.
Other details: All transparencies should carry 'common' or English name of organism,

plus scientific name, and some binomic information if possible. Should also carry photographer's name. Will make constructive criticism if requested. Minimum submission not specified. Pictures held for three years.

Northern Picture Library*
Unit 2, Bentinck St Industrial Estate, Ellesmere St, Manchester M15 4LN
Tel: 061-834 1255
Contact: Janet Cummings
Markets: Advertising, publishing, travel trade, greetings cards, audio-visual, packaging, etc.
Formats accepted: 35 mm (Kodachrome and Ektachrome preferred), 120, 4 ×5 in, larger formats
B/W accepted: No
Approach: Contact before sending material
Agency fee: 50 per cent
Subjects: People at work, high technology, etc. Also oil rigs, chemical plants, industrial scenes. Shots of people enjoying themselves, families at play, etc.
Other details: No minimum submission

P.F.B. Photo Library
11A The Crescent, Leeds LS6 2NW
Tel: (0532) 789869 or 742054
Contact: Mr P. F. Brown
Markets: All
Formats accepted: 35 mm, 120, 4 ×5 in, larger formats
B/W accepted: No
Approach: Write before sending material (enclose stamped, addressed envelope)
Agency fee: 50 per cent
Subjects: Most subjects. Emphasis on sport, scenes and views, specialised subjects.
Other details: Try to avoid people in each picture unless they are relevant. On 6 ×6 cm format, allow space for cropping. Duplicate transparencies rarely used. Transparencies must be captioned accurately. Submit 35 mm in slide sheets, rather than boxes.

Photo Library International*
St Michaels Hall, Bennett Rd, Leeds LS6 3HN
Tel: (0532) 789321
Contact: Kevin Horgan
Markets: Advertising, books, calendars, greetings cards, magazines, posters, record sleeves, travel brochures, television
Formats accepted: 35 mm (Kodachrome or Ektachrome), 120, 4 ×5 in, larger formats
B/W accepted: No
Approach: Contact before sending material
Agency fee: 50 per cent
Subjects: Wide range, from agriculture to world views
Other details: Initial submission 300 transparencies, plus similar number of slides per annum afterwards. Also willing to make cash offers to buy pictures outright.

Pictorial Press Ltd
30 Aylesbury St, London EC1R 0BL
Tel: 01-253 4023
Contact: Tony Gale
Markets: Worldwide
Formats accepted: 35 mm (Kodachrome preferred), 120, 4 ×5 in, larger formats

B/W accepted: Yes. Minimum print size 8 ×10 in
Approach: Contact before sending material
Agency fee: 50 per cent
Subjects: Aircraft, cars, medicine, pop music, children, royalty, military, teenagers, wildlife personalities, dramatic events, etc.
Other details: Must be top-quality to have any chance of selling. Material will not be returned without a stamped, addressed envelope.

Pictor International Ltd
Lynwood House, 24–32 Kilburn High Rd, London NW6 5XW
Tel: 01-328 9221
Contact: Alberto Sciama
Markets: Various
Formats accepted: 6 ×6 cm, 6 ×7 cm, 4 ×5 in, larger formats
B/W accepted: No
Approach: Subject material by mail (offices in London, Paris, Milan)
Agency fee: 50 per cent
Subjects: All subjects
Other details: Initial portfolio of 350 transparencies required.

PicturePoint Ltd*
770 Fulham Rd, London SW6 5SJ
Tel: 01-736 5865
Contact: Ken Gibson
Markets: Most (except 'hot' news media)
Formats accepted: 35 mm (Kodachrome preferred), 120, 4 ×5 in, larger formats
B/W accepted: No
Approach: Write before sending material
Agency fee: 50 per cent
Subjects: Localities, aerial, people at work, family life, leisure, romance, glamour, local events, industry, natural history, agriculture, sport, architecture, fine art, medical and scientific
Other details: Looking for something 'special' in the work of prospective contributors— top-class transparencies only. Regular submissions of at least 50 slides (card mounted) required. Accurate captions essential. Fees average out at £35

Robert Harding Picture Library*
5 Botts Mews, Chepstow Rd, London W2 5AG
Tel: 01-229 2234
Contact: Robert Harding
Markets: Wide range, including publishing, advertising, audio-visual, television, UK and worldwide
Formats accepted: 35 mm (Kodachrome preferred), 120, 4 ×5 in, larger formats
B/W accepted: No
Approach: Submit by mail, or arrange a visit
Agency fee: 50 per cent
Subjects: Travel, people, children, girls, industry, natural history, transport
Other details: Minimum initial submission of 500 transparencies.

S & G Press Agency
68 Exmouth Market, London EC1
Tel: 01-278 5661 (picture desk) 01-278 1223 (library)
Contact: Picture desk (news material), library

Markets: National/international media, television and radio, book publishers, advertisers
Formats accepted: 35 mm (Kodachrome/ Ektachrome preferred), 120, 4 ×5 in, larger formats
B/W accepted: Yes. Minimum print size 8 ×10 in. Negatives supplied where possible
Approach: Contact before sending material
Agency fee: 50 per cent
Subjects: News, sport, feature material— Britain and abroad.

Seaphot Ltd: Planet Earth Pictures*
23 Burlington Rd, Bristol BS6 6TJ
Tel: (0272) 741206
Contact: Gillian Lythgoe, Keith Scholey or John Lythgoe
Markets: Publishers, advertising agencies, designers, calendars, promotional material, audio-visual, etc.
Formats accepted: 35 mm (Kodachrome preferred), 120, 4 ×5 in, larger formats
B/W accepted: Yes. Minimum print size 8 ×10 in
Approach: By mail or arrange personal visit
Agency fee: 50 per cent
Subjects: Marine photography of all kinds (above and underwater), natural history in water, on land and in the sky
Other details: Minimum of 100 images required, but will accept less if work is of unusual nature. Booklet available for photographers.

Spectrum Colour Library
146 Oxford St, London W1
Tel: 01-637 1587
Contact: Chris Mathews, Keith or Ann Jones
Markets: Various
Formats accepted: 35 mm, 120, 4 ×5 in, larger formats
B/W accepted: Yes. Minimum print size 8 ×10 in
Approach: Contact before sending material
Agency fee: 50 per cent
Subjects: Industry, technology, conferences, meetings, offices, Third World development, children, couples, families, medical, ecology
Other details: Minimum of 300 pictures required.

Travel Trade Photography
18 Princedale Rd, London W11 4NY
Tel: 01-727 4571
Contact: Teddy Schwarz
Markets: Travel brochures/supplements, magazines, book publishers, guide books, etc.
Formats accepted: 120, 4 ×5 in, larger formats
B/W accepted: No
Approach: Submit material by mail. Include postage for return
Agency fee: 50 per cent
Subjects: Holiday destinations worldwide and activities of tourists (people, markets, national pastimes, water sports, food, entertainment, etc.)
Other details: Shots must be taken under sunny conditions, be of excellent quality and have deep saturated colour. Initial submission of 40–50 pictures required.

Vision International*

30 Museum St, London WC1
Tel: 01-636 9516
Contact: Sue Pinkus or David Alexander
Markets: Editorial (books, magazines),
advertising, calendars, greetings cards,
postcards, record sleeves, audio-visual,
television
Formats accepted: 35 mm, 120, 4 ×5 in, larger
formats
B/W accepted: Yes. Minimum print size
6 ×8 in
Approach: Contact before sending material
Agency fee: 50 per cent
Subjects: Travel, gardens and plants,
architecture, abstracts, interiors, sport,
landscapes, natural history, reportage,
leisure, pregnancy, birth, child development,
medicine, health.
Other details: Initial submission of 500
pictures required. A gallery on the premises
is used to display and market prints by
photographers represented.

Visual Life

Middle Barmston Farm, District 15,
Washington, Tyne & Wear NE38 8LE
Tel: (091) 4165454
Contact: Brian Gadsby
Markets: Book publishers, magazines, travel
brochures, greetings cards
Formats accepted: 35 mm (Kodachrome or
Ektachrome preferred), 120, 4 ×5 in
B/W accepted: Yes. Minimum print size
6 ×8 in
Approach: Contact before sending material
Agency fee: 50 per cent
Subjects: Children activity, natural history,
travel (not 35 mm)
Other details: Queries by letter first. Enclose a
stamped, addressed envelope. No minimum
submission.

Woodmansterne Publications Ltd*

Holywell Industrial Estate, Watford, Herts
Tel: Watford (92) 28236/45788
Contact: Ruth Powell, librarian
Markets: Publishers, novelty and souvenir
market, calendars, television, audio-visual,
videograms, posters, greetings cards
Formats accepted: 35 mm (Kodachrome
preferred), 120, 4 ×5 in
B/W accepted: No
Approach: Contact before sending material
Agency fee: 50 per cent
Subjects: English scenes, ie, housing,
transport, industry, agriculture, services,
customs, landscapes (town, county,
coastal)
Other details: High pictorial and technical
standard only. No minimum submission

Zefa Picture Library (UK) Ltd*

PO Box 210, 20 Conduit Place, London
W2 1HZ
Tel: 01-262 0101/5
Contact: H. Harris
Markets: Worldwide
Formats accepted: 35 mm (Kodachrome
preferred), 120, 4 ×5 in, larger formats
B/W accepted: No
Approach: Write before sending material
Agency fee: 50 per cent

Subjects: Over 8000 categories
Other details: Initial submission 200
transparencies. Further input of at least 200
images per year. Agents worldwide.
Computerised service. Five years' use of
pictures.

CARD, CALENDAR AND POSTER COMPANIES

Companies producing greetings cards,
calendars and posters are often interested in
receiving material from photographers. The
selective list here shows what kind of
photographs are required, indicating the most
sought-after subjects, and the approximate
fees paid. In general, the companies often look
for the highest technical quality in the
photographs submitted, as well as the right
subject matter. Take careful note of the advice
here before submitting any material.
* Member of the CGCA (Calendar and
Greetings Card Association).

A. R. Mowbray

St Thomas House, Becket St, Oxford
Tel: (0865) 242507
Contact: Art Director
Material produced: Church magazines, books
Formats accepted: 120, 4 ×5 in, larger formats
B/W accepted: Yes—minimum size 8 ×6 in,
glossy, good tonal value
Approach: Submit material by mail. Include a
stamped, addressed envelope (black and
white normally retained for possible future
use)
Fees paid: £27–£50 for colour, £6–£10 for
black and white
Other details: Transparencies for next series of
magazine covers should be submitted by
December 1. Subjects should be of human
interest, indoors or outdoors, connected
with work or leisure. One colour shot
used per month. Black and white shots
should be of churches and church life, or
religious subjects of interest.

Athena International

PO Box 13, Bishops Stortford, Herts
Tel: Bishops Stortford (0279) 56627
Contact: Mr B. M. Everitt
Material produced: Posters, cards, postcards
Formats accepted: 120, 4 ×5 in, larger formats
B/W accepted: No
Approach: Contact before sending material
Fees paid: Not specified
Other details: All subjects suitable for posters
required, especially humour. Small
selections only to be sent, with a stamped,
addressed envelope.

Castle Publishing

Great George St, Preston PR1 1TJ
Tel: (0772) 59267
Contact: Irene Nicholas, design manager
Material produced: Christmas cards and other
occasion cards
Formats accepted: 4 ×5 in, larger formats
B/W accepted: No

Approach: Submit by recorded or registered
post
Fees paid: £50–£70
Other details: Subjects include landscapes,
flowers, gardens, scenes, still-life, winter
sports.

E. T. W. Dennis & Sons Ltd

Printing House Sq, Melrose St, Scarborough,
North Yorks YO12 7SJ
Tel: (0723) 61317
Contact: Mr C. G. Rhodes, Managing director
Material produced: Postcards and calendars
Formats accepted: 35 mm (Kodachrome
preferred), 120, 4 ×5 in, larger formats
B/W accepted: Yes. Enprint with negative
Approach: Contact before sending material
Fees paid: £18 per subject
Other details: Pictures of any views in the UK.

Giesen & Wolff Ltd*

Kaygee House, Dallington, Northampton NN5
7QW
Tel: (0604) 55411
Contact: Gordon Wood
Material produced: Greetings cards, calendars,
jigsaw puzzles
Formats accepted: 120, 4 ×5 in, larger formats
B/W accepted: No
Approach: Submit material by mail, or contact
first
Fees paid: £35–£50
Other details: Subjects include flora,
landscapes, cars, glamour.

J. Arthur Dixon*

Forest Side, Newport, Isle of Wight
Tel: (0983) 523381
Contact: Publishing department
Material produced: Greetings cards and
postcards
Formats accepted: 120, 4 ×5 in, larger formats
B/W accepted: No
Approach: Submit material by mail
Fees paid: Postcards £30, greetings cards £50
Other details: Subjects include sport, pets,
scenic views and snow scenes. Postcard
and greetings card rights are purchased and
transparencies returned after use, allowing
photographer to sell rights elsewhere.

Lowe Aston Calendars Ltd

Saltash, Cornwall PL12 4HL
Tel: (075 55) 2233/4
Contact: Mr L. C. Lowe or Mr D. E. Arthur
Material produced: Calendars
Formats accepted: 4 ×5 in
B/W accepted: No
Approach: Contact before sending material
Fees paid: Negotiable
Other details: Purchase material outright of
landscape subjects. Subjects include
country scenes, children, animals, old cars
and other attractive subjects. Approximately
36 pictures required annually.

Photo Production Ltd

Featherby Rd, Gillingham, Kent ME8 6PJ
Tel: Medway (0634) 33241
Contact: I. A. Surita, publishing manager
Material produced: Greetings cards
Formats accepted: 4 ×5 in, larger formats
B/W accepted: No

Approach: Submit material by mail
Fees paid: £45–£55
Other details: Subjects include views, still-life, flora and children.

Royle Publications Ltd*

Royle House, Wenlock Rd, London N1
Tel: 01-253 7654
Contact: Karen Simpkin
Material produced: Cards, calendars and prints (calendars only for photographs)
Formats accepted: 4 ×5 in, 8 ×10 in transparencies
B/W accepted: No
Approach: Contact before sending material
Fees paid: £75 per photograph
Other details: Produce two calendars, 'Moods of Nature' and 'Gardens of Britain'. 1984 and 1985 selection for these calendars already made, and work for the 1986 calendars must be submitted by mid-September 1983. Minimum number of pictures required is five, maximum 20.

Whitehorn Press Ltd

Thomson House, Withy Grove, Manchester M60 4BL
Tel: 061-834 1234
Contact: W. D. Amos
Material produced: Scenic calendars and magazines
Formats accepted: 120, 4 ×5 in, larger formats, 35 mm (in magazines)
B/W accepted: By arrangement
Approach: Contact before sending material
Fees paid: By arrangement
Other details: Require scenic views of Lancashire, Yorkshire, Cheshire, Warwickshire, Worcestershire, West Midlands, Gloucestershire and Avon.

Wilson Bros Greetings Cards Ltd

Academy House, Springfield Rd, Hayes, Middx UB4 0LW
Tel: 01-573 3877
Contact: E. W. Stewart
Material produced: Greetings cards and allied products
Formats accepted: 120, 4 ×5 in, larger formats
B/W accepted: No
Approach: Submit material by mail
Fees paid: £60–£80
Other details: Subjects include landscapes, seascapes, studio shots (flowers, Christmas, etc.), animals, transport.

W. N. Sharpe

Bingley Rd, Bradford BD9 6SD
Tel: Bradford (0274) 41365
Contact: A. R. Groves
Material produced: Greetings cards
Formats accepted: 6 ×7 cm, 4 ×5 in and larger formats
B/W accepted: No
Approach: Submit material by mail
Fees paid: £75
Other details: Subjects include children, sport, pastimes, transport, flora, landscapes.

Some freelances with enterprise may wish to create their own calendars or greetings cards. One idea is to buy a ready-made A4 card calendar, with twelve pages including the dates of each month, but with sufficient room for the photographer's own prints to be included. The photographer could select a theme, compile a set of prints, and market a number of special calendars among friends, colleagues or business contacts. This custom calendar can be used as a profit-making venture or as a promotional vehicle to help attract further work. One company which produces a blank calendar for this purpose is Bunce Products, 12 West End, Hurworth on Tees, Darlington OL22 HB. Tel: Darlington 720377. Cost is around £2.50.

MAJOR EXHIBITIONS

Throughout the year there are various exhibitions organised to attract the work of photographers. It is impossible to list all of them here, but here are some to consider. While they cannot be considered to be profitable ventures—for some you have to pay a fee to enter—they do have their own rewards in terms of public showing, awards, and the enjoyment of participation. Sometimes the exhibits are shown all over the world, making them an excellent platform for photographers.

Bristol Salon of Photography

Contact: P. J. McClosky, 3 Cranside Ave, Redland, Bristol BS6 7RA.

London Salon of Photography

Contact: Edwin Appleton, 8 Paddock Walk, Warlingham, Surrey CR3 9HW.

Midland Salon of Photography

Contact: Alan Millward, 3 Beauscale Croft, Mount Nod, Coventry CV5 7HL.

Royal Photographic Society Annual Slide Competition
Royal Photographic Society International Exhibition of Photography

Contact: Royal Photographic Society, The Octagon, Milsom St, Bath.

Scottish Salon of Photography

Contact: C. Turner, 30 Methuen Rd, Paisley, Scotland PA3 4JX.

Smethwick PS Colour International Exhibition

Contact: Tony Wharton, 2 Ashfield Grove, Halesowen B63 4LH

Solihull PS Open Exhibition of British Photography

Contact: Bob Moore, 102 Richmond Rd, Solihull B92 7RR.

Welsh International Colour Slide Exhibition

Contact: W. A. Stuart-Jones, Bryan Hafod, 52 Caswell Rd, Mumbles, Swansea.

FREELANCE ORGANISATIONS COURSES

Bureau of Freelance Photographers

Focus House, 497 Green Lanes, London N13 4BP. Tel: 01-882 3315

Mallinsons School of Photography

Little London Quay, Newport, Isle of Wight PO30 5BS. Tel: (0983) 529955

New York Institute of Photography

18–20 High Rd, London N22 6BR. Tel: 01-888 1242

PHOTOGRAPHIC ORGANISATIONS

AFAEP (Association of Fashion, Advertising & Editorial Photographers)
10A Dryden St, London WC2. Tel: 01-240 1171

APL (Association of Photographic Laboratories)
9 Warwick Ct, Gray's Inn, London WC1R 5DJ Tel: 01-405 2762

BAPLA (British Association of Picture Libraries and Agencies)
PO Box 284, London W11 4RP. Tel: (0242) 89373

IIP (Institute of Incorporated Photographers) Professional membership, training.
Amwell End, Ware, Herts. Tel: (0920) 4011/2

IPART (Institute of Photographic Apparatus Repair Technicians)
228 Regents Park Rd, London N3. Tel: 01-346 8302

IPPA (Irish Professional Photographers Association)
12 Ludford St, Dublin 14, Ireland.

MPA (Master Photographers Association)
1 West Ruislip Station, Ruislip, Middx HA4 7DW. Tel: Ruislip (71) 34515

NUJ (National Union of Journalists)
Acorn House, 314 Grays Inn Rd, London WC1. Tel: 01-278 7916

PAGB (Photographic Alliance of Great Britain). Camera clubs information.
c/o Marjorie Marshall, 'Amstel', High View Close, Upper Norwood, London SW19

PPANI (Professional Photographers Association of Northern Ireland)
16 Mill St, Comber, Newtonards, Co Down, Northern Ireland.

RPS (Royal Photographic Society)
The Octagon, Milsom St, Bath BA1 1DN. Tel: (0225) 62841

EQUIPMENT HIRE

There are several retailers around the country who specialise in hire of cameras, lenses, lighting, special accessories, and so on. In some cases, this service is open to professionals only, or to someone hiring equipment for a company. Check with the individual hire company first. Sometimes, a returnable deposit covering the value of the hired equipment is necessary.

Anglia Cameras
15 St Matthew's St, Ipswich 1P1 3EL
Tel: (0473) 58185
Audio-visual, cine, still.

Bray & Son
16–22 Dunford Rd, Holmfirth, Huddersfield HD7 1DP
Tel: (0484) 89 3213
Varied range. Example: Contax RTS with 500 mm f 1.4 lens, £7.30 per day £22.50 per week).

Edric Audio Visual Ltd
34–36 Oak End Way, Gerrards Cross, Bucks SL9 8BR
Tel: Gerrards Cross (0753) 886521/84646
Varied range.

George Elliott & Sons Ltd
Ajax House, Hertford Rd, Barking, Essex 1G11 8BA
Tel: 01-591 5599
Overhead projectors, Episcopes.

Leopold Cameras Ltd
17 Hunter St, London WC1N 1BN
Tel: 01-837 6501/6382
Varied range. Example: Hasselblad 500CM with standard lens, £10 plus VAT per day (£40 plus VAT per week).

Nottingham Photo Centre
28–30 Pelham St, Nottingham
Tel: (0602) 55503/4
Varied range. Example: Hasselblad 500CM with lens, from £11 plus VAT per day.

Pelling & Cross Ltd
104 Baker St, London W1M 2AR
Tel: 01-487 5411
2 Balantine St, Manchester 15 4LF
Tel: (061) 832 4957
Radio House, Aston Rd, North, Birmingham B6 4DA
Tel: (021) 359 5751
5–9 Welsh Back, Bristol BS1 4SP
Tel: (0272) 24024
Comprehensive range of equipment. Example: Hasselblad 500CM with standard lens, £11.25 plus VAT per day (£45 plus VAT per week). Deposit equivalent to value of equipment required (returnable).

EQUIPMENT SERVICING/REPAIRS

* *Member of IPART (Institute of Photographic Apparatus Repair Technicians).*
** *Member of PIRA (Photographic Instrument Repairing Authority).*
† *Member of SPT (Society of Photo Technicians).*

Advance Technical Cameras
24 Poland St, London W1
Tel: 01-734 0895
Type of equipment serviced/repaired: All types of camera, still and cine, as well as lenses and light meters.
Average cost of camera repair: £20 plus parts
Average cost of camera service: £24
Guarantee: Six months

Axco Instruments Ltd*
228 Regents Park Rd, Finchley, London N3 3HP
Tel: 01-346 8302
Type of equipment serviced/repaired: Cameras, lenses, meters, flashguns, cine, accessories. Authorized service centre for Olympus and Multiblitz.
Average cost of camera service/repair: Estimates on request.
Guarantee: Six months, parts and labour

Bournemouth Photographic Repair Services*†
237 Capstone Rd, Bournemouth BH8 8SA
Tel: (0202) 513586
Type of equipment serviced/repaired: Cameras, flash and accessories of most makes. Zeiss Ikon-Voigtlander servicing. Also spares for large range of vintage cameras, as well as for modern equipment
Average cost of camera service/repair: List of standard charges available

Central Camera
29 Salters Rd, Walsall Wood, Walsall, WS9 9JD
Tel: (0543) 370263
Type of equipment serviced/repaired: Most types of cameras, also projection equipment and flash units, lenses and accessories
Average cost of service: £20 for most SLRs
Average cost of repair: £15–£20 for most SLRs
Guarantee: Six months, parts and labour

Clifton Technical Services*
153 London Rd, North End, Portsmouth, Hants
Tel: (0705) 695411
Type of equipment serviced/repaired: All types of cameras, flashguns, lenses, projectors, cine cameras, accessories
Average cost of camera repair: £10–£30
Average cost of camera service: £10–£30
Guarantee: Three months (on electrical repairs) to 12 months on full overhauls

Cousins & Wright*†
5 The Halve, Trowbridge, Wilts BA14 8SB
Tel: Trowbridge (02214) 4242

Type of equipment serviced/repaired: All
Average cost of camera repair: £20 plus VAT
Average cost of camera service: £5 plus VAT (if no spares or major dismantling)
Guarantee: Yes

East Herts Faultfinding Services
30 Cardigan St, Luton LU1 1RR
Tel: Luton (0582) 421640
Type of equipment serviced/repaired: Electronic flash. Good stock of most parts for many models, also accumulators and leads. Also specialise in repair of Halina cameras
Average cost of service/repair: No prices given
Guarantee: Three months, parts and labour

H. A. Garrett*†
300 High St, Sutton, Surrey
Tel: 01-643 5376/7/8
Type of equipment serviced/repaired: All types of cameras, 35 mm SLR to cine. Also slide projectors, cine and audio-visual equipment, lenses (re-polishing and coating), electronic flash. Main service agents for Olympus
Average cost of camera repair: £19–£35, excluding major spares for electronic SLRs. Around £12.50 for mechanical SLRs, excluding major spares.
Average cost of camera service: £12.50 (Olympus Trip) to £35 (Canon A-1)
Guarantee: Six months
Other details: Estimates can be provided free. Modification of some items possible.

H. Lehmann*†
249 London Rd, Stoke-on-Trent ST4 5AA
Tel: (0782) 413611/2
Type of equipment serviced/repaired: Most
Average cost of service/repair: £17 upwards
Guarantee: Yes

Instrument Services Co (London) Ltd
208 Maybank Rd, London E18
Tel: 01-504 5885
Type of equipment serviced/repaired: Weston Master exposure meters only
Average cost of repair: £18
Guarantee: Six months

J. L. Forrester*
Unit 1, Warstone House, 160 Warstone Lane, Hockley, Birmingham B18 6NN
Tel: (021) 236 9644
Type of equipment serviced/repaired: All types, including cameras, flashguns and projectors
Average cost of service/repair: Depends on fault
Guarantee: Six months

Leslie H. Frankham FRPS*
166 Westcotes Drive, Western Pk, Leics. LE3 0SP
Tel: (0533) 857771
Type of equipment serviced/repaired: Every kind of still camera of mechanical design, with or without metering built-in, from 1890 to modern cameras. No multi-mode electronic cameras repaired. Zeiss Ikon specialists

Average cost of camera repair: Quotation
forwarded to owner on examination
Average cost of camera service: £7.50 to £20
Guarantee: Yes

Pelling & Cross
104 Baker St, London W1M 2AR
Tel: 01-487 5411
(Also in Birmingham, Manchester and Bristol)
Type of equipment serviced/repaired: Most
cameras, as well as Bowens, Braun and
Mecablitz flash. Most 'professional'
equipment serviced and checked on test
equipment
Average cost of service/repair: Depends on
equipment and fault. Estimate can be
prepared on any item if required.
Guarantee: Three months

Sendean Ltd*
6/7 D'Arblay St, London W1V 3FD
Tel: 01-439 8418
Type of equipment serviced/repaired: Most
makes of still cameras, projectors, cine
equipment, and light meters
Average cost of camera repair/service: Not
given
Guarantee: Six months

Technica Camera City Ltd*
39A Foxbury Rd, Bromley BR1 4DG
Tel: 01-464 9217
Type of equipment serviced/repaired: Most
modern cameras and professional
photographic equipment
Average cost of service/repair: Not
given—£2.50 for estimate
Guarantee: Six months

Vanguard Photographic Services*†
156 Boston Rd, Hanwell, London W7 2HJ
Tel: 01-840 2177
Type of equipment serviced/repaired: All
Average cost of camera repair: £20
Average cost of camera service: £4
Guarantee: Yes

EQUIPMENT DISTRIBUTORS' CLUBS

Some of the major photographic distributors,
in order to encourage brand-name loyalty to a
particular product (or range of products),
organise participation clubs for
photographers. Here is a list of the current
distributor clubs, with details of membership.

Club Canon
PO Box 104, Sheffield S1 4FP
Annual membership cost: £10.95
Members receive a card, newsletter, magazine
and handbook. Benefits include special club
discounts, club events, technical advice,
holidays, clothing items.

Durst Darkroom Club
c/o Johnson's of Hendon Ltd, 14 Priestley
Way, London NW2
Annual membership cost: £5 (free first year for
purchasers of a new Durst enlarger)
Members receive a card, quarterly Durst
Darkroom Club magazine, special offers on
equipment, and badges and stickers are also
available. Two-day printing courses are run at
Hendon, and there are also regional meetings.

Leica Fellowship
14 Ravensdale, Acklam, Middlesborough,
Cleveland TS5 8TD
Annual membership cost: £7
Designed for Leica users who have attended
one of Leitz's user courses. Activities include
two meetings per annum, competitions.
newsletters.

Leica Postal Portfolio
c/o Dennis Hambury, 61 High St, Southwold,
Suffolk
Annual membership cost: £3.50
Boxes of pictures are circulated between
members, and each member gives a written
appraisal of the pictures, and contributes
his/her own pictures. There are around 18
circles, each with 15–20 members. There is a
newsletter, an annual meeting and
prizegiving.

Minolta Club of Great Britain
Minolta (UK) Ltd,1–3 Tanners Drive,
Blakelands North, Milton Keynes
Annual membership cost: £4.95
Quarterly magazine, camera insurance
scheme, special camera service facilities,
regular workshops, club discounts.

Nikon Club
Nikon (UK) Ltd, 20 Fulham Broadway,
London SW6
Annual membership cost: £10
Quarterly newsheet, servicing, trips,
insurance, promotional activity, teach-ins.

Pentacon Club
29 Cavendish Rd, Redhill, Surrey
Annual membership cost: £5
The club is for owners of Praktica, Exacta and
Pentacon cameras. A bi-monthly journal is
available, and there is help with camera
insurance/servicing, film discounts, club trips,
and so on.

Pentax Club
143 Hersham Rd, Walton-on-Thames, Surrey
Annual membership cost: £4.95
Pentax Magazine published quarterly. Special
offers on books, calendars, clothing,
accessories, etc. Also preferential terms on
repairs and servicing. Foreign trips arranged
frequently. Free advisory service and
competitions.

For camera club information, contact PAGB
(see Photographic organisations)

PRESENTATION

**Frames/mounts/folders/bonding and
laminating**

Ademco Ltd
Coronation Rd, Cressex Estate, High
Wycombe, Bucks HP12 3TA. Tel: High
Wycombe (0494) 448661.
Equipment and materials for heat sealing,
mounting dry and canvas.

Classic Frames
124–128 Alfreton Rd, off Newdigate St,
Nottingham. Tel: Nottingham (0602)
781761.
Frame manufacturers. Mounts, folders, photo-
albums.

Coated Specialities Ltd
Chester Hall Lane, Basildon, Essex SS14 3BG.
Tel: (0268) 3331.
Heat seal films, tissue for dry mounting,
presses, laminate materials.

Gemini Photographic Services
Victoria Rd, Yeovil, Somerset BA21 5AZ. Tel:
(0935) 26678.
Varied service, including exhibition mounting,
heat sealing, block mounting, framing,
laminating.

Juon Plastics Ltd
Old Windsor, Berks SL4 2RB. Tel: (07535)
53217.
Print display folders, transparency sleeves
(PVC).

Kay Mounting Service
351 Caledonian Rd, London N1. Tel: 01-
607 7241/2.
Mounting and heat sealing service.

Parma Agency Ltd
St Andrews Hall, Waghorn St, Peckham,
London 4LA. Tel: 01-732 9801.
Suppliers of albums, mounts, folders,
mounting tissue, presses, frames, negative
bags, etc.

Photobition
Byam St, Fulham SW6. Tel: 01-
736 1331/2/3.
71 Portland Sq, Bristol BS2 8SJ. Tel: (0272)
427195.
Prints and display transparencies, artwork,
typesetting.

Rexel Art & Leisure Products
Gatehouse Rd, Aylesbury, Bucks. Tel: (0296)
81421.
Frames, albums, mounting materials.

SLIDE STORAGE VIEWING

Audio Visual Material Ltd
AVM House, 1 Alexandra Rd, Farnborough, Hants GU14 6BU.
Tel: (0252) 540721
Slide storage cabinets.

Cyan Products Ltd
2 Worple Way, Richmond, Surrey TW10 6DF.
Tel: 01-948 5488.
Transparency sleeves.

DW Viewpacks Ltd
Unit 2, Peverel Drive, Granby, Bletchley, Milton Keynes. Tel: (0902) 642323.
Slide wallets, masks, mounts, light boxes.

Koroseal Trading Co Ltd
No. 1 Valentine Place, London SE1 8QH.
Tel: 01-928 8981.
Slide storage systems (PVC wallets, file sheets, etc.).

Nicholas Hunter Ltd
PO Box 22, Oxford OX1 2JT. Tel: (0865) 52678.
PVC slide and transparency wallets.

Photo-Science Ltd
Charfleets Rd, Canvey Island, Essex. Tel: Canvey Island (0268) 682122.
Negative and slide storage systems, cardboard mounts.

S. W. Kenyon
6 Fore St, Wellington, Somerset TA21 8AQ.
Tel: (082 347) 4151.
Slide storage systems.

Top Line Equipment
1 Tranley Mews, Fleet Rd, London NW3 2QX.
Tel: 01-485 0665/7.
Presentation masks and acetate sleeves

MARKETING

Photique
Key-ring Studios, 33 Coronation St, Blackpool FY1 4NY. Tel: (0253) 20303.
Key rings, fobs, other sales ideas.

Photoleaflets Ltd
Leodis House, Woodhouse St, Leeds LS6 2PY. Tel: (0532) 449241.
Single-sided leaflets (lettering and photographic printing combined).

Robert Wheal
23–24 Redan Place, London W2 4SA. Tel: 01-727 3828.
Photographers' index cards. Exclusive mailing list of possible clients available.

Walkerprint
46 Newman St, London W1P 3PA. Tel: 01-580 7031.
Photographers' index cards. Distribution to agencies if required.

STUDIO PROPS/ COSTUMES

Charles H. Fox Ltd
22 Tavistock, Covent Garden, London WC2.
Tel: 01-240 3111 or 01-836 8237.
Costume hire. Theatrical make-up available.

Eldridge & Eldridge London (Hire) Ltd
Farringdon House, 103–107 Farringdon Rd, London EC1. Tel: 01-278 8901.
Hire of furniture, paintings, objets d'arts, and unusual objects. Items made to order.

Lewis & Kaye (Hire) Ltd
50 Eversholt St, London NW1 1DA. Tel: 01-388 0419.
Studio props for hire.

Studio Accessories
443–449 Waterloo Rd, Blackpool, Lancs. Tel: (0253) 694340.
Studio props, painted backgrounds.

MISCELLANEOUS

Polysales Photographic Ltd
The Wharf, Godalming, Surrey GU7 1JX. Tel: (04868) 4171.
Wide range of photographic accessories. Catalogue available.

USEFUL READING

Make Your Pictures Win, John Wade (BFP Books)

Making & Managing a Photographic Studio, Bob Bluffield (David & Charles)

Creative Techniques in Photo-Journalism, Terry Fincher (Batsford)

The Darkroom Handbook, Michael Langford (Ebury Press)

Writers' & Artists' Yearbook (A & C Black)

Photographer's Market (USA) (Henry Greenwood)

British Journal of Photography Annual (Henry Greenwood)

Book of Special Effects Photography, Michael Langford (Ebury Press)

Book of Nature Photography, Heather Angel (Ebury Press)

Pictures on a Page, Harold Evans (Heinemann)

Successful Glamour Photography, John Kelly (Hamlyn)

Professional Photography, Michael Langford (Focal Press/Butterworth)

Earning Money at Home (Consumers' Association)

Index

Acknowledgments

Black and white photographs
2 Ed Buziak
3 Richard and Sally Greenhill
3 Lone Eg Nissen
9 Ed Buziak
12 Ed Buziak
14 Peter Griffiths
16 Brian Gibbs
17 Homer Sykes
18 Richard and Sally Greenhill
19 Richard and Sally Greenhill
21 Richard and Sally Greenhill
22 Homer Sykes
25 Nick Birch
28 Richard and Sally Greenhill
31 Barry Monk
32 Richard and Sally Greenhill
36 National Magazine Company
38 Ed Buziak
39 Richard and Sally Greenhill
41 Ed Buziak
42 Ed Buziak
43 Joy James
44 National Magazine Company
48 Stephen Goodger
49 David Kindred

50 Nick Birch
51 Brian Gibbs
54 Tony Boxall
55 Ed Buziak
56 Kevin Proctor
57 Derek W. Rodgers
58 John Pierce
60 F. G. Cuthbert
61 Clemens Kalisher
62 Damen First
64/65 Barry Monk
66 Popperfoto
67 Martin C. Smith
70 Richard Francis
71 Ed Buziak
72 Nick Birch
74 Bo Dahlgren
77 David Herrod
79 National Magazine Company
80 R. L. Snow
81 Michael Dobson
82 Tony Millar
84 Popperfoto
86 Martin Morris
87 Richard and Sally Greenhill
90 Wandsworth Photo Co

91 Judith Platt
92 Richard and Sally Greenhill
93 Dick Field
95 John Renwick
96 Richard and Sally Greenhill
97 Richard and Sally Greenhill
98 Richard and Sally Greenhill
99 Richard and Sally Greenhill
99 Phil Stobart
100 Martin Haswell
101 Philippe Monnet
102 Richard and Sally Greenhill
103 Bob Collins
104 Richard and Sally Greenhill
107 British Tourist Authority
109 Ed Buziak
110 Paddy McGakey
111 Mark Shearman
112 Bob Thomas
113 John Cleare
115 David T. Grewcock
116 J. Whitworth
117 Mervyn Rees
119 R. J. Clow
120 Richard and Sally Greenhill;
 Nick Birch

121 Richard and Sally Greenhill
125 R. J. Harban
126 Richard and Sally Greenhill
127 John Bramfitt
128 Richard and Sally Greenhill
129 Ed Buziak
131 P. H. Furst/Zefa
132 John Hartshorn
137 Rudy Lewis
138 Tony Boxall
140 Steve Anderson
144 Tony Boxall
145 Laurie Wilson
146 Jeremy Burgess
148 Koroseal Trading Company

Colour Photographs
All Photographs by Barry Monk
except for:
33 Michael McIntyre
34 Homer Sykes
70 Spectrum
106 Homer Sykes
123 Homer Sykes
124 Nick Birch